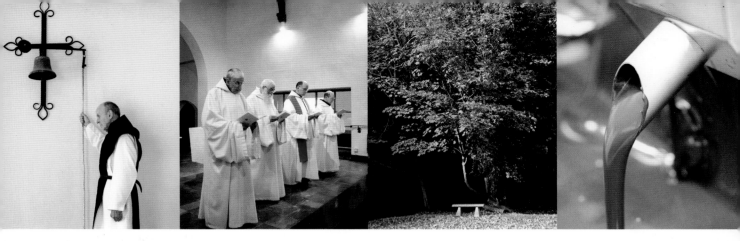

Contents

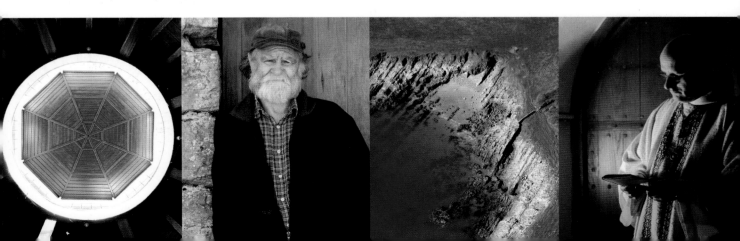

Caldey Island

▲
Tenby

C a l d e y S o u n d

Saint Margaret's Island

Reef

Little Sound

Eel Point

Sandy Bay

Star Cliff

Cathedral Caves

Sandtop Bay

B r i s t o l C h a n n e l

West Beacon Point

N

0.5 mile

0.8 km

C a r m a r t h e n B a y

Wales

Ferry route to Tenby: 3 miles

High Cliff

Priory Bay

Tŷ Gwyn

Den Point

Nanna's Cave

Jetty

Rubbishy
Corner

Chapel of our
Lady of Peace

Paul Jones
Bay

Spur Island

Caldey Point

Saint Philomena's
guesthouse

Saint David's
Church

Daylight Rock

Post Office
and Museum

Monastery

Small Ord Point

Bullum's Bay

The Old Priory &
Saint Illtud's Church

Little Drinkim

Drinkim Sand

Drinkim

Red Berry Bay

Shag Stack

The Flats

Caldey Island Lighthouse

Red Stack

Chapel Point

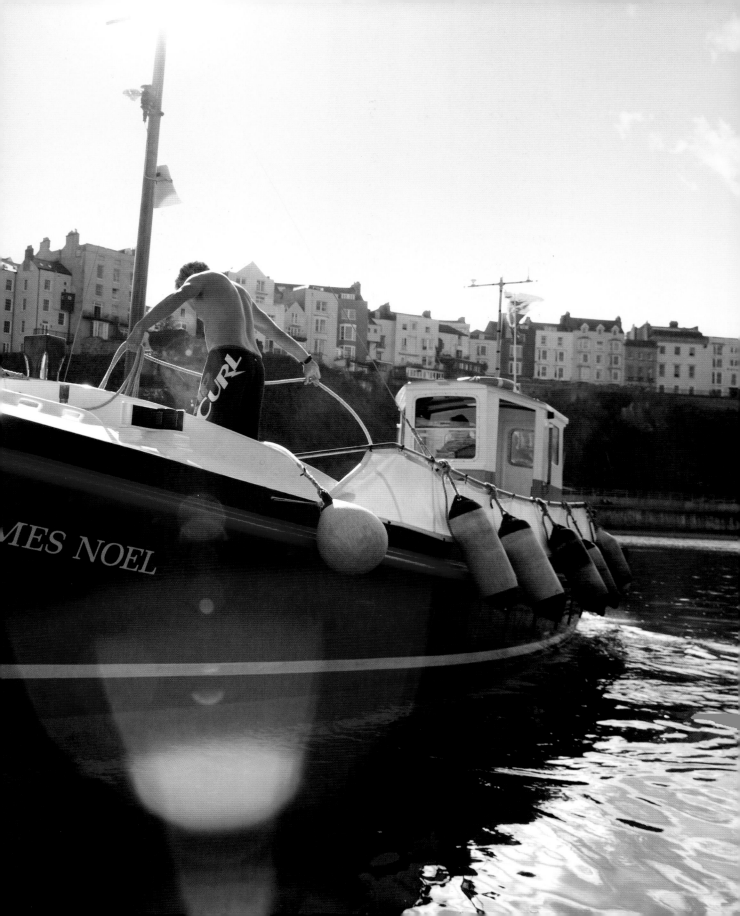

1

A trip to Caldey Island

Tenby, a walled town since the thirteenth century, lies on the south coast of Pembrokeshire. With its fine Georgian architecture and two sweeping beaches, it has been a tourist haven since the Victorian age, and remains one of the most popular visitor destinations in Wales.

Just a few miles off Tenby's medieval harbour lies Caldey Island. A mile-and-a-half wide and two miles long, the island has been home since the 1920s to a community of Cistercian monks and a number of villagers, some employed by the Abbey Estate. Every summer this fascinating community is visited by around 55,000 tourists.

Caldey's history of monasticism is comparable to that of Iona and Lindisfarne. The island still possesses a working abbey and anyone who has visited or stayed on the island will know it is a rare place indeed. It has a romance, mysticism, an atmosphere and an exceptional landscape.

Islands can hold a dual place in our minds. They are sometimes portrayed as desolate, lonely places to be dreaded. Throughout history islands have been used to isolate deadly diseases or, in the case of Alcatraz and Devil's Island, deadly criminals. In the adventure stories we once read as children, the ultimate punishment was to be marooned on an island – condemned to a life of living on the edge of survival, an almost inevitable slow death.

Yet islands can also occupy a reassuring place in our psyche. The pirate's worst nightmare becomes a haven of safety, of refuge and of peace – a space in which to reflect on one's life. For decades on BBC Radio 4's Desert Island Discs programme guests have been encouraged to look back over their lives while we as listeners contemplate seeing out our days in an island idyll surrounded by the music, the literature and the luxury we cherish the most. In this respect being marooned is largely embraced, almost desired.

The roots of monasticism have thrived on isolation from the wider world, and many religions have chosen islands for a life of contemplation and study. Since the earliest Celtic missionaries of the sixth century who spread monasticism across Europe, islands have often been the perfect places to pursue a life's vocation. The monks of Caldey Island follow in this ancient tradition.

A guide to Caldey Island

The tourist season on Caldey generally starts on Easter Monday and runs until October. Eight boats provide the service between Tenby and Caldey, and on a normal day in summer each may make six trips, carrying forty passengers on each crossing.

Left: A Caldey Island tourist boat prepares to leave Tenby Harbour.

Next page:

Bottom: Georgian buildings in Tenby overlooking South Beach seen from a passing Caldey tourist boat.

Top left: Boats moored at Tenby harbour.

Top right: Tourists leave for Caldey from South Beach, Tenby.

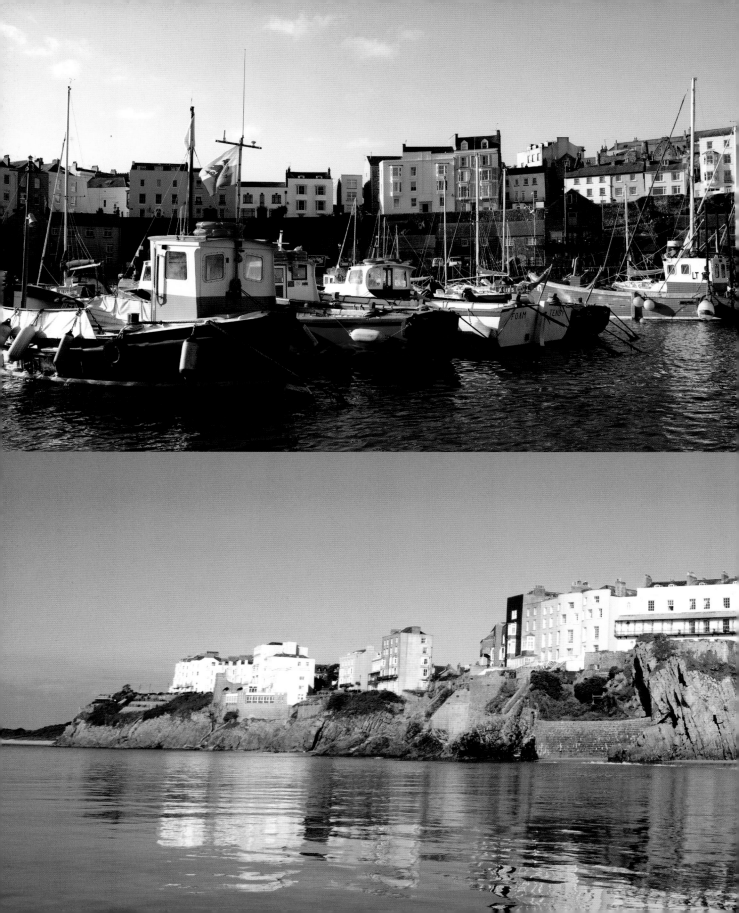

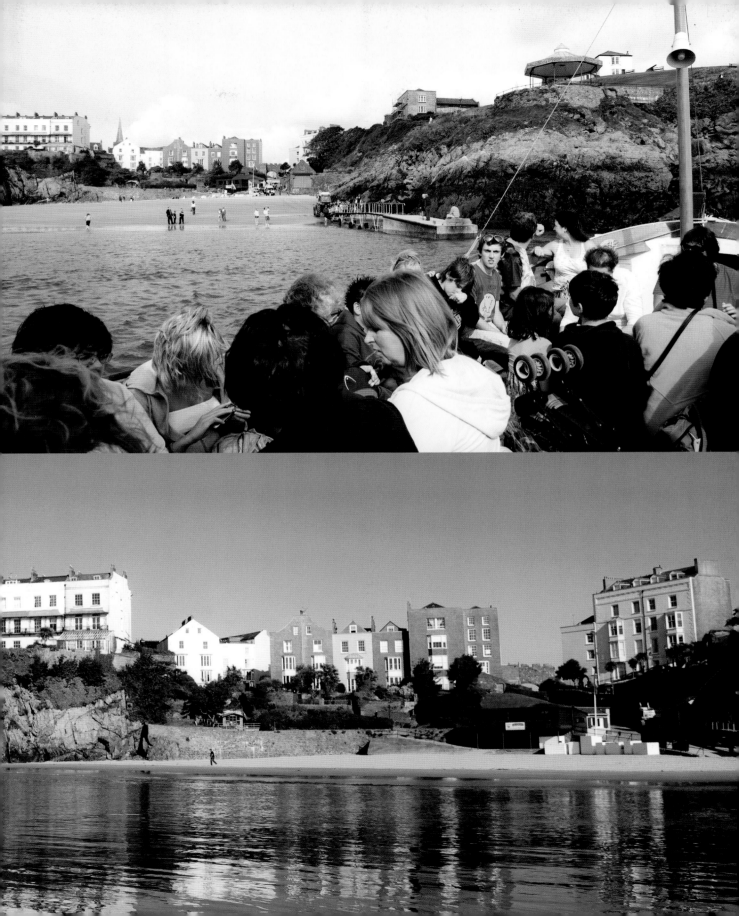

The architecture of Caldey Abbey

The project to make Caldey a monastic island once more was national news up to the start of World War I.

The architect for the abbey and many of the village buildings was one of the most talented Welsh architects of the twentieth century – John Coates Carter. His work on Caldey suggests that he was influenced by a range of prominent architects. Based in Penarth, Coates Carter could not avoid being impressed by the work of William Burges who had designed a number of great buildings in Cardiff in the late nineteenth century – the conical roofs and tall chimneys of Caldey Abbey reflect the fairytale forest retreat Castell Coch, on the northern outskirts of the Welsh capital.

The present Caldey Abbey was intended to be the gatehouse for a huge monastery that would have taken up much of the area that is now the island's woodland. On completion of this immense abbey the gatehouse would have served as a boys' school.

The deteriorating financial situation of the Benedictine community behind the scheme meant that their ambitious plans never came to pass – by 1913 it was estimated that £68,000 had been spent on their island building projects. Lack of funds and waning interest in the venture led to adjustments being made as the construction of Caldey Abbey progressed.

The monastic guesthouse – originally built to be the abbot's quarters – has hints of the garden city movement, led by men such as Barry Parker and Raymond Unwin. Other influences on were the American architect Henry Hobson Richardson, whose designs were renowned for having Romanesque parallels; and a former mentor JP Seddon, a Gothic Revivalist architect.

Even with the scaling back of plans for Caldey Abbey, the final result was an abbey that is thought to be one of the best examples of large-scale Arts and Crafts architecture in Wales. In his work on the island, John Coates Carter confirmed himself as a leading light in the Arts and Crafts movement and this work is described as the high point of his career.

Saint David's Church

In old records Saint David's is called "the church on the sea shore" as until the late eighteenth century the sea around the island reached the rocks under the present Abbey. The nave and north wall are probably medieval and there is evidence of Norman work in the church.

The Old Priory and Saint Illtud's Church

- These are the oldest buildings on Caldey and are of national significance. The Priory was established by the Tironesian monks of Saint Dogmael's in the twelfth century.

- Nearby there is thought to have been a cemetery of pre-Norman origin. This theory is supported by the presence of the Ogham Stone that now sits in Saint Illtud's Church.

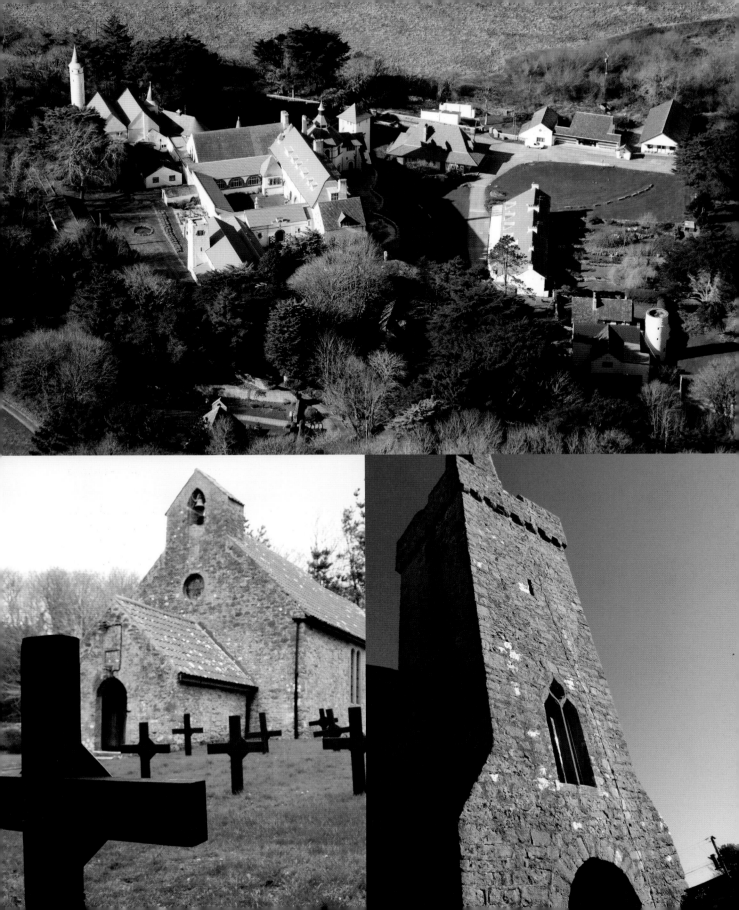

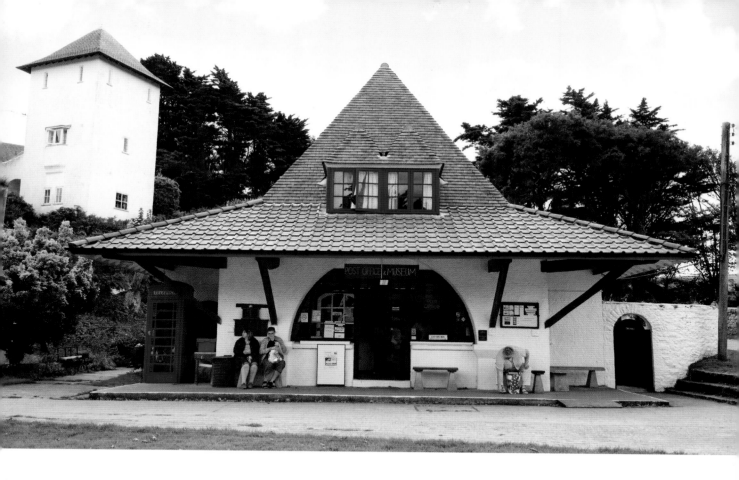

Above: Caldey Post Office and Museum.

- The grounds are on one of the highest points on the island, close to the natural water springs and watercourse – the adjacent fishponds are probably medieval. The old Priory corn mill is now a ruin.

- Constructed from Caldey limestone and sandstone, the buildings have been unoccupied since the Dissolution of the Monasteries except for brief use by the Benedictine community in the early 1900s.

- Saint Illtud's Church is still a consecrated Roman Catholic church and is occasionally used for services.

The Post Office

With its large gambrel roof and dormer windows, Caldey Post Office is Arts and Crafts in style. The high arches are influenced by the work of Henry Richardson.

The village cottages

Originally early nineteenth century, the row was re-worked by Coates Carter. He demolished two cottages, whitewashed the remaining six in the row, installed sash windows and roofed the terrace with red pantiles. The cottages stand beside the village green, directly under the Abbey.

Below left:
Saint Philomena's guesthouse and retreat.

Saints Joseph and Peter's cottages

A pair of cottages built in a T plan and sharing a chimney, Saint Peter's faces the Abbey, while Saint Joseph's sits at the back.

The Forge

A two-storey L plan nineteenth-century building that was first used as a cottage. It was developed to house the blacksmith's workshop and the perfumery.

Saint Philomena's guesthouse

Presently used to provide accommodation for visitors hosted by the monastery's guestmaster. Built of limestone, it is quite different from the other buildings on the island. It was designed by a former monk, J. C. Hawes, in 1906 and has been extended in recent years.

Tŷ Gwyn

The large house that overlooks Priory Bay. Like all of Coates Carter's buildings it is rendered with whitewash with a red roof and dormer windows. First used as the home for the island steward.

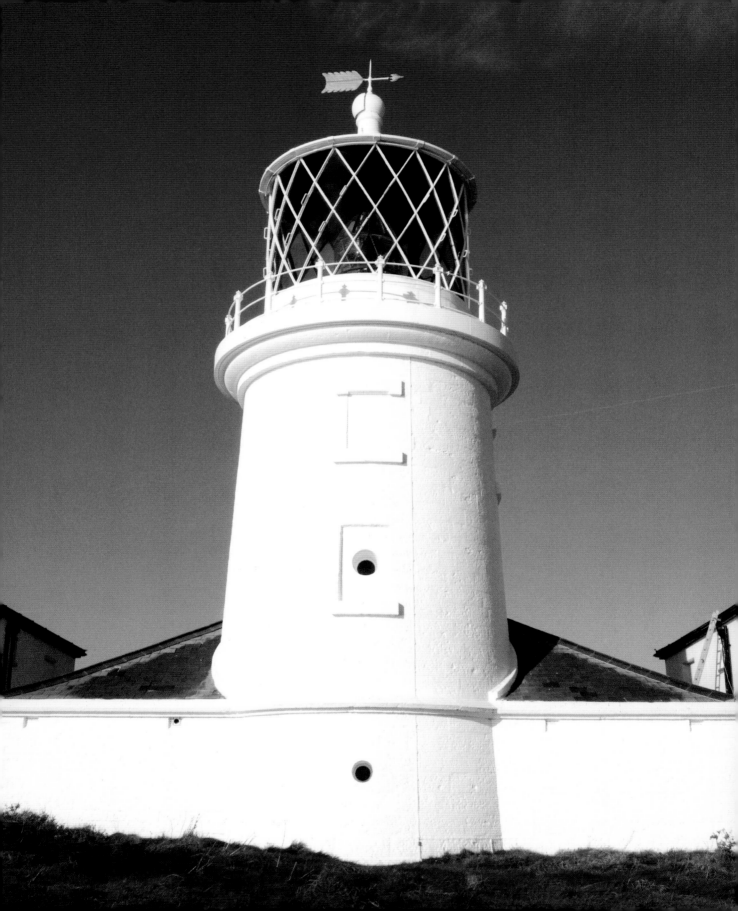

Caldey Island lighthouse

Position 51° 37'.86 N 04° 41'.00 W

Caldey Island's lighthouse is situated on the highest point of the island, on the southern edge overlooking the cliffs at Chapel Point. It was built by Trinity House in 1829 at a cost of £3,380 11s 7d. Next to the lighthouse tower are two houses that accommodated the keepers and their families before its conversion to an automated service in 1927. Caldey was the last light owned by Trinity House to be powered by acetylene gas until it was converted to electricity in 1997.

Caldey Island lighthouse	
Built: 1829	**Lamp:** 50 watt halogen lamp
Height of tower: 16 metres (52ft)	**Character:** White and red group flash three times every 20 seconds
Height of light above mean high water: 65 metres (213ft)	**Intensity:** White 5010 candela, red 939 candela
Automated: 1927	**Range of light:** White 13 nautical miles; red 9 nautical miles
Optic: 2nd order 700 mm catadioptric	

Dom Armand de Veilleux's visit

The brothers of Caldey Abbey are visited every year by Dom Armand de Veilleux, the Abbot of Notre-Dame de Scourmont near Chimay in Belgium, the mother house that provided the first Cistercian monks of Caldey. Every other year his trip is referred to as a "canonical visitation"; part of an ancient tradition in the Cistercian Order that goes back to the twelfth century. He stands on the quayside at Tenby, a neat-looking man casually dressed in a blue jacket and white crew neck sweatshirt. He has white hair and a beard and wears thick black-rimmed glasses. He takes his small dark blue suitcase onto the boat and chooses to sit on the starboard side, picking the best place to take in the view on the crossing to Caldey Island.

Dom Armand's annual pilgrimage is an important date on the abbey's calendar. His visits are designed to be a check-up on the Abbey's community, its maintenance of regular monastic life and its economic health.

During this process Dom Armand interviews the abbot and all the brothers, who are encouraged to say whatever they wish about their experience on Caldey – both the positive and the less positive. At the end of the week spent with the island community, he draws up a report and presents it to the monks to read through and study. The report is also sent to the central office of the Order in Rome, so that the Cistercians' Abbot General and his council will also know how well Caldey Abbey is doing.

The visitation is not intended as an inspection but is led by a sympathetic observer to pinpoint the community's successes and shortcomings with the overall aim of improving its life. Dom Armand's approach is everything, as Father Daniel van

Left: Caldey Island lighthouse.

Next page: Interior of Saint David's Church.

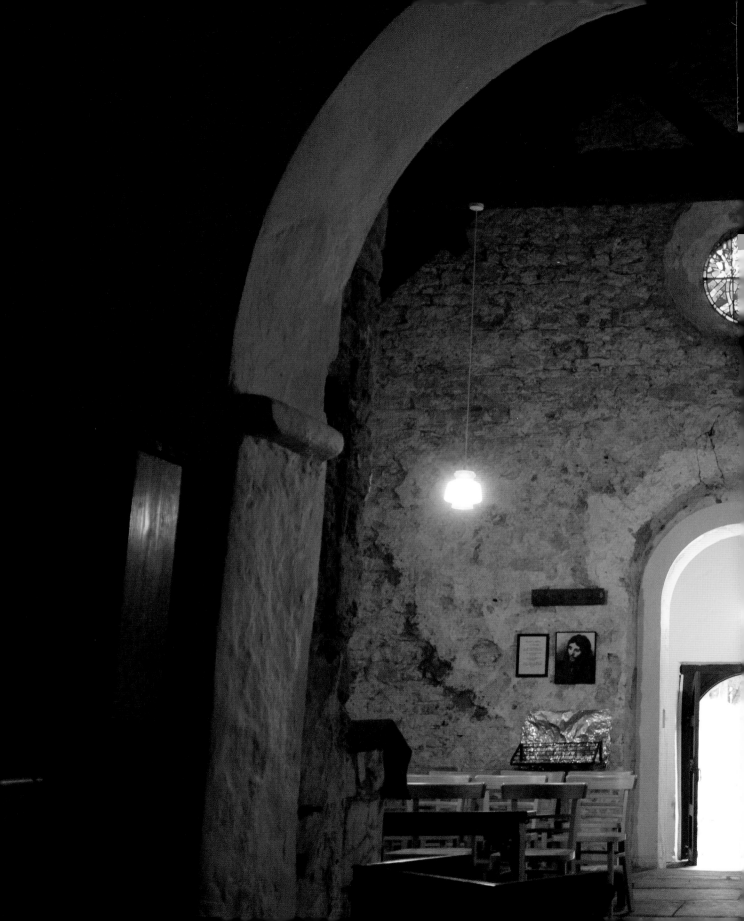

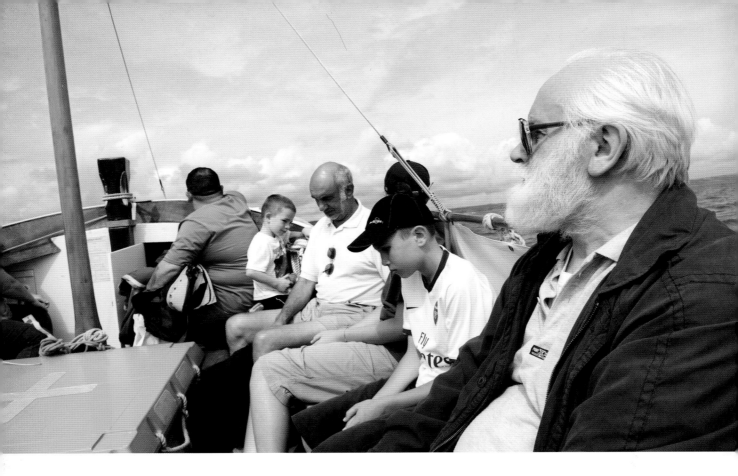

Above:
Dom Armand de Veilleux, Abbot of Notre-Dame de Scourmont, travels to Caldey Island.

Opposite:
Top: The door of the village hall. The bell in the abbey cloisters.

Bottom: Dom Armand in the monastic guesthouse lounge.

Santvoort, the abbot, explains: "It is much more a listening ear, that's what he wants to be – a listening presence – trying to help the community to look at themselves. To hopefully be able to say that 'Yes – that's a positive life, it's a healthy life – but there are several matters that can make it even more healthy.'"

How does Dom Armand approach the visitation here in comparison to other visits he might make to communities all over the world? "There is something in common even though each community is very different," he says. "They have the same basic orientation, the same basic spirituality. But each community is conditioned by its cultural environment – a French one will not have the same atmosphere as an African one or an Indonesian one or one in Wales."

The Caldey monks are well accustomed to the visitation process, and it clearly plays a vital role in helping them understand where they are in life. But for Father Daniel, a man who rarely has someone to lean on, it could be an examination that questions his management. He doesn't see it that way, however. "It is an encouragement for me to share because he is also an abbot, so you have similar experiences. And you are both sometimes in a situation where you just don't know what to do and if you hear him saying 'I don't know what to do' – wow! It's a real encouragement! He doesn't have all the answers, which is important – very important."

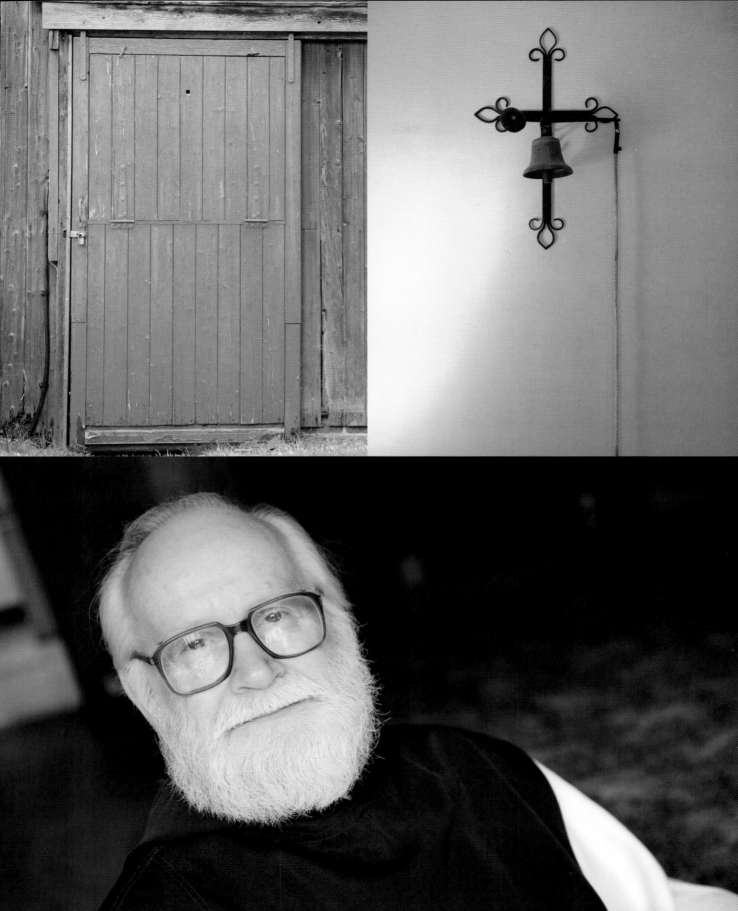

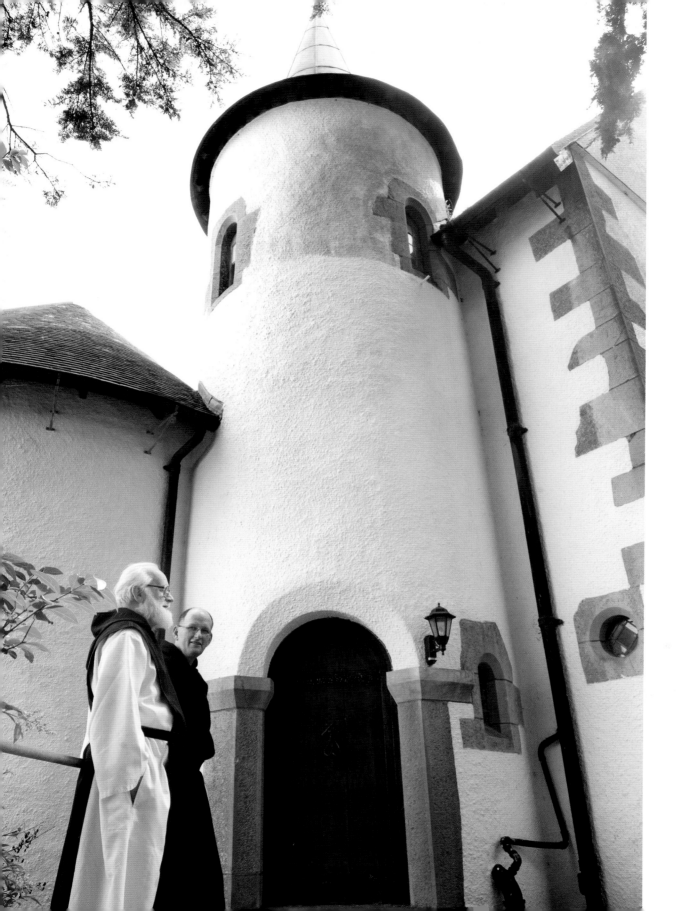

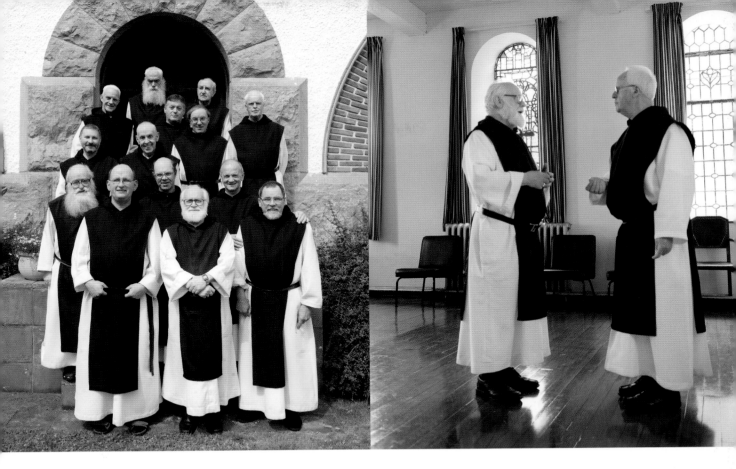

Above left:
The brothers with
Dom Armand.

Above right:
Dom Armand talks
with Father Senan
in the community
Chapter Room.

Left: Father Daniel
and Dom Armand
walk through the
gardens surrounding
the monastic
guesthouse.

Dom Armand comes across as an exceptional man, somewhat enigmatic. He speaks seven languages fluently. When you speak to him you feel that you are in the presence of someone who has great knowledge, wisdom and humility. To become an abbot is an achievement in itself – it is recognition of personality, wisdom, trust and inspiration. You are voted by a community of experienced people to be their leader – Dom Armand has been selected three times. He has also been sent by the Cistercian Order to found communities in countries across the world. Added to this, he spent seven years working in Rome on behalf of the Cistercian governing body.

When a monk enters a community, he makes a vow of stability and so fully expects to spend the rest of his days within that brotherhood. Dom Armand considers it a gift to have experienced such a diverse career. "Some people, because of circumstances or responsibilities, are called to go and help other places, or have various types of service to render, so I have been lucky to have visited practically all the monasteries of our Order. Every place I have been to, I have always loved everything I have done. Every time I have been called to begin a new chapter in my life, I put the last dot on the former chapter, turn the page and start a new one."

With his intimate knowledge of the Cistercians and all their houses, he has a particular affection for Caldey, one of only two island houses in the entire Order. "It has a special atmosphere," he says. "We have monasteries all over the world, each one has a specific character, but a community living on an island is something special. It attracts a

Right: The brothers make their way up to Saint Illtud's Church.

Next page:
Dom Armand and Father Daniel.

specific type of person who loves this atmosphere. It gives a large amount of solitude. It is pretty much in the tradition of the Celtic monasticism that they live on islands, on rocks off the coast."

So what about this rare island group on Caldey? "I think at this point I find a very peaceful community – people are ageing as we all do. But they are ageing well, which is important. It's not obvious to age well in a community like this. I quoted to one of them something I read recently that 'Age is not a pretext to get old' – you can remain young even if you have a larger number of years behind you."

Many people perceive monks as being shut away, shunning reality in a monastery, but it is easy to forget that to live on Caldey requires energy and vitality. The unpredictable weather, along with the tens of thousands of visitors every year, make the island a challenging place to be.

The unpredictable rugged seclusion attracts the men of Caldey to a life of contemplation. Father Daniel has grown to love Caldey's unforgiving nature. "You can hear very high wind – it howls its tremendous force and I'm very happy when that happens. I love it, I love every time of the year, you are very open to the change of the seasons and that is very important for my spiritual life. You are reminded in so many ways what life wants to tell you."

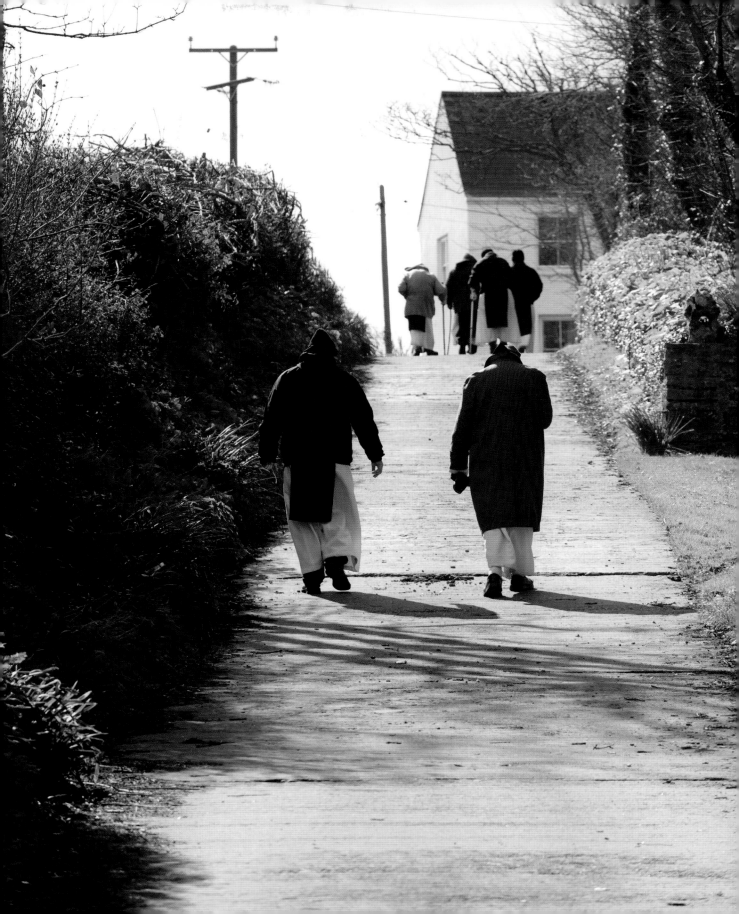

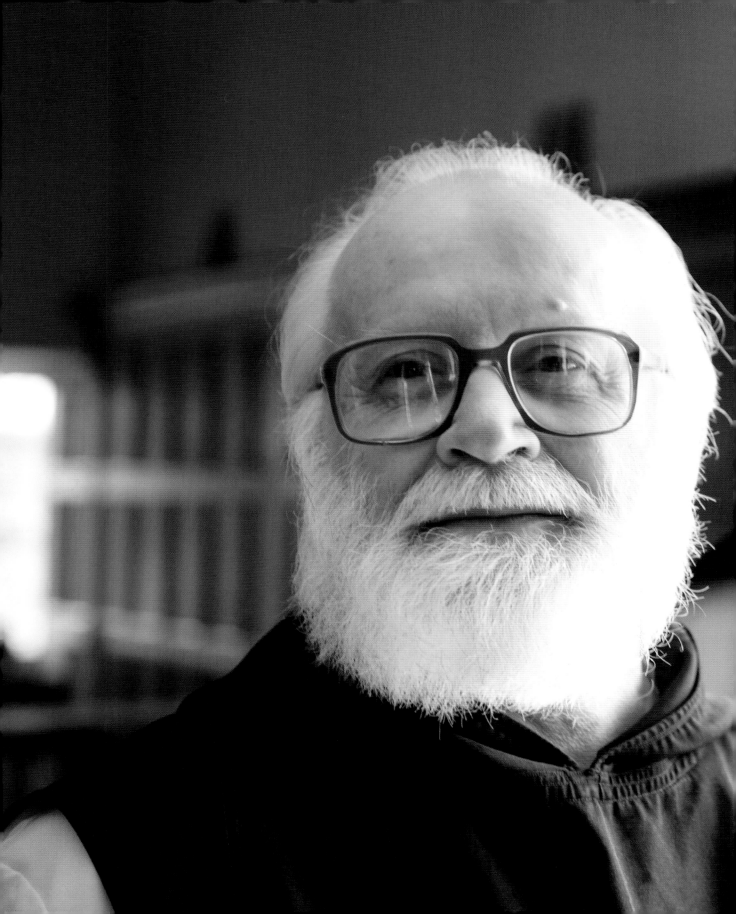

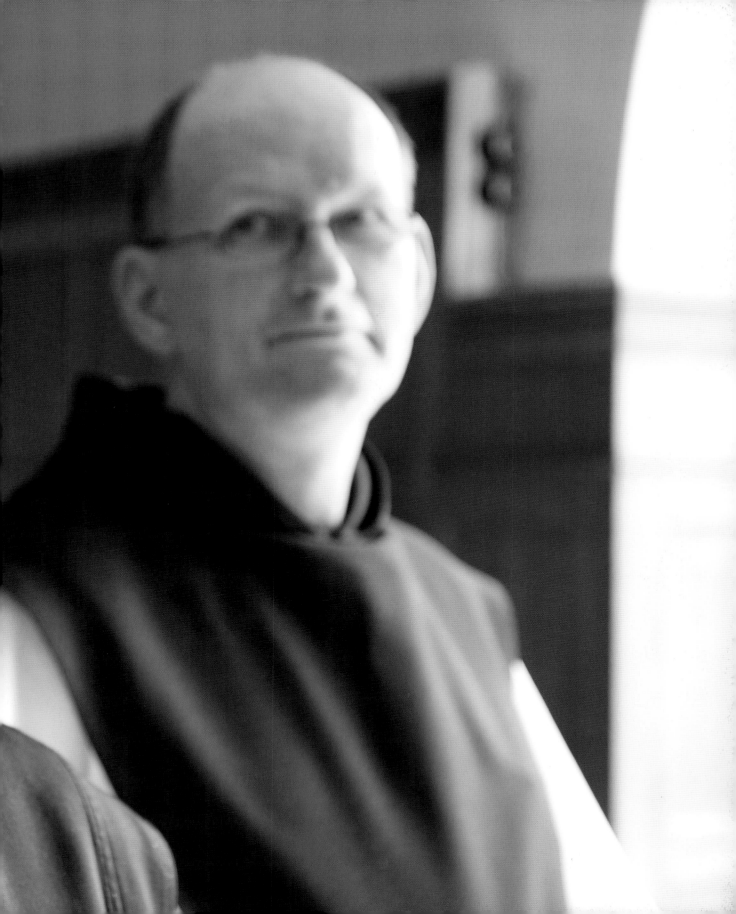

Brother Luca

Brother Luca Cestaro, a cradle Catholic, was born into an Italian family from Neath, South Wales.

He spent more than five years with the Franciscans, but just before making his final commitment to the order Luca felt that the life wasn't for him: "I think I stayed in longer than I should have because the people I entered with were great pals. I didn't rule out religious life completely, after all I ended up here."

As a Franciscan Luca had experienced various areas of pastoral charitable work. He qualified as a nurse specialising in caring for people with mental disabilities, but it was becoming clear to him that he still hadn't found his way in life: "I didn't find it very easy work. With the Franciscans I cared for people who had been brought up in loving families, whereas those that needed nursing had often been abandoned at an early age. Their mental handicaps were exacerbated by their upbringing and neglect. It was very challenging and very skilled nursing was needed. I found it difficult work."

In the late 1990s Luca's parents fell ill, and he used his nursing skills to care for them. During this time he started visiting Caldey. The interest in a monastic life clearly hadn't gone away but he felt that to become a Cistercian would be too severe a vocation for him. His mother died in 1999 and his father a year later. Luca decided to pursue his desire to lead a monastic life.

A Franciscan advised him that when choosing a monastery its setting was important: "Because the one you choose will be the one where you stay put for life. I had two other monasteries on the go at the time and Caldey was certainly the most beautiful."

In the hours outside prayer and contemplation Luca will often be seen at work in the abbey gardens. "I'm more a practical person rather than an intellectual. Caldey is a community where you feel that you're all valued equally."

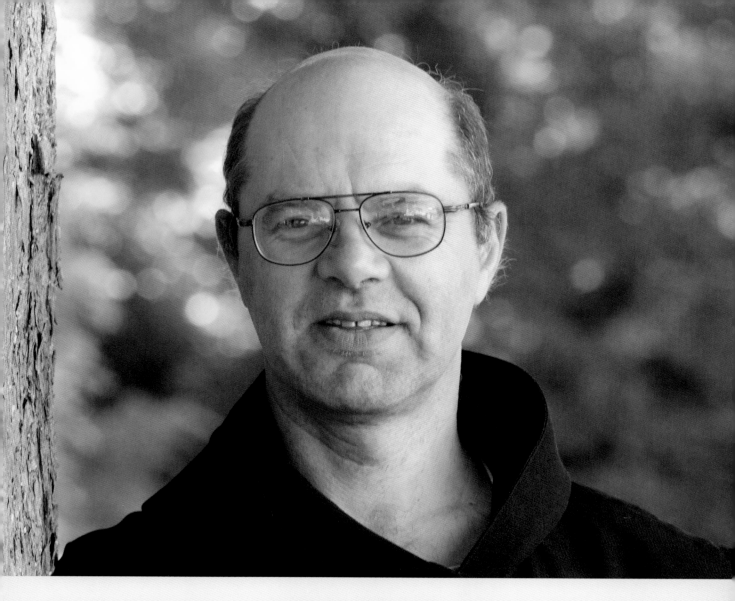

Place and date of birth: Neath, South Wales on 15th March 1959.

When did you become a novice? 26th July 2002.

When did you take full vows? On the Solemnity of the Assumption, 15th August 2007.

Why Caldey? Because I feel particularly suited to the Cistercian way of life, prayer and work. It is also near to where I was born and bred.

What is your favourite part of the island? Drinkim Bay. It is hard to get to, so nice and private!

What is your favourite canonical hour? Vigils, for its inspiring readings.

What are your interests? My interests are numerous – music, art, writing, nature, architecture, history, family history, sport, to name a few.

What do you miss from the outside world? The biggest thing I miss is having my own car, and sometimes a bit of noisy street life, though I quickly tire of it and yearn once more for the peace of this island!

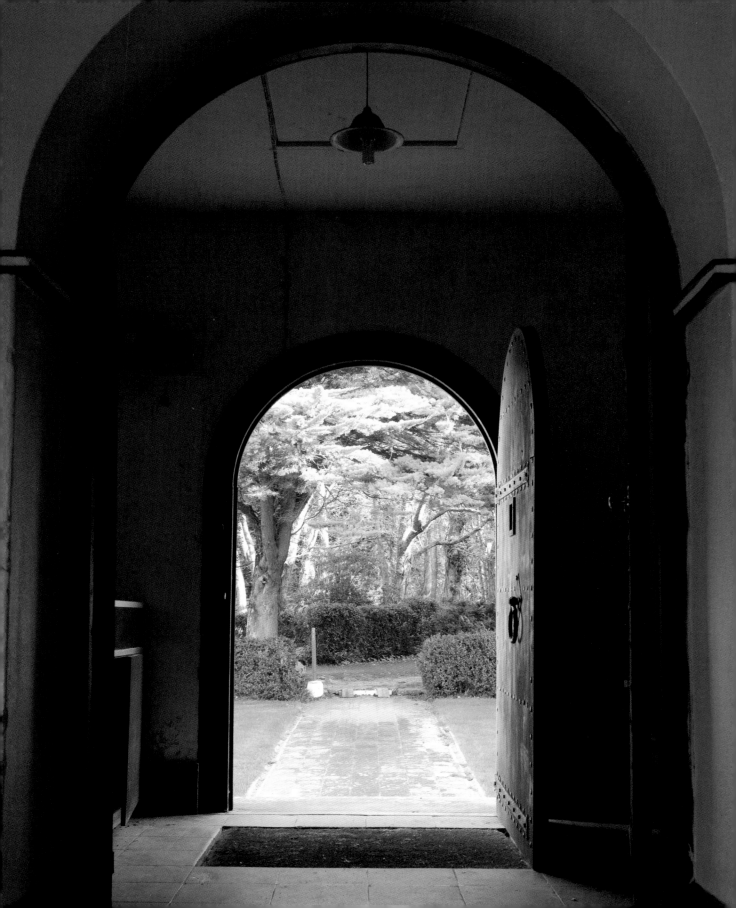

2

The history of the Cistercian Order

Cistercian origins – the Rule of Saint Benedict

The origins of the Cistercians lie in the sixth century with Saint Benedict who wrote a guide for living within a community of monks – his Rule for Monasteries. Many Christian monastic groups lead their lives according to its precepts. Today the Cistercians are one of the largest orders of monks and nuns to base their lives on the Rule of Saint Benedict.

Saint Benedict of Nursia and his Rule for Monasteries

Saint Benedict, regarded as one of the fathers of European culture, was born in about 480 AD into a wealthy family in central Italy. He studied law in Rome, but was so dispirited by the dissolute nature of Roman society that he devoted his life to God.

After spending some time with a small religious community he lived as a hermit, gaining a reputation as a deeply holy man. He was persuaded to become the abbot of a monastery near Subiaco, but after the monks there rebelled against his discipline and tried to poison him, Benedict returned to the wilderness. He continued to attract a large number of followers, prompting him to found 12 monasteries, each with 12 brothers and with himself as their leader.

In 530 AD Benedict founded a monastery on Monte Cassino, where he formalised his Rule, combining monastic traditions from the East with a commune founded on the principles of "Ora et Labora" – "Pray and Work". His Rule proposed: "To establish a school of the Lord's service and in setting it up we hope to order nothing that is harsh or hard to bear."

When the Lombards attacked Monte Cassino in 581 AD the monks fled to Rome, taking with them a copy of the text. When the Holy Roman Emperor Charlemagne defeated the Lombards he restored the monastery at Monte Cassino and asked for a transcription of the Rule, which then became perhaps the most influential document in Western monastic history.

Apart from its effect on Christianity, the Rule of Saint Benedict is considered to have helped shape Western society. Ahead of its time, it is a written constitution that explains the authority and the extent of its power under a clear law. It also provides for the right to review the legality of decisions made by its rulers, and contains many clearly defined elements of democratic rule.

Left: View through one of the doors leading to the cloisters.

Next page:
A cloister wall.

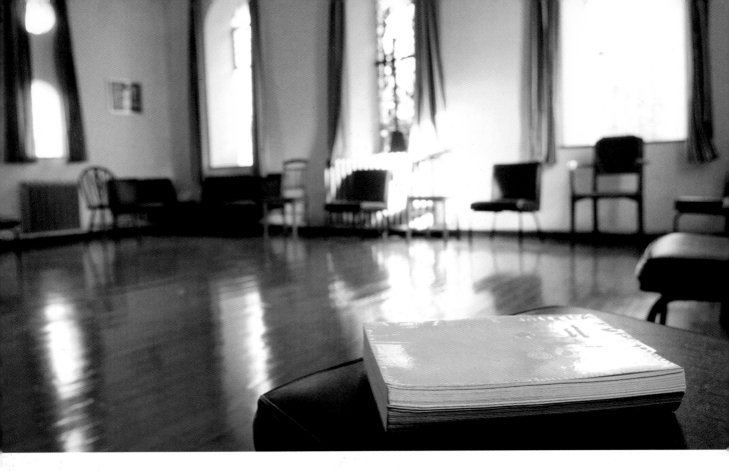

Above: The community
Chapter Room.

The beginnings of the Cistercian Order

In 1098 a group of monks established a monastery near Dijon in Burgundy on
marshland at Cîteaux (Latin: Cistercium).

From this isolated community one of history's most sophisticated and formidable
monastic movements was born – the Cistercians. They became renowned for their
staunch commitment to a life of contemplative prayer and manual work, and famous
for their political brilliance, effective internal government, business and construction.

As the order grew it built spectacular abbeys, made significant advances in farming,
water management, civil engineering and established its own international system of
self-government.

Within 100 years of their foundation the Cistercians had grown from being a splinter
group of idealists to a pioneering mass organisation at the heart of religious life in
western Europe.

The Cistercian movement started with the career of Saint Robert of Molesme,
from Champagne in the Grand Duchy of Burgundy. By his death in 1111 Robert had
founded two monasteries. The first at Molesme was known as one of the most fervent
Benedictine abbeys of its time. The second at Cîteaux became the mother house of the
Cistercian Order.

Below: The Stations of the Cross Service on Good Friday morning in Saint Illtud's Church.

In its early days the community at Molesme was poor but well disciplined. As the settlement's reputation grew, a church and monastic quarter was built with donations from local nobility. These riches seriously undermined discipline, and the abbey was split between the more devout founders and the less motivated new monks.

Robert's efforts to restore discipline failed, so he resigned and, with those still loyal to him, founded a new monastery, inadvertently sowing the seeds of the Cistercian Order.

Foundation at Cîteaux

Abbot Robert, his prior Alberic, an English monk Stephen Harding, and 21 colleagues settled at Cîteaux. The site was described in the Exordium Cistercii as "a place of horror and of vast solitude". With limited funds they began building accommodation and preparing the land for farming. The Duke of Burgundy, Odo I, who was impressed by the monks' devotion, gave them money and the Novum Monasterium (New Monastery) of Cîteaux was established.

While Cîteaux gathered strength, the monks left at Molesme regretted the loss of their abbot and asked Pope Urban II to request him to return. The Pope accepted and Robert returned to Molesme on condition that the monks promised to follow the Rule of Saint Benedict loyally.

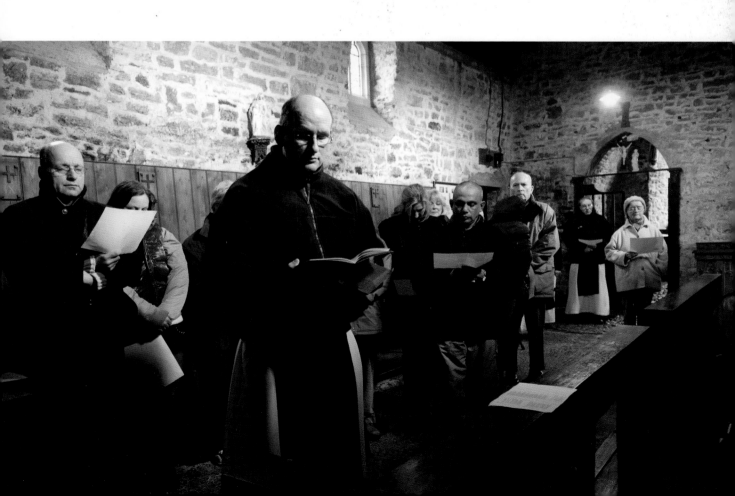

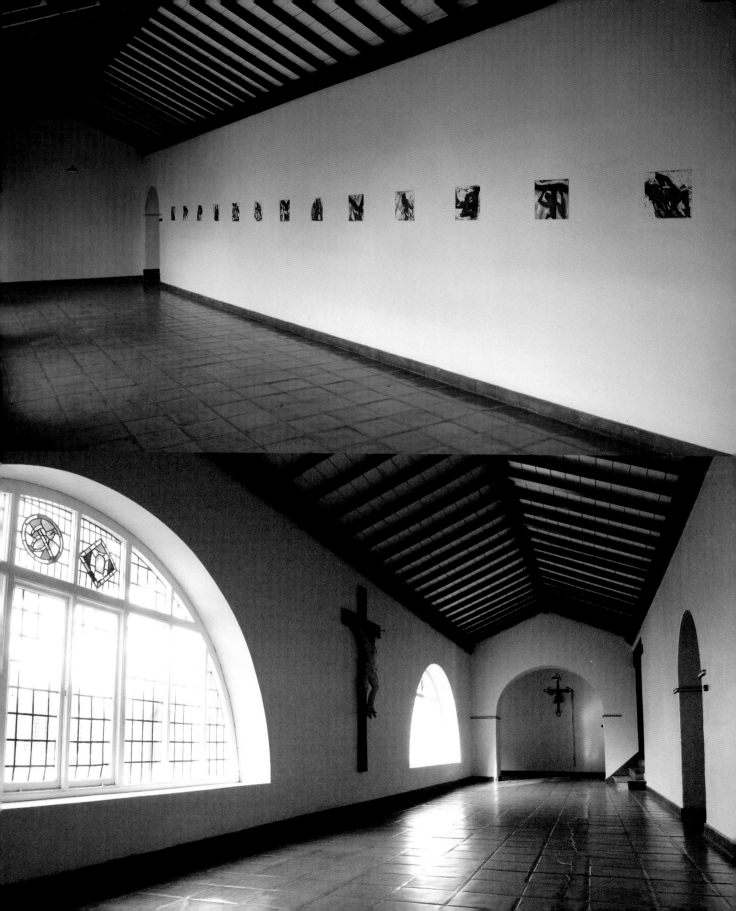

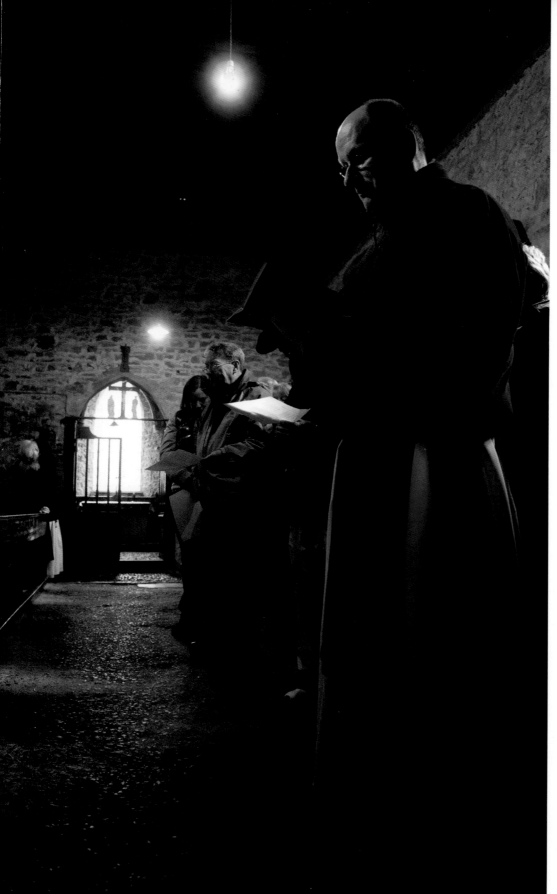

Left: The Stations of the Cross Service on Good Friday morning in Saint Illtud's Church.

Opposite:

Top: Cloister wall with the Stations of the Cross.

Bottom: The cloisters.

Next page: The Stations of the Cross Service on Good Friday morning in Saint Illtud's Church.

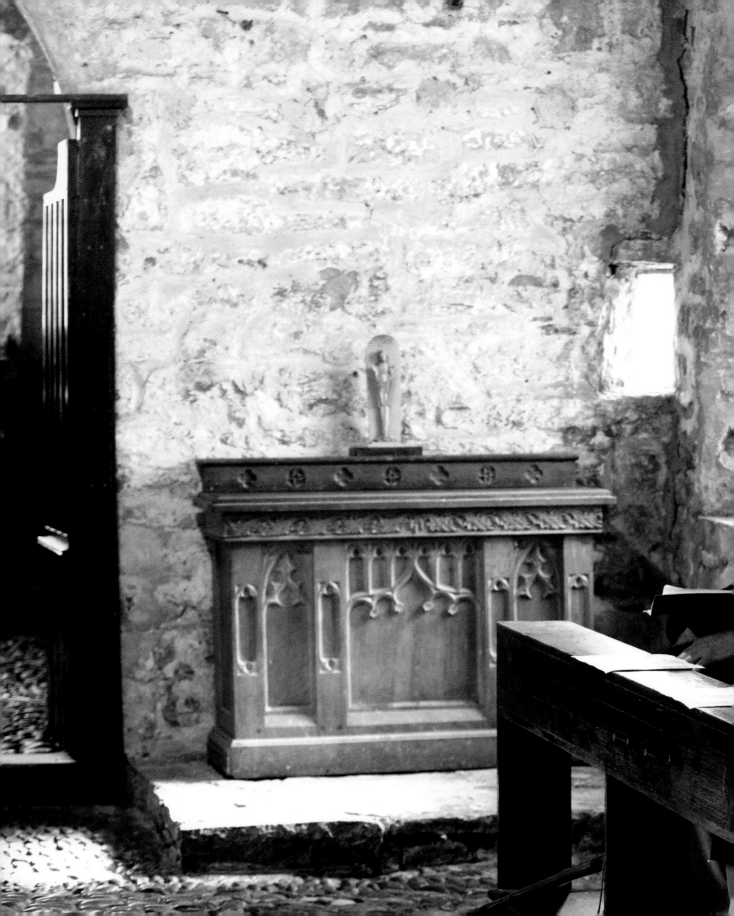

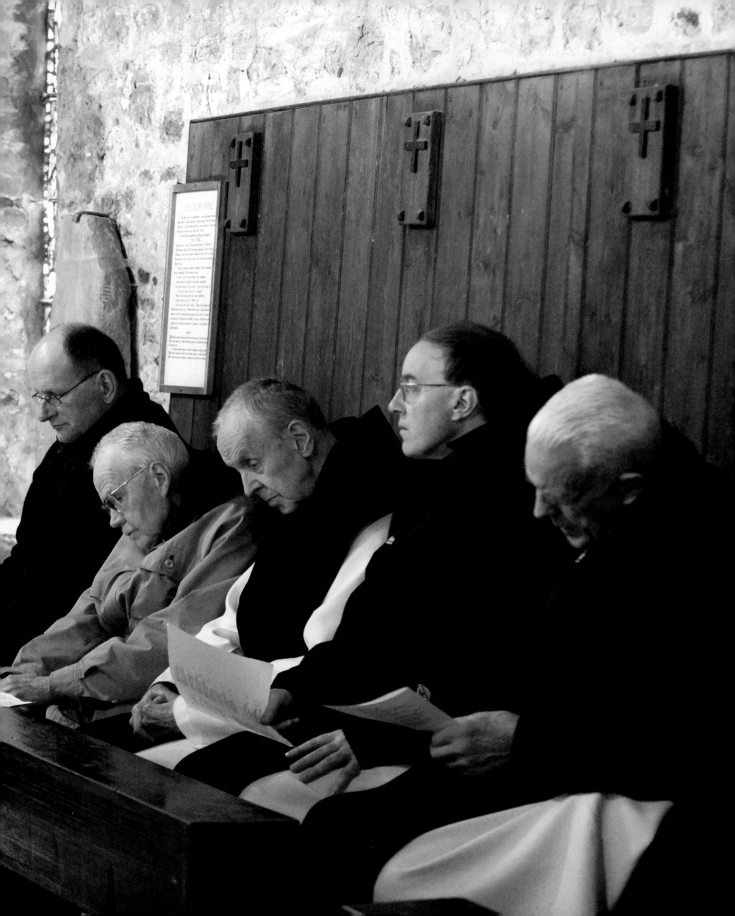

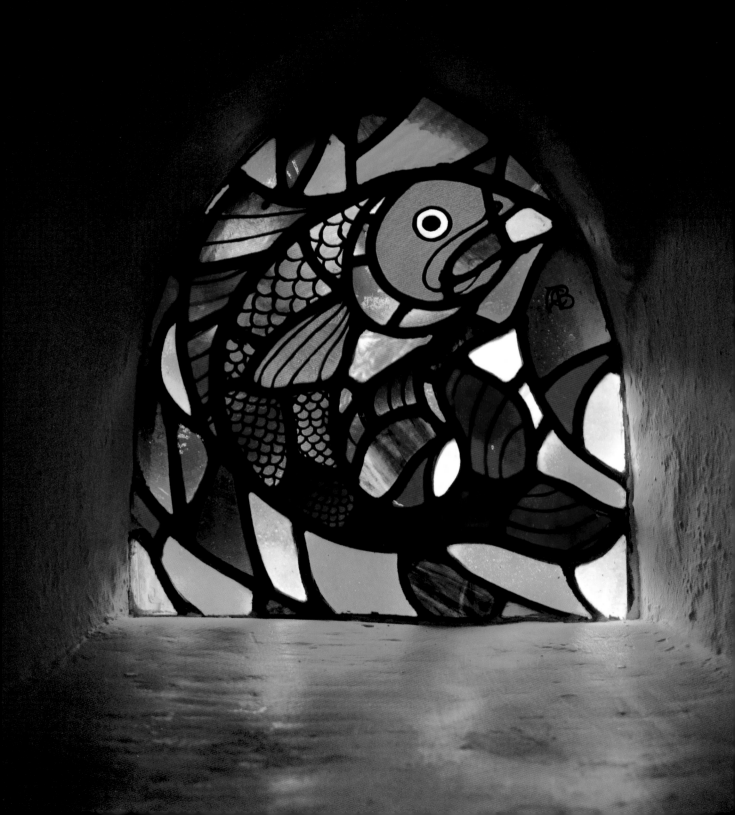

Left: An ancient Christian symbol, the fish window in Saint David's Church. The windows in the church were all designed and made by Dom Theodore Baily, one of the Benedictine monks living on Caldey in the 1920s.

Cîteaux's second Abbot

Robert's successor at Cîteaux, Alberic, was equally influential, and under his abbotship the community consolidated.

With Papal protection Alberic introduced lay-brothers, who helped with manual work and business affairs and were accepted as full members of the monastic family, without having the full duties of a choir monk. This provided choir monks with time to follow fully the demands of the Benedictine Rule. Alberic introduced white habits instead of black, and the Cistercians became known as the "White Monks".

Abbot Harding – the founder of the Cistercians as an Order

The third abbot of Cîteaux was Stephen Harding, the Anglo-Saxon nobleman. A scholar, who spoke English, Norman French and Latin, Harding became arguably Cîteaux's most influential founder – an expansionist of great vision.

During Harding's time the Cistercian movement was born and grew rapidly. By his death in 1134 Cîteaux Abbey was the ruling house of a pre-eminent European religious order – a network of houses all governed by a clearly defined manifesto and constitution.

In 1112, with a surplus of members, the community sent monks out to establish monasteries at La Ferté, Pontigny, Morimond and Clairvaux. The abbots of these new abbeys were known as the first four Fathers of the Order, and each established further monastic communities. Perhaps the most influential of these was Clairvaux, which by 1153, when its abbot Bernard died, had established 180 out of 340 Cistercian communities.

Abbot Harding felt strongly that abbeys should always be located in places "far from the concourse of men", often in areas of exceptional beauty. He was also an innovator, facilitating the opening of the first Cistercian nunnery for women at Tart near Dijon in 1125.

The Charter of Charity

In the face of such rapid expansion, Abbot Stephen Harding saw the need for a code of conduct, to ensure that the new Cistercian Order could evolve progressively and remain united. Mindful that Cîteaux itself had been formed by a splinter group, he created the Charta Caritatis, Charter of Charity, a 12-chapter constitution clarifying the relationship between Cîteaux and its daughter houses. It compelled abbeys to a common observance of the Benedictine Rule and requested that all brothers swear their allegiance to the abbot of the house. Harding devised a visitation system which respected the independence of each house but ensured loyalty from and to the governing body. This system was the template for the way in which the houses of the Cistercian Order still administer themselves today.

Above: Stained glass windows in the abbey cloisters.

Harding's Charta Caritatis also specified that all abbots should visit Cîteaux annually for an assembly of the general chapter. This practice of meetings and visitations proved to have many significant benefits for the Order, not least the dissemination of knowledge in whatever industry a house might be expert – be it engineering, farming, finance, or metal working.

Cistercian expansion and move into Wales

Throughout the twelfth century the order continued to expand. Within 50 years of the founding of Cîteaux, the Order numbered 339 houses; by 1200 there were more than 500. In Wales they settled quickly and unexpectedly became a driving force in the movement for Welsh nationhood. The monk-chronicler William of Malmesbury described the Cistercian life as "the surest way to heaven".

The first monastic orders established themselves in Wales with the permission of the Normans who had conquered England and some parts of Wales in the eleventh century. They used abbeys and churches to serve their own needs for religious worship but also to consolidate political control. In 1131 under the patronage of the Anglo-Norman Lord of Chepstow, Walter fitz Richard de Clare, a colony of monks from L'Aumône settled on the banks of the river Wye at Tintern – the first foundation of a Cistercian Abbey in Wales. The Cistercians who founded this and two other remote abbeys at Whitland and Margam were 'frontiersmen'.

Below: A clearing in the monastic enclosure.

The Normans eventually lost their grip on Wales and its religious establishments. The Cistercians distanced themselves from them, and the Order became trusted by some of the most prominent dynastic families in Wales and flourished with their sponsorship.

Whitland in Carmarthenshire, the first house to settle in Welsh-speaking Wales, was the driving force behind the spread of Cistercian monasticism into the heart of Wales. Key to this was the protection of Rhys ap Gruffudd, later known as the Lord Rhys. In 1165 he captured the Anglo-Norman Robert fitz Stephen who had established a community at Yr Hen Fynachlog, The Old Monastery. Rhys ap Gruffudd re-sited the monks to Strata Florida and promised to guarantee their safety as well as those at Whitland Abbey. A Charter of Endowments written in 1184 stated that Lord Rhys had "begun to build the venerable monastery called Strata Florida and after building it to have loved and cherished it".

Other Welsh chieftains sponsored and protected monasteries in the west and north of Wales. Valle Crucis Abbey in northeast Wales was founded in 1200 by the ruler of northern Powys, Madog ab Gruffudd. Whitland sent monks to settle at Cwm-Hir, north of Llandrindod Wells, who were sponsored by Cadwallon ap Madog, the cousin of Lord Rhys. Another of Whitland's foundations was a colony established by the poet-prince and ruler of northern Powys, Owain Cyfeiliog.

Right: The community Chapter Room. On one side of the statue of Saint Benedict hangs a photograph of Dom Aelred Carlyle, the abbot of the Benedictine community that re-established monasticism on the island in the early 20th century. On the other is Father Daniel.

In 1188 Giraldus Cambrensis, Gerald of Wales, travelled through Wales with Baldwin of Forde, the Archbishop of Canterbury and a former Cistercian abbot, recruiting for the Third Crusade. Giraldus wrote a travelogue entitled "Journey through Wales". He was not a supporter of the Cistercians, but did acknowledge their ingenuity for settling in challenging locations: "Give them a wilderness or a forest and in a few years you will find a dignified abbey in the midst of smiling plenty."

The success of the Cistercians across Wales led to a surge in the number of vocations from Welshmen, reaching 2,000 at its height. Though the Order had become increasingly Welsh, not all abbeys were able to be so openly loyal to the Welsh princes. The houses near the English border were in a more delicately balanced political position – they were in Wales, but overt regard for Welsh ambitions could easily lead to swift and damning reprisals. Borderland houses such as Tintern and Grace Dieu were founded by Anglo-Norman barons and sympathising with the Welsh would have been reckless.

Where the houses could safely support the Welsh it was unconditional. Communities in the far west such as Strata Florida strongly supported Welsh nationalism. King John, fighting a civil war against the disaffected English barons, was well aware of how the abbey "sustains our enemies". Prince Llywelyn ap Gruffydd protected the monks at Strata Florida to such a degree that King Henry III failed to collect a large fine imposed on the monastery.

However Llywelyn's refusal to attend the coronation of Henry's successor, Edward I, and his building of a castle in Montgomery, antagonized the new king who soon set about regaining control of the Welsh by building a ring of fortresses across North Wales, many of which stand today. Llywelyn died in battle against the English near Builth Wells in 1282 and his headless body was buried at the Cistercian Abbey Cwm-Hir. His death ended hopes for a Welsh monarchy and prompted a significant reduction in the influence of the Cistercians.

Whatever its local political loyalties, the Cistercian Order remained united throughout Wales. The abbeys became important havens of prayer and learning, and pioneered farm production. They had a unity of purpose, governed by the same constitution and rule while belonging to a distinct European federation.

In the fifteenth century the Cistercians sided with another Welsh revolt. During Owain Glyndŵr's rebellion the abbots of Whitland and Aberconwy were both known as rebels, as was the abbot of Llantarnam who died urging on Glyndŵr's men in a battle in 1405. After the death of Glyndŵr, circa 1415, the revenge on Cistercian houses that had been loyal to him was devastating.

The contribution by Cistercians to Welsh patriotism extended to the encouragement and development of artistic and literary culture in Wales. In the eleventh and twelfth centuries most books and manuscripts were kept and copied in abbeys. The monks' literacy put them at the forefront of the dissemination of knowledge and their monasteries became centres for inspiration as well as for religious worship.

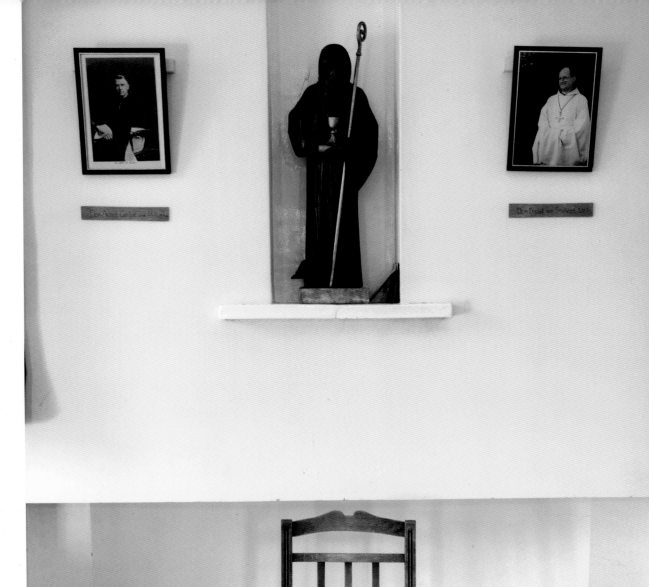

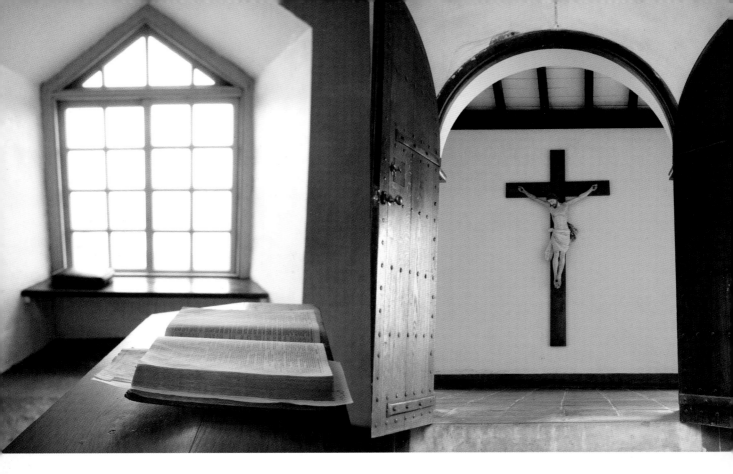

Above left: Interior of what was originally an island watchtower.

Above right:
The crucifix in the abbey cloisters.

Their work contributed hugely to the creation of Welsh cultural identity. Soon after settling in Wales the Cistercians compiled a record of national events. The Brut y Tywysogyon (Chronicle of the Welsh Princes) was written at Strata Florida and Valle Crucis. Strata Florida was thought to have contributed to the Annales Cambriae and also acquired a collection of books from Giraldus Cambrensis. Margam owned works written by the cleric Geoffrey of Monmouth and William of Malmesbury.

The Cistercians have been credited as significant patrons of the Welsh bardic tradition and one of the greatest Welsh poets, Dafydd ap Gwilym, is thought to have been buried at Strata Florida. Welsh princes, aristocrats and poets all sought to be buried within monastic grounds.

Given their picture-perfect locations today, it is easy to underestimate the achievements of the founding monks in turning inhospitable tracts of land into some of the most fertile and profitable property in medieval Europe. But the Cistercians were extremely adept at exploiting land for business and this was fundamental to their growing power and influence across Europe.

By the middle of the twelfth century the Cistercians had harnessed hydro-power. Monasteries sprang up near water sources which provided power for milling, wood cutting and metal working. Water was also channelled for use in cooking, washing, bathing and sewage disposal. In the medieval age this was cleanliness and efficiency of the highest order.

Below: Stairwell in the tower of the monastic guesthouse.

The Cistercians developed a highly diversified economy across Wales. Each house took full advantage of its geographic location. Margam, Neath and Tintern all exported goods along the Severn Estuary by ship. Tintern's monks fished many weirs along the rivers Wye and Severn. Monks at Strata Florida grew oats and wheat in the Aeron and Severn Valleys, fished at inland pools and maintained tidal fish traps on the west coast. They possessed corn mills and farmed peat on marshland near Tregaron.

The Cistercians also converted bare, uncultivated countryside into profitable areas of wool production. Most Welsh houses possessed large sheep flocks; Tintern's wool had by far the best reputation and was exported as far as the Low Countries.

In France the Cistercians were credited with pioneering the iron smelting industry. Their contribution to early industry in Wales was similar to that elsewhere on the continent – Neath had coal mines, Strata Florida ran a lead mine at Cwmystwyth, Basingwerk in north Wales mined silver, and at Tintern and Grace Dieu in Monmouthshire iron ore was smelted.

Left: The woodland within the monastic enclosure.

Decline

After a prolific first 100 years the growth of the Cistercians was significantly slowed by the establishment of new monastic orders, increasing resistance to the Church, and the Black Death.

By the early 1200s, religious fervour had receded throughout Europe. Those thinking of leading the life of a monk had other, arguably less challenging, options. Orders began to live outside the monastery. Franciscans and Dominicans, with the express aim of showing God to be working among the people, attracted significant patronage from the local community.

The Black Death of 1348-9 killed a third of the population of Europe, drastically reducing the supply of potential recruits for the church. Clergy numbers plummeted and the contribution of the Cistercians to education and literature declined markedly. The inability of the Church to explain this most fearful epidemic to their congregations led to growing resentment.

The final destruction of a strong Cistercian presence in England and Wales came during the Protestant Reformation that swept Europe in the sixteenth century. In much of Europe the Catholic Church was damaged by a reaction to its perceived corruption, hypocrisy and indulgences. In England and Wales the damage was wrought by both Henry VIII's decision to break with the Papacy so that he could divorce Catherine of Aragon, and the Dissolution of the Monasteries.

But by this time monasteries in Wales were relatively weak. Their populations had fallen sharply; many were seriously in debt, and discipline was lax. The once-huge Tintern Abbey now housed just twelve monks and in many areas the Cistercians were less popular. In 1520 the Margam monks fell out with the burgesses of Afan over rights to common land, and a year later merchants in Neath clashed with the brothers of Neath Abbey. The protection of the Welsh princes and the cherished place that the Cistercians once held in medieval Wales was now in the distant past.

Religious houses with fewer than twelve brothers or generating less than £200 a year were closed. Three Welsh houses – Strata Florida, Neath and Whitland paid £66, £150 and £400 respectively to appeal. Within a few years all three abbeys had been shut down.

The Dissolution of the Monasteries brought about the destruction of some of the finest architecture in Wales: '... buildings like Margam's chapter house or Neath's abbot's house must have been structures of peerless beauty' Glanmor Williams writes. Tintern, Margam, Cwm-Hir and Valle Crucis were once grand abbeys that possessed "exquisite treasures in sculpture, wood-carving, jewellery, plate, glass, floor tiles and vestments". Their extensive libraries were destroyed. Only twelve books survive that are thought to have belonged to the Welsh Cistercian abbeys.

Right: Interior of
the watchtower. The
building now serves
as the Chapel of Our
Lady of Peace.

The elimination of the Cistercian abbeys, centres for charity, medical care, education, trade and employment, was not without greater consequence. Some historians believe Henry VIII's dissolution may well have stopped an early industrial revolution in its tracks.

The Trappists

By the mid-seventeenth century the decline in monasticism, the Reformation, the long religious wars in France, and a loosening of discipline in many abbeys caused the Cistercian Order to become fractured and inconsistent in its observances. Before the Order disintegrated further it was time for another major reforming group to step forward – the Trappists.

In 1664 the Abbey of Notre-Dame de la Grande Trappe in Normandy called for a return to the devoted adherence to monastic life. Led by their abbot, Armand Jean de Rancé, the Trappists applied a rigorous observance of the Rule of Saint Benedict that was closer to its interpretation by the earliest Cistercians, and sought to establish a strict secular monastic life. They attracted many followers.

The Trappists followed faithfully the 48th Chapter of the Rule of Saint Benedict which says: "You are only really a monk when you live from the work of your hands." This is why Trappist houses are especially renowned for producing food and goods to sell to provide an income.

The French Revolution in 1789 caused a severe setback. In 1790 all monasteries in France were suppressed and religious vows were declared invalid.

Under the leadership of Augustine de Lestrange, who led a nucleus of Trappists to Switzerland and on a long odyssey through Central Europe, the Cistercian Reform survived. Ultimately, daughter houses were founded in Spain, Belgium, England, Italy and later in the United States. Just as Robert of Molesme established a new foundation through his desire to follow the Rule of Saint Benedict, 600 years later the brothers of La Grande Trappe secured the future of the Cistercian Reform. Today the Trappists are the largest group within the Order.

Present structure of the Order

In 1892 Pope Leo XIII united the three Reformed congregations of Cistercian monasteries as Cistercians of the Strict Observance (OCSO) or Order of Reformed Cistercians (OCR). The remaining Cistercian congregations, less numerous in membership, are known as the Common Observance (OCist) and are not represented in Britain and Ireland.

In 2008 Cistercians of the Strict Observance, or Trappists, numbered 3,930 people – 2,130 monks and 1,800 nuns. There were 175 monasteries in the five continents, 102 houses of men and 73 of women. The Cistercian houses meet at the general chapter every three years and the houses manage themselves through the centuries-old practice of visitation by the superior of the founding abbey.

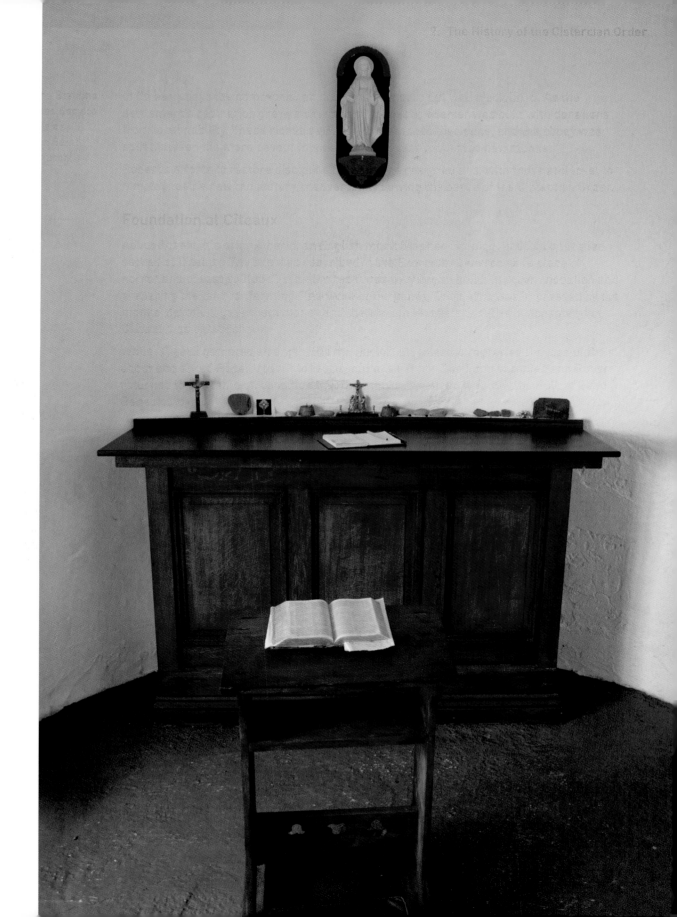

Brother Michael

An islander says of Brother Michael: "If ever there was a living saint – it's that man." Michael Strode, one of four brothers, was brought up in Woking in the 1920s. His parents were Anglican. His mother later converted to Catholicism so the two eldest sons, including Michael, were Anglican and the youngest two Catholics.

During World War II Michael studied medicine at Saint Thomas' Hospital. When his elder brother was killed at Monte Cassino it profoundly affected Michael and prompted him to consider becoming a Catholic. "I do believe that people who die recently have a special slot for intervention for family, friends and so on. It's only a personal belief; I don't think that the Holy Father would agree with it." Knowing it would be difficult for his father, Michael somewhat unexpectedly was faced with no resistance: "I was the only one in the family supporting him as an Anglican, which showed what a big heart he'd got."

As a student Michael had thought about becoming a monk but was firmly discouraged: "My Benedictine spiritual director told me, 'You've got to get qualified first, you can't do this now,' so obediently I did, but it was always in my mind." In 1946, Michael graduated in medicine. He then took a diploma in child health, which led to a position at Chailey Heritage Hospital in Sussex, a craft school and hospital for disabled children. Here he worked for 36 years.

In 1954 Michael and his colleagues to join the Birmingham Diocesan Pilgrimage to Lourdes in south west France.

After a successful trip, they returned the following year with all the Catholic children from the hospital. This visit proved so successful that Bishop Humphrey Bright suggested the foundation of a charity that would take children from the United Kingdom and in 1956 the Handicapped Children's Pilgrimage Trust was formed. In all Michael made 30 trips to Lourdes.

Throughout his life Michael has had an affinity for Caldey; his mother had visited the Anglican Benedictine Order that re-established monasticism on the island in the early twentieth century. After he retired, Michael was on holiday on the island and his long held wish to become a monk was re-ignited. Even though he was in his late sixties, Abbot Father Robert suggested that he would be welcome to try out the life. Michael took his vows to become an oblate monk. This means he does not have to surrender all his worldly assets, and he can take two weeks off a year. He is not allowed to vote in any community decisions. It is a course of life that Michael is delighted to have been given the chance to follow: "I do feel that Father Robert was terribly sporting to take me on, a man of such mature years."

Michael's career in children's medicine and devotion to his faith has contributed to a wonderful legacy: "I can remember one of our early hospital children saying, 'I'm sick and tired of praying!' But what generates such a lovely spirit in the HCPT is that the helpers forget themselves – they'll stand on their heads, they'll do anything. I'm delighted with the way it's grown – it's totally unexpected."

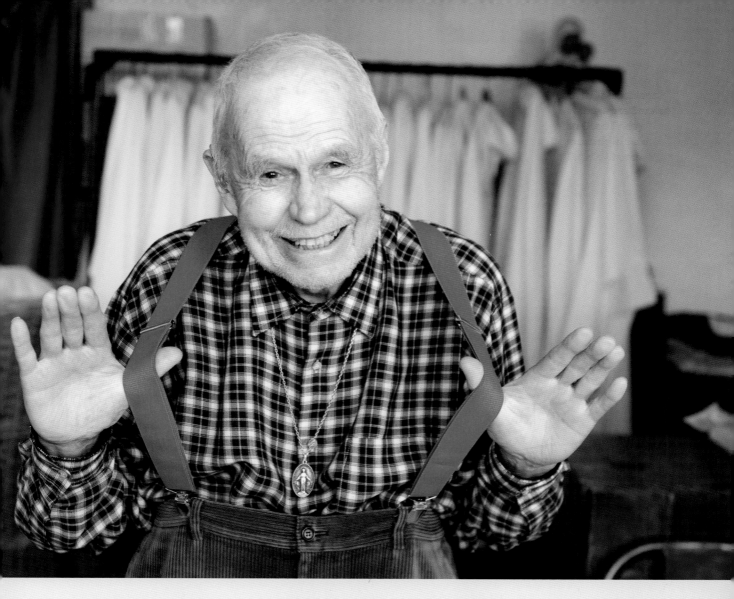

Place and date of birth:
Woking, Surrey on 5th June 1923.

When did you become a novice?
26th January 1991.

Why did you become a monk?
To try and deepen my friendship
with Jesus.

**What other monasteries have
you been part of?** Guest at
Quarr Abbey and Saint Michael's
Abbey, Farnborough.

Why Caldey? To try my vocation
(cloistered oblate).

**What is your favourite part of the
island?** Enclosure wood.

**What is your favourite canonical
hour?** Community Mass and Lauds.

What are your interests? Printing/
photography (prayer cards).

What are your jobs on the island?
Laundry and infirmary doctor.

**What do you miss from the
outside world?** Freedom
of movement.

Caldey Island timeline

500s	First monastic settlement on the island.
900s	Viking raids along the Welsh coast. The Vikings gave the island the Norse name Caldey or Cold Island. Norse: Kald - Cold, ey - Island.
1113	Henry I gives Caldey to an Anglo-Norman nobleman, Robert fitz Martin, who passed the island to his mother Giva.
1136	Given to the monks of Saint Dogmael's, near Cardigan, who opened a priory on Caldey.
1536	Henry VIII's Dissolution of the Monasteries begins. Monks expelled from Caldey; the monarch leases the island to John Bradshaw.
1597	Passed to Walter Philpin.
1653	Purchased by Reeve Williams of Llanrhidian, Gower, and Robert Williams of Loughor.
1786	Purchased by the Earl of Warwick for £3,000.
1798	Purchased by Thomas Kynaston.
1812	Thomas Kynaston dies, island passed to Cabot Kynaston.
1867	James Wilson Hawksley buys Caldey for £15,950 for his son James Taylor Hawksley.
1894	Purchased by Thomas Smith Cunninghame for £12,750.
1897	Purchased by Reverend Done Bushell for £12,000.
1906	Purchased by Dom Aelred Carlyle's Anglican community of Benedictine monks for £12,000.
1907 – 1910	Saint Philomena's guesthouse, workmen's cottages, Tŷ Gwyn, shop, post office and clubroom built. Water supply and sewerage system modernised.
1910 – 1913	Present Caldey Abbey built, designed by architect .
1913	Dom Aelred Carlyle and 22 Anglican Benedictine monks left the Church of England and joined the Catholic faith.

1925	Island sold to the Order of Reformed Cistercians for £60,000.
1928	Benedictine monks left Caldey to settle at Prinknash Park near Gloucester.
1930	First party of monks arrived from the mother house of Notre-Dame de Scourmont Abbey, near Chimay in Belgium. The new Cistercian community founded on 6th January 1930.

Leaders of Caldey Island's Cistercian Community

1929 – 1930	Andrew Garcette	Superior ad nutum
1930 – 1934	Aelred Lefevre	Superior ad nutum
1934 – 1942	Aelred Lefevre	Conventual Prior
1942 – 1946	Jerome Robert	Conventual Prior
1946 – 1954	Albert Derzelle	Conventual Prior
1954	Godefroid Belorgey	Conventual Prior
1954 – 1959	Eugene Boylan	Conventual Prior
1959 – 1980	James Wicksteed	Abbot
1980 – 1984	Robert O'Brien	Superior ad nutum
1984 – 1997	Robert O'Brien	Abbot
1997 – 1999	Daniel van Santvoort	Superior ad nutum
1999 – Present	Daniel van Santvoort	Abbot

Abbots of Caldey Abbey

1959 – 1980	Dom James Wicksteed
1980 – 1997	Dom Robert O'Brien
1999 – Present	Dom Daniel van Santvoort

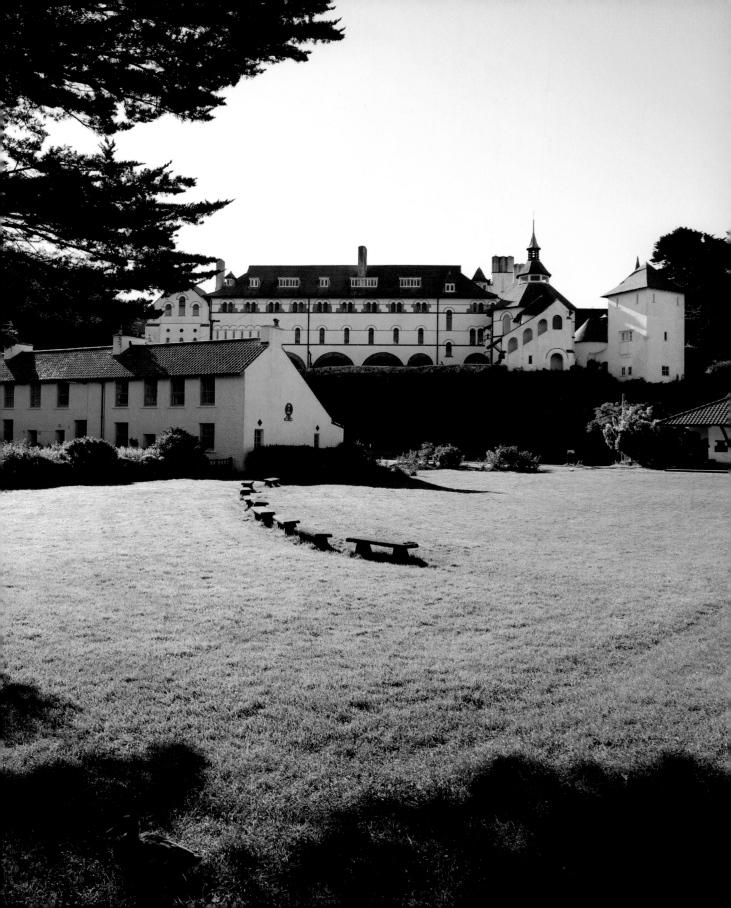

3 The history of Caldey Island

The island has been inhabited since the Stone Age. Celtic monks first settled there in the sixth century and a monastery stood there for the next 1,000 years.

After the Dissolution of the Monasteries Caldey's monastic presence was interrupted for 370 years as the island became a Crown asset. Subsequent owners exploited its resources with varying degrees of success.

In the early twentieth century Caldey was bought by a newly-formed group of Anglican Benedictines. They became Catholics in 1913, but when their ambitious plans got them into financial difficulties in the 1920s, the Cistercian Order took over and founded a new community comprised of Belgian monks.

Local people were suspicious of their foreign neighbours but the community survived both the local tensions of the 1930s and universal threat of World War II, preserving the monastic heritage of Caldey into the twenty-first century.

Ancient history

It is thought that man lived on Caldey 12,000 years ago when it was still linked to the mainland by a strip of marshland – a hill on the Bristol Channel plain.

Excavations from the 1950s onwards uncovered human remains, flint tools, crockery and animal bones in Potters Cave, the Cave of the Ox and Daylight Rock. Analysis of bones from circa 10,000 – 4,500 BC showed that about 70 per cent of the diet was fish. By circa 4,500 – 2,300 BC, more meat was being consumed, suggesting that the island was now being farmed.

Caldey's first monastery

There are many accounts of Celtic saints and missionaries settling a network of coastal monasteries in the Dark Ages.

But the written account of the life of Caldey's second abbot, Samson, provides the most reliable record of the island's early monastic life. It refers to a monastery on an insula and describes the first abbot, Pyro, as a man who "worked with his hands all day". Despite his ignominious demise, falling down a well when drunk, Abbot Pyro was remembered as "an excellent man, and a holy priest". From him the island derived its Welsh name: Ynys Bŷr.

Left: View of Caldey village green from the tower in the monastic guesthouse.

СЛИКНОСЕ
ЦСГПИКЕСП
АНЕП ПОВО
ОТНЫЫСП
ТЦСНПОЦ
ЫДСОЛЕНС
РПОСПИПЕ

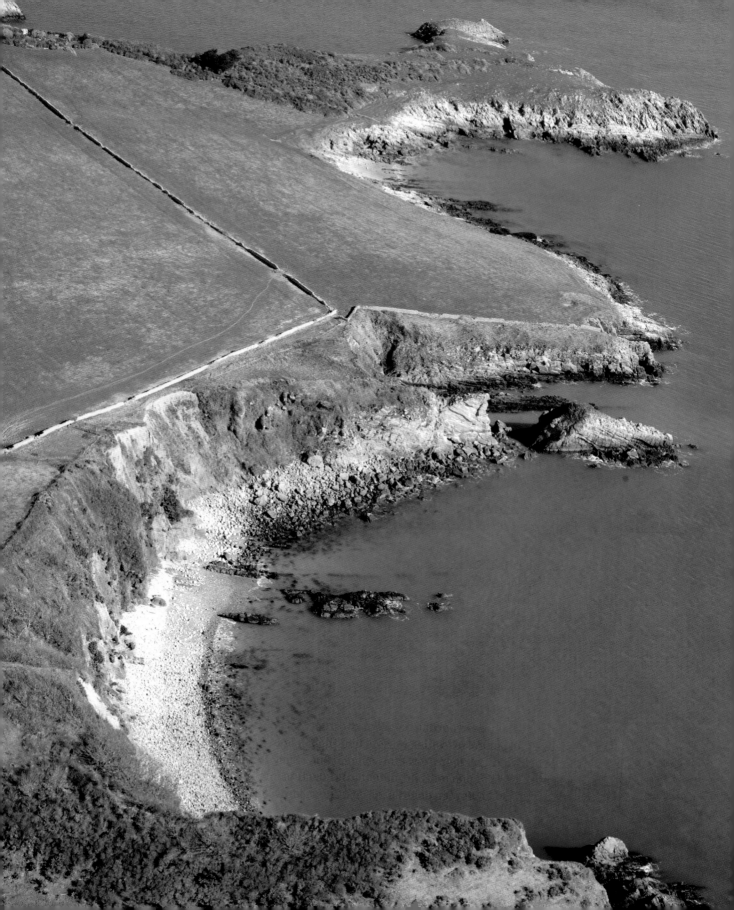

Samson, a nobleman educated by the learned Illtud at the monastery at Llantwit Major, was well prepared for a monastic career which eventually led to him becoming the Bishop of Dol in Brittany and one of the most influential Celtic missionaries in northwest Europe.

Caldey Ogham Stone

Ogham Stones are common in Wales, Scotland and Ireland. Inscribed in the language of the Irish tribes who settled on both sides of the Irish Sea, they are among the earliest written records in existence. In Pembrokeshire they are thought to be the work of an Irish tribe known as the Deisi, who from the fourth century governed much of the area for five hundred years.

Eighteenth-century excavations in the grounds of the Priory uncovered the Caldey Ogham Stone, dating from the 5th or 6th century, among a number of stone coffins. Crosses on the edge of the stone are in Ogham script, and refer to Dubricius (Saint Dyfrig), an early Bishop of Llandaff who visited Caldey for Lent each year, and is said to have consecrated Samson as abbot.

Perhaps to dilute its pagan characteristics, a cross and a Latin inscription were chiselled into it. This inscription was added later, probably in the 9th century, and is thought to ask for prayers for the soul of Catuoconus (Cadwgan).

Right: Mill pond at the 12th century site, Caldey Priory.

Below left: Saint Illtud's Church tower.

Below right: Remnants of millstones in the medieval Old Priory corn mill.

Twelfth century

Caldey's re-establishment as a monastic island was partly due to the Anglo–Norman, Robert fitz Martin, who took part in the Norman invasions of Wales during the reign of Henry I. Under his patronage a priory was opened at Saint Dogmael's, near Cardigan, for Benedictine monks from the Abbey of Tiron, near Chartres in France.

The King gave Caldey Island to Robert fitz Martin, whose mother in turn gave it to the monks of Saint Dogmael's in 1131. The Priory at the island's centre is thought to have been developed from a fortified house originally built by fitz Martin. Around this time the round Watch Tower above Priory Bay was also built. In 1291 a tax document of Pope Nicholas IV valued Caldey Priory at £3 6s 8d. Its one carucate (100 acres or 0.5 sq km) of ploughing land, with a rental of £1 10s 0d, was included in the valuation of Saint Dogmael's.

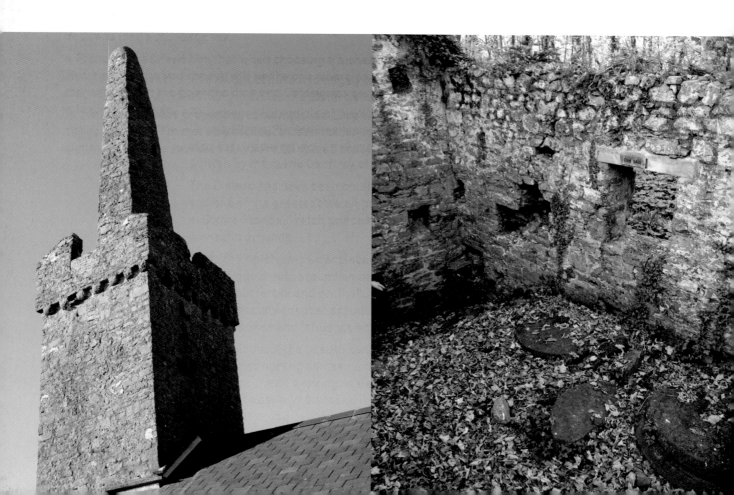

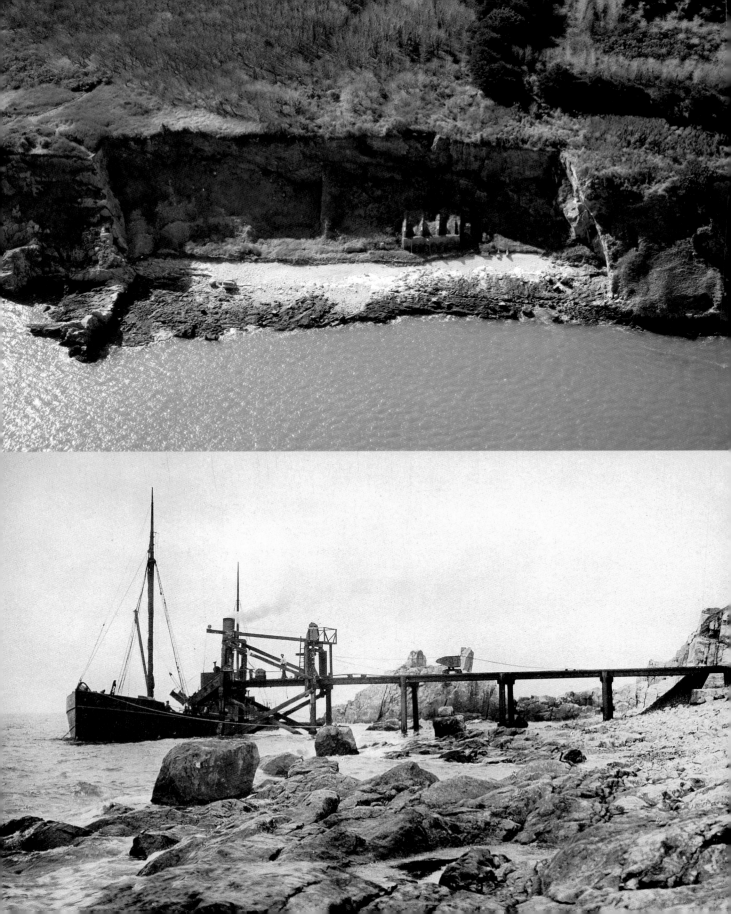

Top left : Remains of High Cliff quarry.

Bottom left: The Firefly cargo ship at the jetty of High Cliff quarry, circa 1910.

Dissolution of the Monasteries

A thousand years of monastic presence on Caldey ended in 1536 when Henry VIII began the closure of 800 abbeys and priories across England and Wales and confiscated their assets.

The Valor Ecclesiasticus, a crown survey of the value of church properties and revenues, noted that Caldey contributed £2 3s 4d to its mother house. It also recorded that the island had nine farming tenants who paid rent to a total of £5 16s 10d a year.

After expelling the monks from the island, Henry VIII's commissioners allowed John Bradshaw to lease Saint Dogmael's Abbey and its estates, including Caldey. At Saint Dogmael's Bradshaw built a manor house from the stones of the abbey itself. But in 1603 Saint Dogmael's was described as a ruin.

Post-Dissolution

Caldey changed hands until 1798 when it was bought by Thomas Kynaston of Pembroke. Kynaston planned to exploit the island's limestone and profit from the early nineteenth century boom in construction and road building. Up to 20,000 tons (18,000 tonnes) a year were exported from High Cliff quarry.

When Kynaston died in 1812 his son Cabot took over, filling the quarry with local workers, many from Tenby. His philanthropic style of leadership earned him the affectionate nickname 'King of Caldey'.

CALDEY ISLAND
From Lewis' Topographical Dictionary of Wales (1833)

CALDEY ISLAND, the principal of a cluster of insulated rocks in the bay of Tenby, and forming an extra-parochial district in the hundred of CASTLEMARTIN, county of PEMBROKE, SOUTH WALES, 2 miles (E.) from the main land. The population is returned with the parish of Penalley. This island, of which the ancient British name is Ynys Pyr, is about one mile in length, and half a mile in breadth, and comprises more than six hundred acres of good land, lying on bed of limestone, something less than half being in state of cultivation. Owen, speaking of the fertility of this spot, describes it as abounding with corn; but he adds that "all their ploughs goe with horses, for oxen the inhabitants dare not keepe, fearing the purveyors of the pirattes, as they themselves told me." Robert, son of Martin de Tours, founded a priory here, in the reign of Henry I, which he dedicated to Saint Mary, and made a cell to the abbey of Dogmael, to which establishment the whole of the island was granted by his mother: its revenue, at the dissolution, was £5. 10. 11. The remains have been mostly converted into offices attached to a mansion erected on part of the site, now belonging to – Kynaston, Esq., who is sole proprietor of the island. Among them is the tower of the ancient conventual church, which is surmounted by a stone spire, and forms a conspicuous object of picturesque appearance, imparting, with the rest of the ruins, an interesting and romantic character to this sequestered spot. A lighthouse, with a steady light has been erected on this island, which is of great service to vessels entering Tenby harbour.

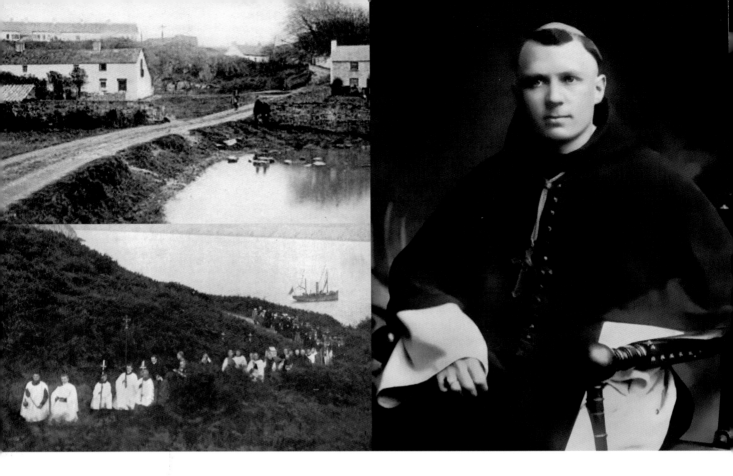

Top left: Caldey village in 1908 after the building of the workmen's cottages which became the temporary monastery.

Bottom left: The Homecoming Procession of the Benedictine group of monks on Saint Luke's Day 1906.

Above right: Dom Aelred Carlyle, abbot of the Anglican Benedictines on Caldey, who re-established monasticism on the island in the early 20th century.

The dangers of island life came into sharp focus during Christmas week in 1834 when thirteen men and two women set out for the mainland in dangerous conditions. Approaching Tenby their boat was hit by two waves. The first threw eight people into the water. The second, according to The Welshman newspaper, "hurried them all into eternity".

The accident left seven widows, thirty-three fatherless children and four dependent elderly relatives. The workers took £13 of wages between them onto the boat, and £9 was retrieved on the beaches of Tenby and shared out among the families. Within a week a local relief fund for the families amounted to £150.

Cabot Kynaston died in 1866. A year later the island was bought by James Wilson Hawksley for £15,950 for his son James Taylor Hawksley, another popular owner of Caldey.

James made significant improvements to the island buildings and grew vegetables, which he shipped to wholesalers in Pembroke Dock, Swansea and Tenby. Long before sickness pay and benefit systems, James insisted that labourers unable to work were paid for several months. When news of his death in 1891 reached the quarries, the men downed tools and went home as a mark of respect. At his funeral they carried his body for half a mile.

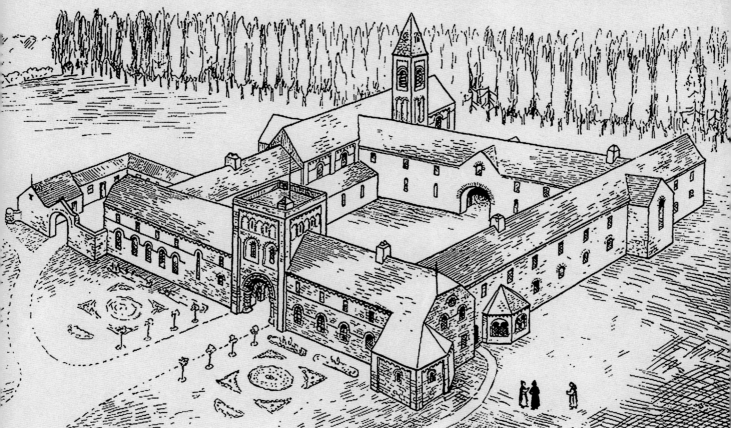

THE·ABBEY·GATE-HOUSE ☩ ISLE·OF·CALDEY, South Wales.

Above: Architectural elevation of the planned Abbey Gate House that was part of Dom Aelred Carlyle's grand vision for Caldey Abbey.

Hawksley's widow Emily took over the running of Caldey, but the agricultural slump of the 1890s forced the family to sell up. In 1897 the island was bought for just under £12,000 by a housemaster at Harrow School, the Reverend W. Done Bushell. He used the island as a holiday retreat and a sanctuary for his mentally handicapped son. He leased out the farm land and rented out cottages to the island's quarrymen.

Dom Aelred Carlyle's Anglican Benedictines

In 1900 Bushell invited Dom Aelred Carlyle, the abbot of an Anglican group of Benedictine monks, to use Caldey as a temporary home.

Their arrival marked the first monastic settlement on Caldey since the dissolution and on January 10, 1901, Vespers was sung in the Priory Church for the first time since 1536. One of the brothers kept a diary of the occasion: "How the very stones of the vaulted roof seemed to take their share in the praise of God, and multiply our voices and re-echo our notes till it seemed as if the old dwellers in the long deserted cloister had returned, and were blending their voices with ours to welcome our arrival on this hallowed spot..."

The monks earned money as farm labourers and stayed in whatever spare accommodation was available. During Bushell's summer holiday visits the brothers

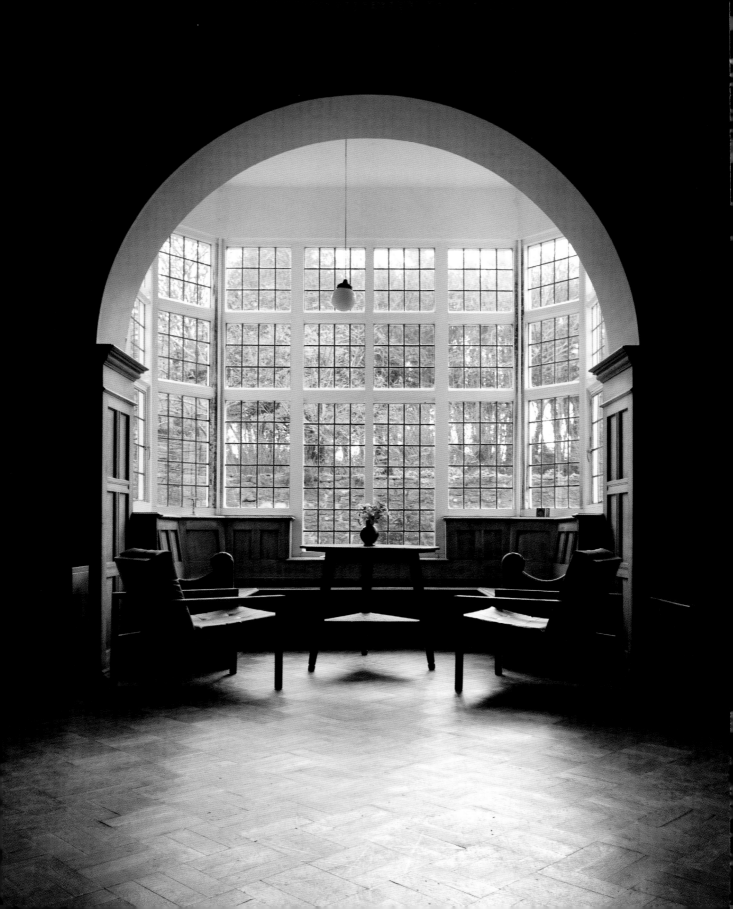

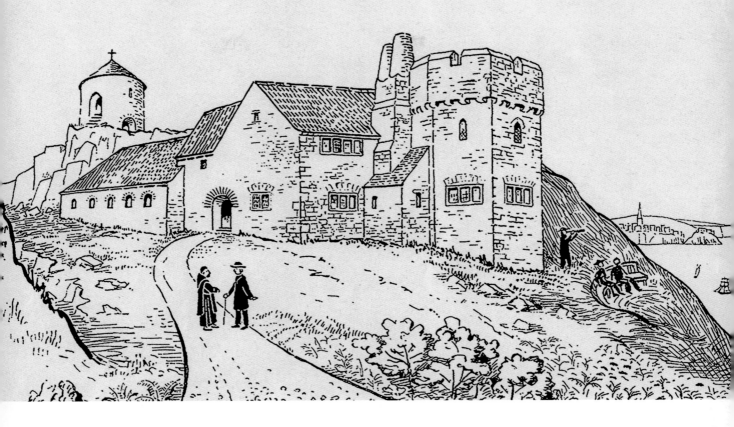

Left: The monastic guesthouse lounge.

Above: Architectural elevation of Saint Philomena's guesthouse. It is now used to host visitors to the island on retreat.

camped in the pine woods. When the Bushells left for Harrow, the monks returned to the Mansion House next to the Priory.

Unable to afford to erect their own housing on the island, in 1902 Carlyle's monks accepted the influential Anglican Lord Halifax's offer of a house in Painsthorpe, Yorkshire. But in 1906, after his son's death, Mr Bushell put Caldey up for sale. Unable to resist the opportunity, Carlyle raised £12,000 to buy it.

Carlyle's grandiose plans – the construction of the abbey

Carlyle's plans to build a monastery on the scale of the greatest European abbeys make him a controversial character in the Caldey story. He began with the construction of Saint Philomena's guest house, the row of workmen's cottages and renovation of the Priory. Then came the shop, the post office, village hall and Tŷ Gwyn, the house overlooking Priory Bay. His enterprise, underwritten by a group of well-connected high Anglicans, regularly made the national news.

Conceptual drawings show Carlyle's desire to construct a striking example of Christian art and architecture, but a disagreement with the Anglican Church, and the withdrawal of funding, forced him to rethink.

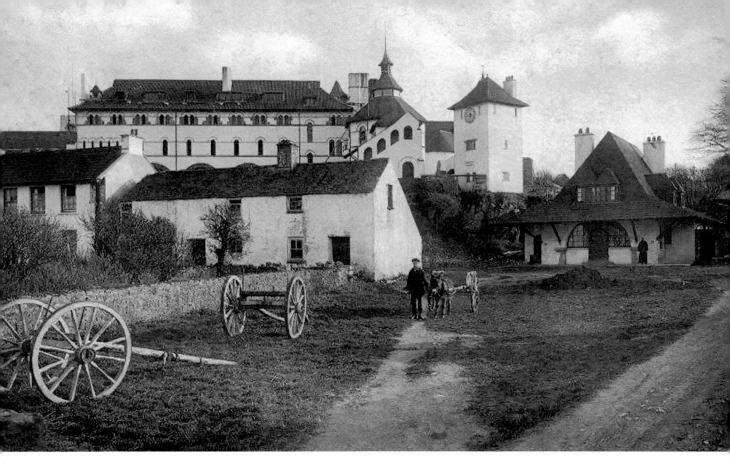

Above: Caldey Abbey and the village green, circa 1913.

Using stone from High Cliff, more than one hundred local men worked on the building between 1910 and 1913. But costs spiralled and, in consultation with John Coates Carter, significant adjustments had to be made. Carlyle's ideas for a towering cliff top monastery were abandoned.

When the Church of England concluded in 1913 that parts of the community's daily timetable were not in keeping with the Anglican doctrine, Dom Carlyle and 22 of his monks promptly converted to Catholicism and lost financial support in the process.

A persuasive and charismatic man with many qualities, Carlyle had dreams for Caldey that ultimately proved his undoing as abbot and undermined his prime achievement of buying Caldey in the first place. He worked tirelessly to generate income but started a number of misconceived, short-lived projects. During his time the community opened a printing press, a stained glass window factory, grew medicinal herbs, started pheasant breeding for shooting parties, installed cheese-making equipment and started making stone crosses, bird baths and holy water stoups. As each new scheme failed, the community's limited resources dwindled.

When six monks left the community to join other orders, and one wrote a letter of complaint to Rome about Carlyle's leadership, his days on the island were numbered. A visitation by Catholic authorities led to Abbot Carlyle leaving for British Columbia. In the 1920s the Caldey Estate was £21,000 in debt.

Below:

Left: The altar in the original Caldey Abbey church.

Top right: The Anglican Benedictine community of Caldey Island in 1914.

Bottom right: The Cisterican brothers at work in the 1930s.

The move towards becoming a Cistercian Abbey

The Vatican was keen that Caldey should remain within the Catholic Church. Pope Pius XI asked the Order of Reformed Cistercians to buy the island. The Cistercians would allow the Benedictines three years to stabilise their finances and, if successful, the latter would be offered the chance to buy back the estate.

The purchase went ahead in 1925 but when it became clear that the Benedictines were never going to recover financially, the Cistercians looked for a suitable abbey to be the mother house of a new foundation on Caldey.

Caldey's Mother House

Notre-Dame de Scourmont Abbey in Belgium, founded in 1850 by monks from La Trappe, the famous Cistercian house in Normandy, ran a successful farm, making a range of soft cheeses and beers still produced today. By the 1920s its community had grown to eighty and space was becoming tight. In February 1928 the Abbot General of the Cistercian Order took the Abbot of Scourmont to Caldey Island, where they stayed for a week to consider its potential as a daughter house.

The island had resources to develop, its soil had potential for further cultivation, and its vacant properties could generate an income. The monastery with workshops, kitchen,

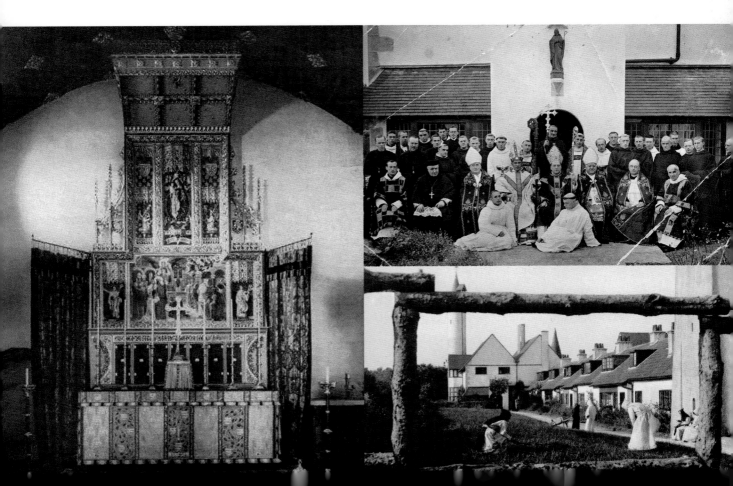

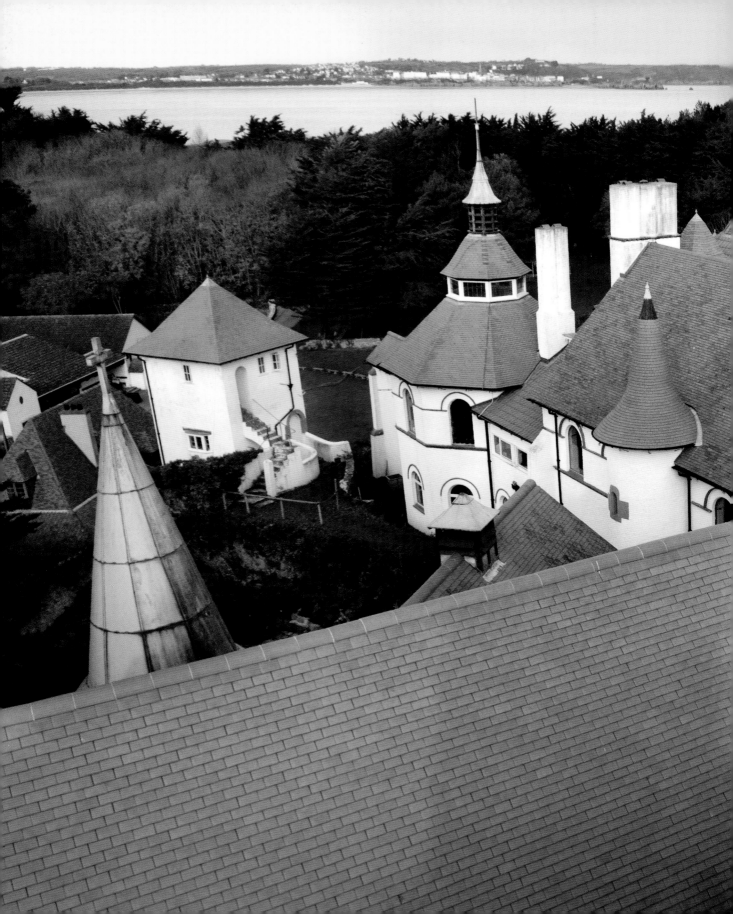

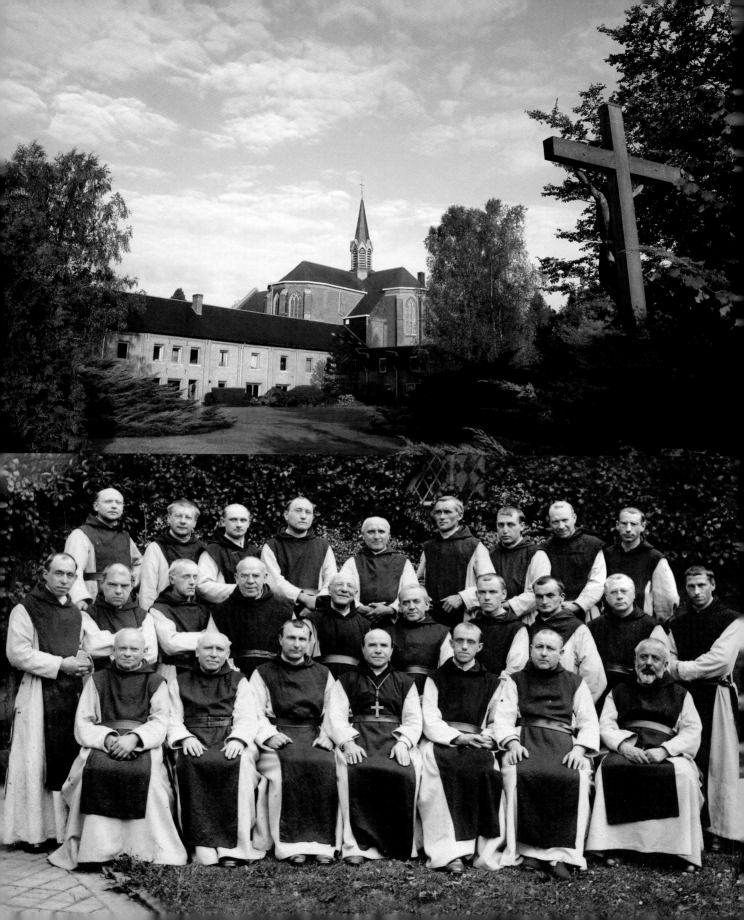

Previous page:
Caldey Abbey looking towards Tenby from the monastic guesthouse tower.

Top left: Notre-Dame de Scourmont Abbey, the mother house of Caldey.

Bottom left:
Cistercian monks from Notre-Dame de Scourmont Abbey.

refectory, bakery and dormitories was already built. The monks considered Britain to be tolerant and other Catholic houses had settled well and prospered. Furthermore the leader of the Catholic Church in England and Wales, Cardinal Bourne, had arranged permission for the Belgian monks to settle.

In March 1928 the monks of Scourmont agreed to found a Cistercian community of ten choir monks and three lay brothers on Caldey.

On the morning of New Year's Eve 1929 the departing monks left for Wales. At Dover they were met by a local priest and put on a train to London where they were hosted by Cardinal Bourne for two nights. Then on January 2 the Scourmont brothers made the journey to Tenby station, walked through the town to the harbour and boarded a boat to Caldey.

On the island they followed the Foundation Cross bearer to the church with the bells ringing and the Te Deum being sung in celebration.

They found the Benedictines had taken anything moveable with them. The sacristy was empty, the library had no books, there were no chairs in the refectory and no beds in the cells. Thankfully a wagon packed in Scourmont with vestments, linen, candlesticks, crucifixes and fruit, coffee and some bottles of their famous Chimay beer arrived on January 5. A telegram from Rome also arrived announcing the establishment of the new Cistercian foundation of the house on Caldey.

At 1am on the Epiphany, January 6, Dom Anselm Le Bail, the Abbot of Notre-Dame de Scourmont, declared in Latin, English and French the birth of its new daughter house: Caldey Priory.

Period of suspicion

In their early years the Belgian community was treated with much suspicion by the people of Tenby. The monks were Catholic and spoke little English. Their devotion to the Rule of Saint Benedict and their workload made language learning difficult. In 1932 the Western Mail ran a series of articles fuelling wariness of the Belgian Cistercians. The newspaper also claimed, quite unfairly, that the Cistercians were likely to close off the island to visitors and so jeopardise the livelihoods of some Tenby boatmen.

Caldey Abbey Journal entry
July 7th 1936: Abbot urged all to become externally more British, to feel in a British way. Language use should be exclusively English, instructions, public readings, sermons but not Thursday evening talks. As regards diet a more British style presentation taking on a much more British mentality, which is much more difficult.

Top right: Annales de Caldey book, the diary kept by the founding monks from Notre-Dame de Scourmont Abbey.

Bottom right: Annales de Caldey book, diary page.

In August 1936 the same newspaper suggested the island community posed a potential risk to national security. The next day the Home Office sent the Chief Constable of Pembrokeshire to investigate. The abbey's diary entry said: "They leave the island satisfied and much more favourable towards Caldey than when they arrived."

On September 8, 1936, the situation worsened when Tenby wholesalers refused to accept Caldey-grown tomatoes for fear of undermining producers on the mainland. Boat parties landed at Priory Bay on Sundays, deliberately flouting the fact that the island was private property and that the monks were perfectly entitled to restrict visitors. Later in 1936 the Tenby Observer threw its support behind the Chimay monks dismissing criticisms of them as "puerile, without a scintilla of evidence to support them, and may be dismissed a moonshine".

Second World War

Caldey Abbey Journal entry

September 29th 1938: The international situation regarding Czechoslovakia is very tense. An arrangement between Hitler and Mussolini, on the one side, and Chamberlain and Daladier on the other. The cloud disperses.

March 26th 1939: Gas masks tried on.

September 10th 1939: During supper news is announced about a communiqué first in Polish and then in French. An address to Poles to enrol in the Polish army, which is to be created in France.

World War II affected the community greatly. Even before conflict broke out, a number of the Caldey monks had been conscripted to serve in the Belgian and French Forces.

Caldey Abbey Journal entry

August 19th 1940: At about 3 o'clock in the afternoon while they were stacking the last barley sheaves behind the vegetable shed the Tenby air raid siren and the whistle on Caldey gave the alarm of an air raid warning. Enemy aircraft had just been bombing at Pembroke Dock and had set fire to an oil depot. An immense cloud of black smoke rose and spread over the sea carried by the north wind.

September 4th 1940: The oil depot that still continues to burn has been burning for 17 days. Almost every night the enemy visit this corner – one of the main sectors of Swansea – the station and around it have been destroyed.

Twenty-two fire brigades across the country came to fight this fire at Pembroke Dock. The biggest fire on British soil since the Great Fire of London, it burned for three weeks.

Caldey.

—

Préliminaires de la Fondation.

—

Décision Capitulaire

d'une Fondation
par la communauté de N. D. de Scourmont

à l'île de Caldey, en Angleterre,

Sud du Pays de Galles.

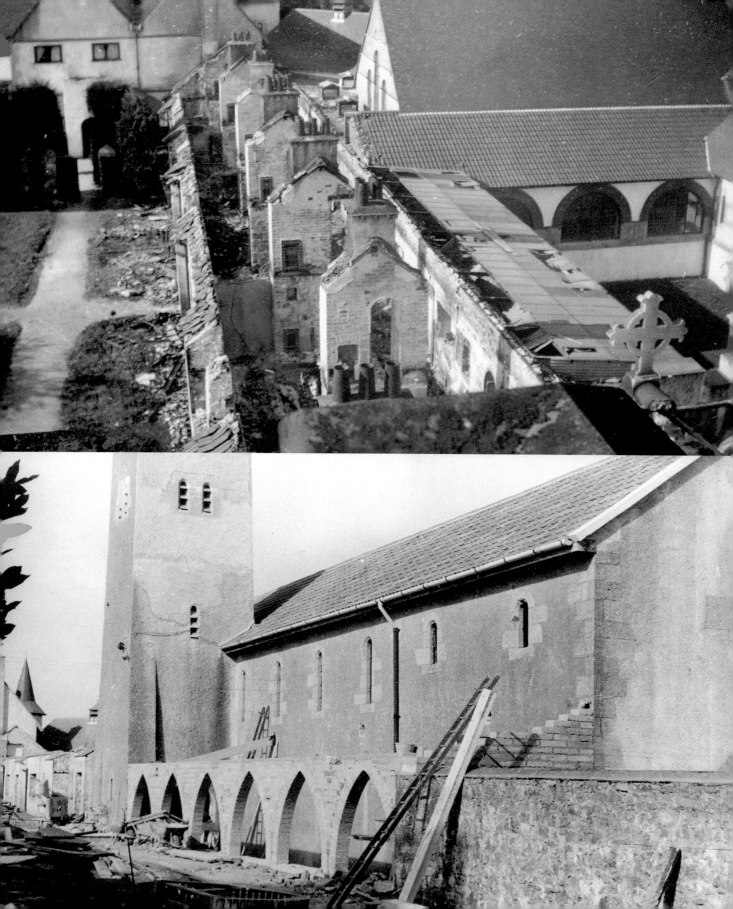

Top left: The ruined church in Caldey Abbey following the fire in 1940. Taken by one of Caldey's founding monks, Father Dominic, who photographed the island extensively leaving hundreds of stills in the monastery's archive.

Bottom left: Construction of the present Caldey Abbey church in the 1950s.

Fire in Caldey Monastery

In September 1940 the southern wing of the monastery suffered severe fire damage. The blaze took hold so quickly that within no time it could be seen from the mainland. The monks and islanders fought as best they could until at 9pm the local fire brigade arrived with a group of volunteer soldiers with pumping equipment. They used water from the island's lily pond and by 6am the following day they had managed to get the fire under control, but the church and library were both destroyed. The monks started the clear up but the new church was not fully rebuilt by the monks until 1951.

Caldey Abbey Journal entry

December 25th 1941: Midnight Masses now discontinued on the mainland due to 'black-out'. After consultation, Mass was said at this time, but there was no réveillion in the guesthouse for the Islanders.

July 21st 1943: Other barges larger and more numerous are still arriving at Tenby. This attracts more German planes in the night for they are not unaware and have already announced on the radio that exercises are taking place on the Bristol Channel.

As the war progressed Caldey lost all its novices and the community's numbers were low. Managing the island became increasingly difficult and certain tasks – such as filling out the Abbey Journal – fell by the wayside.

After World War II

At the war's end the community on Caldey numbered a dozen and was losing money, but in time most of the demobbed Belgian and French monks returned and the abbey started to recover. At the end of the 1940s Scourmont Abbey was thought to be spending £4,000 a year subsidising Caldey but the 1950s saw a marked improvement for Caldey Priory. In 1959 the community was granted autonomous status within the Order and so became the Cistercian Abbey of Caldey.

After establishing a co-operative of boat owners to provide passage for tourists, today Caldey receives around 50,000 visitors a year. Shops on the island and in Tenby sell perfumes, chocolate, shortbread and gifts produced by the community. These businesses all generate the finance to enable the monks to remain on this most unusual of islands.

Brother Paul

Behind Caldey Abbey set in a break in the trees stand garage buildings and a workshop containing the island's fire engine, ambulance and a collection of cars in varying states of repair. Here you will find Brother Paul most mornings, amid a collection of nuts, bolts, gearboxes, fuel pipes: on an island you cannot just pop down to a scrap yard to buy what you need.

Brother Paul can improvise and adapt anything to keep an engine running well. One of the islanders uses an old Suzuki jeep to collect people and goods from the jetty. Its twenty-year-old engine ticks over beautifully, and no wonder because it used to be Brother Paul's own runaround.

Paul was born in Woolwich, London in 1936. At fourteen he left Britain for New York, not seeing his mother again until he was twenty-one. Asking him about his life can be a bit of a dance – he tells you great swathes of detail and when you try to fill the gaps, he is evasive. Paul looks at you sideways, doesn't quite trust you, but will happily sit with you and chat for a while.

His life in America is a blurred story. What is true is that he was married for a time to a woman with whom he is still in touch and that the marriage produced a daughter whom he barely knows. Clearly Paul has had a colourful life, maybe not as colourful as he'd like you to think, but this is a man who has faced many difficult times and through his faith it seems that ultimately he has come through.

After a life in the Americas, in 1980 Paul flew back to London and then walked westwards for a month, ending up in Cardiff. Finding himself in Saint David's Catholic Cathedral he was directed towards the Salvation Army hostel. The next day, looking for work on a building site, he went straight into the manager's office: "I said to him I want one of two answers – yes or no, not maybe or call later." The next day Paul started work. He rented a one room flat and worked for a year-and-a-half, saving two-thirds of his wages.

The most profound change in his life occurred when a construction site colleague who had previously been a monk took Paul to Caldey Island. It had an everlasting effect: "I had never found such peace and quiet before and when I left it kept nagging away at me." Brother Paul came back and 30 years later is still on Caldey. He has only left the island for medical appointments. He recalls being taught to box as a boy by a Benedictine monk who told him he would be a monk in later life: "That comment came back to me when I came here – it rang out to me."

Displaying ostensibly a defensive, wary demeanour, Brother Paul is a member of the Caldey community about whom some people are cautious. Get past his sharp edges and you find a warm, caring person, a personality so welcoming that one eminent Cistercian once said: "If you ever get to the gates of heaven, Paul will be the one to let you in."

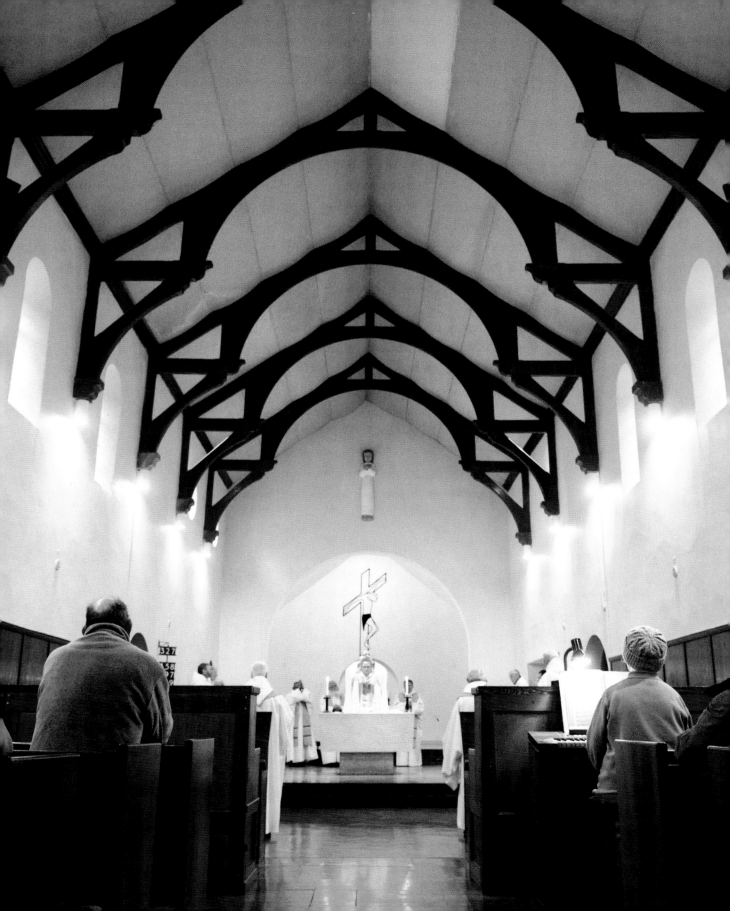

4

The Cistercian way of life

The Rule Of Saint Benedict – the template for a Cistercian life

In the sixth century Saint Benedict of Nursia developed a guide for monks that became the most influential of all monastic codes. Benedict's Rule for Monasteries deals with the duties of the abbot, the worship of God, discipline within a community and the administration of the monastery. Its clarity, fairness and reasoning led to the Rule being "by far the most important factor in the organisation and spread of monasticism in the West". It is Saint Benedict's Rule for Monasteries that the community of Caldey Abbey follows.

There is just one light shining from Caldey Abbey. Above it the moon is bright and almost full. The air is still and all the islanders' homes are quiet. Away from the glare of the mainland the stars in the night sky are surprisingly bright. In the forest nearby an owl hoots. A sudden breath of wind sweeps over the village green rustling the trees on the path as it passes towards Priory Bay.

The abbey bell tolls, its tone more reminiscent of a valley in Tuscany than an island off Pembrokeshire. It is 3.30am and at this time in the morning the ring has the hint of a lament. It is the time for Vigils. The atmosphere in the abbey church is different. The quietness has a serious edge; there is an aura of concentration. There are no distractions at this time of the day and the monks' focus is unwavering.

"It's part of our tradition," says Father Daniel, "but not just the tradition of the Order, it's also in the Bible. Prayer is best done in the very early hours of the day, at the moment of dawn."

It is a time of day that many rarely see. Attending Vigils it is easy to spot the novice monks – they are either half asleep or late. "You are drowsy in the beginning," Father Daniel continues. "In the first years it can be hard. Your biological clock has to adapt. But once that has happened..." He pauses and makes a gesture that signifies a mixture of relief and achievement.

The term 'Vigils' derives from the Latin 'Vigiliae', meaning nocturnal watches or night-guards carried out by soldiers. The night watch is thought to date from the earliest days of Christian worship which was often carried out in secret. It was thought that the middle of the night was the ideal time for prayer. This idea is something that survives today. "We believe that your whole body and mind is more perceptive to what is really going on, and that's what we want to be because it helps to pray," says Father Daniel. "You sense when you get up at that time that the day is pure – that it's something untouched and it's a wonderful experience."

Left: The Eucharist being celebrated at Maundy Thursday mass.

Another reason is that the small hours are universally recognised as being the point during a 24-hour cycle when the human body is at its lowest ebb and people are at their most vulnerable. "Many people can be in distress in the night, people who are harassed by their partner, people who are mugged or just lonely or the incurably sick who can't sleep so we pray for them," says Father Daniel. "That's one of the many reasons why we pray at that time of the day."

Vigils

Lone heart, learning
By one light burning,
Slow discerning of worldhood's worth;
Soul, awaking
By night and taking
Roads forsaking enchanted earth:
Man, unguided
And self-divided,
Clocked by silence which tells decay;
You that keep
In a land asleep
One light burning till break of day:
You whose vigil
Is deed and sigil,
Bond and service of lives afar, -
Seek, in seeing
Your own blind being,
Peace, remote in the morning star.

Siegfried Sassoon
From Vigils 1935

From *Poems Newly Selected 1916-1935* by Siegfried Sassoon. Reproduced with kind permission from Faber & Faber

The Cistercian monk's day is divided into periods of communal and private prayer. In addition to this he balances his life with lectio divina - reading the Bible and other religious texts - and manual labour.

Brother Titus, who was in the same monastery as Father Daniel, Achel in Belgium, likes the range of work that the community offers him. At Achel he was the bursar. On Caldey he is the sacristan. He works in the refectory, updates the Caldey diary and records the island with photographs that are sold to visitors in the island shop. "In the outside world you have to choose just one career, but in the monastery you can do everything – the spectrum is wider," he says.

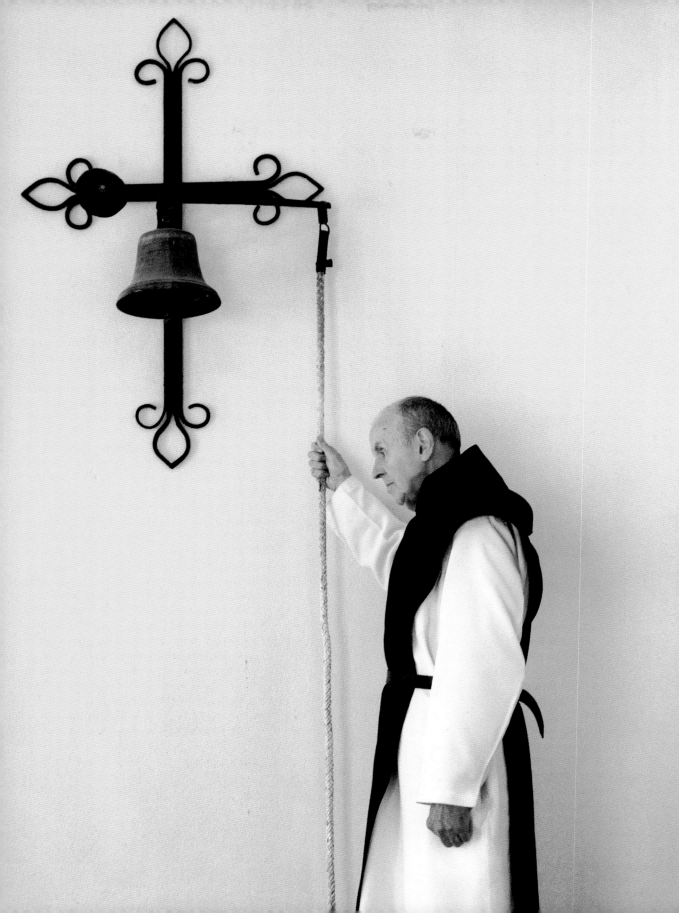

Above: Vigils notice board in the cloisters.

Right: Brother Titus puts away mass vestments in the sacristy.

Lectio divina has been a key element of the daily routine since the earliest days of monasticism. For the early Benedictine monks it was not a formalised process, just the relaxed, unpressured enjoyment of the reading. Brother Titus is a lifelong devoted reader; every morning's study and contemplation will see him reading from the Bible, the Qur'an and the ancient Hindu scripture, the Bhagavad Gita. These texts from three of the major world religions differ from each other greatly but Titus, a former professional photographer, sees only the wider picture: "The focus is God: how do people live with God in the Qu'ran and the Bhagavad Gita and the Old Testament, the Hebrew Bible and the Christian Bible? How do people live with each other? Because you live with each other as you live with God, and you live with God as you live with your brother and sister."

The community's day is structured around what is referred to as the canonical hours, comprising of seven services. In Caldey Abbey the timetable is largely as follows:

- Matins Vigils – 03.30
- Lauds – 06.00 (Sundays 06.30)
- Terce – 08.50 (Sundays 10.30)
- Sext – 12.15
- None – 14.20
- Vespers – 17.30
- Compline – 19.35

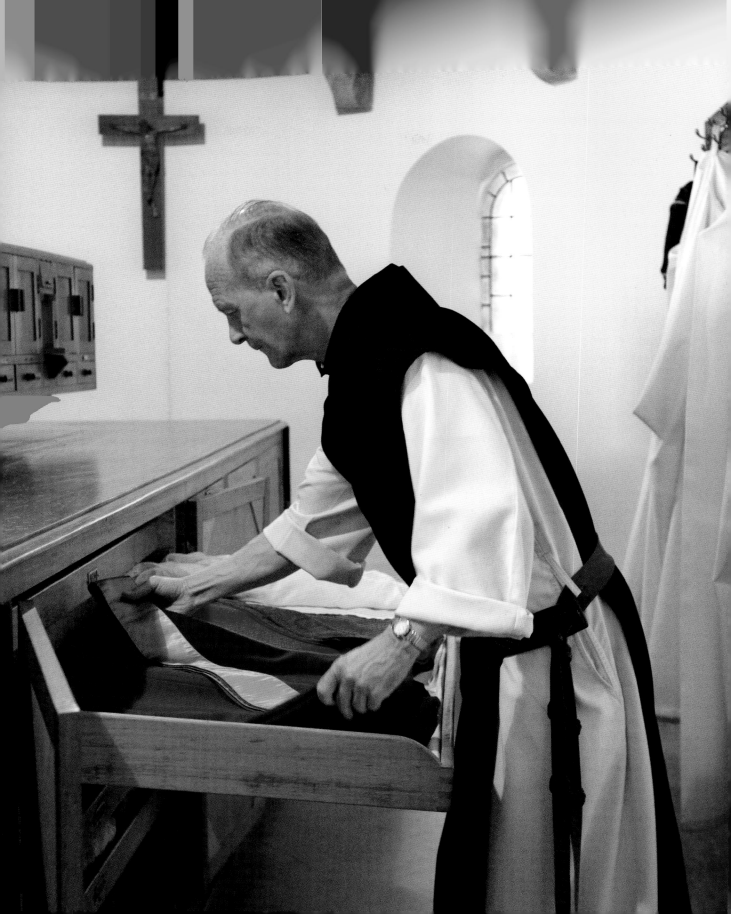

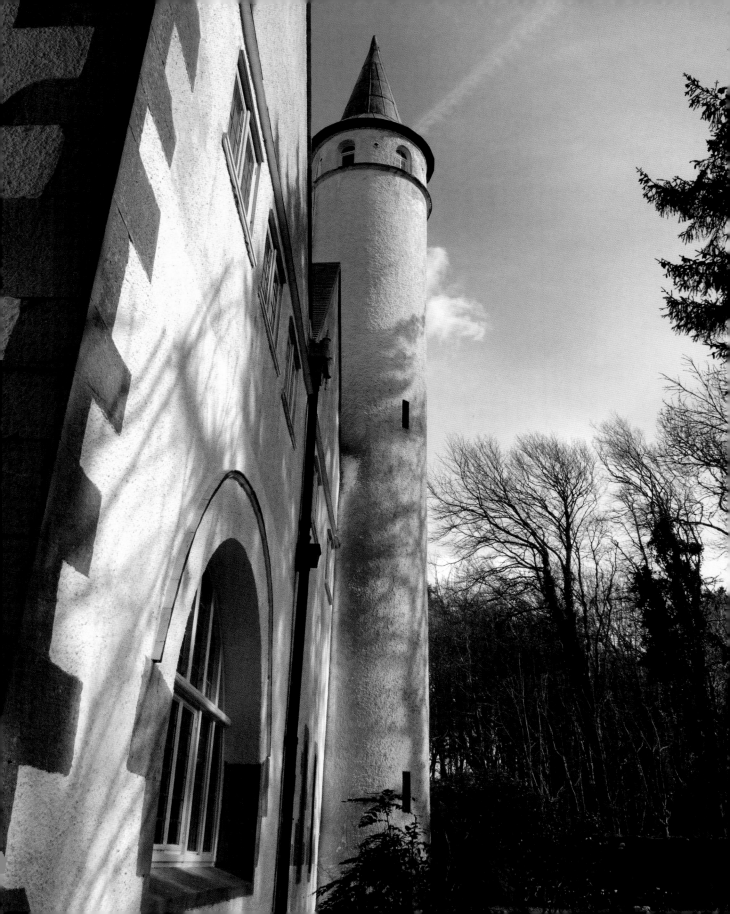

Traditional key roles in a Cistercian community

Abbot: The leader of a community, elected by the monks. The Rule of Saint Benedict makes him the representative of Jesus Christ in the community.

Prior: The abbot's deputy, chosen by the abbot. The prior helps the abbot and is assisted by a Sub-prior.

Bursar: Keeps the Abbey accounts.

Sacristan: Responsible for religious celebrations. Prepares the vestments, hosts and calls the monks to prayer.

Guestmaster: Welcomes guests to the Abbey and arranges for their stay.

Novice master: Mentor and guide for novice monks.

Cantor: Choirmaster for church services and the hours. Also organises and rehearses any processions or more complicated ceremonies. Looks after the books when there is no librarian.

The abbot

Saint Benedict used the family unit as the model for a community – the abbot is the head of the household and the monks are his brothers. He is elected by the monks of the community to serve a term of seven years after which he can offer himself for re-election or step down. Father Daniel was chosen in 1999. He is now well into his second term. "That you are elected is a good thing," he says, "because you have the confidence of the community and this gives you a boost to do your service as abbot."

One of Saint Benedict's rules states that the monks must obey their abbot without question. Today this kind of unquestioning co-operation would generally be considered outdated anywhere other than in the armed forces. Yet in a Cistercian Order it is an accepted practice. But Saint Benedict doesn't allow an autocracy to take hold. He stipulates that the abbot has to consult the community on all issues that might affect them and include their wishes and opinions in his decision-making. "You have to sense what's going on with the brothers," says Father Daniel. "They have the right to express their opinions. It would be dictatorial if I alone made the decisions. I'm still learning, of course, and there's always the one or another who doesn't agree, but that's life."

The Rule allows for the monks to have a certain amount of free will, but Benedict protects the abbot's authority by insisting that the brothers should seek his sanction and approval on all matters of any importance. The Rule itself is a delicately balanced piece of writing which places the responsibility on all members of the community to aim for a consensus of opinion. But ultimately it reminds the abbot to be conscious of his role. Father Daniel sums it up: "I think of it as walking on a tightrope – on an edge – and that's the challenge. I think I'm at a healthy age to be an abbot, but sometimes it can be quite a pressure."

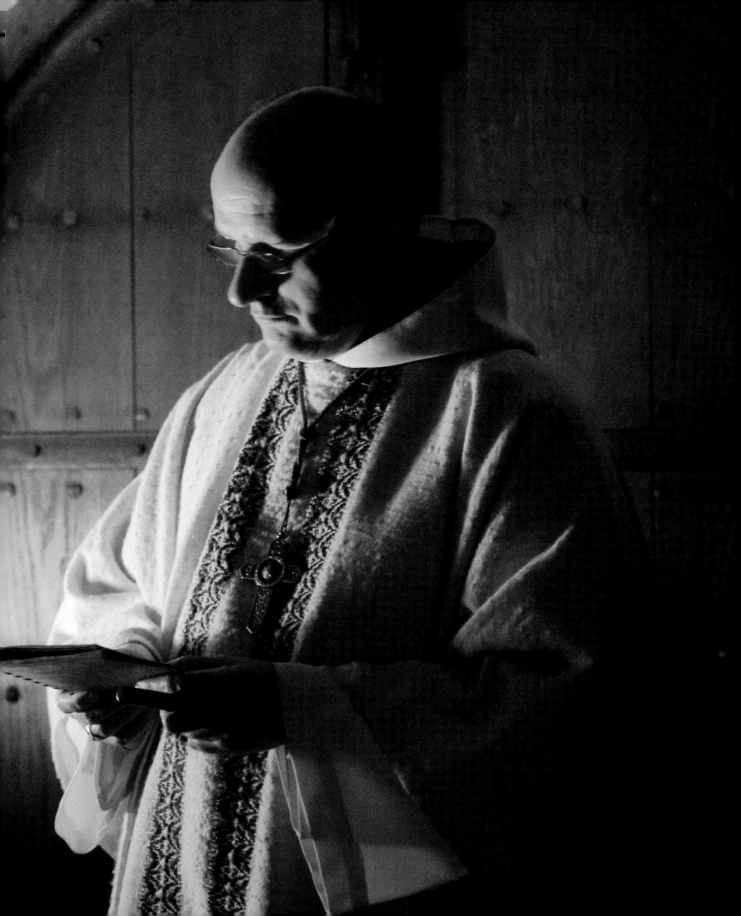

Visitors and hospitality

Under the Benedictine Rule visitors are to be treated "as Christ Himself". Guests are met by the abbot or his deputy. During their stay they are put under the care and protection of one of the monks, usually the guesthouse master. Ancient rules require the guest not to associate with other members of the community except by special permission.

On Caldey, visitors are usually accommodated in Saint Philomena's guesthouse behind Priory Bay, or the two-storey guesthouse at the abbey's northern end. Father Senan is Caldey's former guestmaster. "It's a very demanding role," he says. "We take bookings from January, and we're pretty full, certainly until the end of September."

Guests vary, from Anglican priests on retreat to university students and support groups such as Alcoholics Anonymous. "It gives them three or four days away," says Father Senan. "A lot of them have illnesses due to stress, family problems and so on, which they are able to leave behind for a few days. We try to make their time here as peaceful and calm as possible. The initial welcome is so important. We want our guests to feel welcome, to feel at home, so it's up to us to provide that."

Caldey tends to attract people who want to come year after year. "I think Benedict felt the need for people to come away, so that they can recharge their batteries and go back again to the world," Father Senan says. "Without it I don't think we would really function as monks. It is part of our ethos to provide this service and there's wonderful satisfaction in it."

Novices

Chapter 58 of the Rule deals with the admission of novices. Over the centuries the rule has been adapted but in essence it remains close to what Benedict originally intended.

When someone shows interest in being a monk, he is first invited to spend time with the community as a guest in a series of short stays over many months or even years.

On their first visit individuals are invited to stay for five days. They live in the guesthouse, attend all the services and eat in the refectory with the monks. During this time the novice master, Brother David, speaks with them at length about their lives and their motivation for wishing to be a monk. "What we are looking for when we judge a candidate is whether he is truly seeking God," says Brother David. "Has he fallen in love with God and is he prepared to commit himself to finding Him here in this community?"

Brother David was a lawyer based in Basingstoke who specialised in drafting commercial business contracts. He gave up his life in Hampshire in 2000 to become a novice himself. "It is not always easy to discern a vocation because in the true sense a vocation is a gift from God."

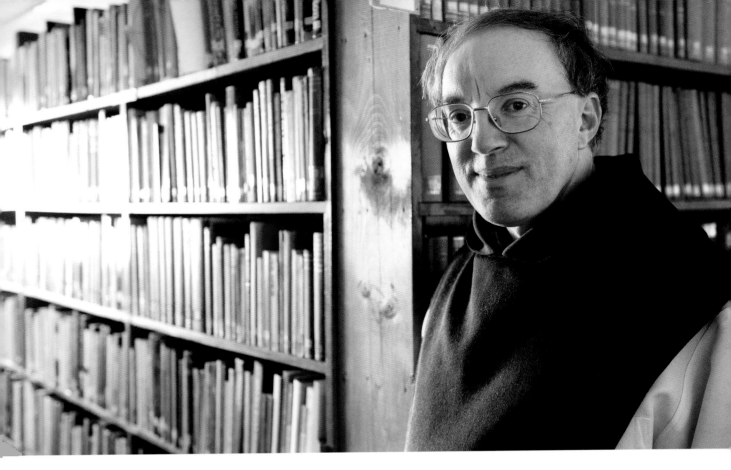

Above: Brother David in the monastery library.

Brother David

Place and date of birth: Surrey, on 23rd October 1951.

When did you become a novice? 1991.

When did you take full vows? Took vows on Caldey in 1993, solemn vows taken in 1996.

Why did you become a monk? To seek God.

What does Caldey mean to you? The place and community which God has chosen for me to seek him in.

What is your favourite part of the island? Blessed Sacrament Chapel.

What is your favourite canonical hour? Holy Mass.

What are your interests? Scripture, prayer, spirituality, poetry, literature, nature, art, music, social justice.

What are your jobs on the island? Novice Director, librarian, gardening, liturgical readings.

What do you miss from the outside world? Mountains

If someone remains interested he is invited back, and if all goes well he may be offered "a month's live-in." The Abbey checks his references, gets a medical report and makes other relevant enquiries.

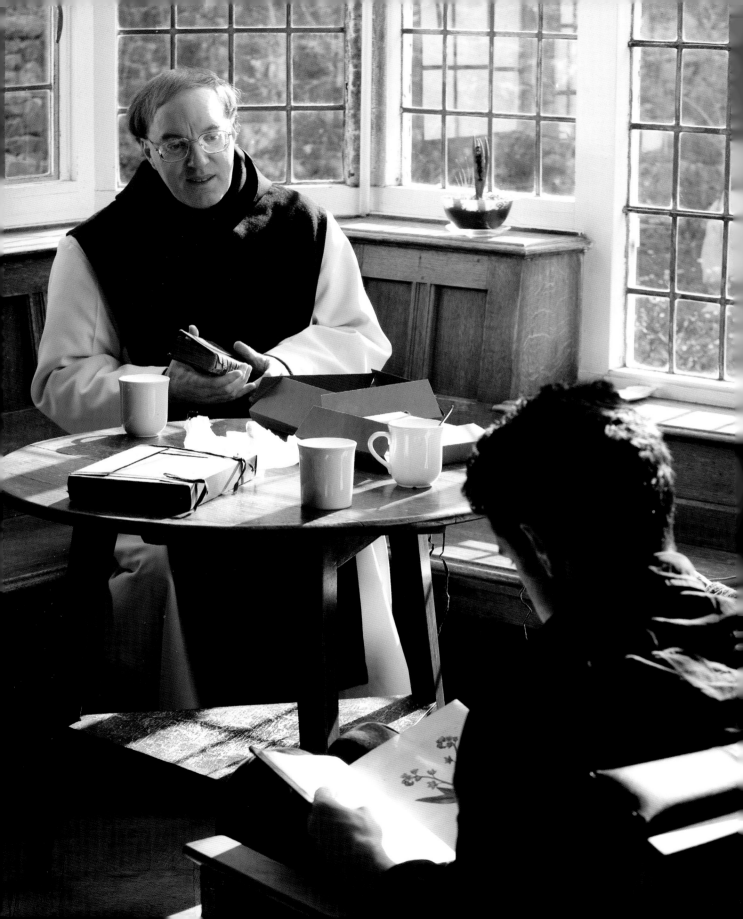

Left: Brother David teaches visiting theology students in the monastery guesthouse lounge.

If an individual is still keen to join he is admitted as a novice monk. Under the guidance of the novice master he receives constant tuition in the study of liturgy, gospel and the Rule of Saint Benedict.

Brother David recalls this phase: "If you're called to the life, when you start off it's absolutely wonderful. You're on cloud nine; everyone seems to be a saint; you just drift through with no problems." But sooner or later the novice's motivation is tested as the training is intense. Once a week Brother David asks the novice to express his feelings about his vocation. The novice receives guidance in understanding the Bible and the nature of belief.

When a novice joins, practically all responsibility is taken away from him and, naturally, this has its effects: "You go back to being in your school days; you're under a novice master so you tend to regress psychologically a bit."

This is a phase that all the monks remember clearly. It can be a traumatic time, so Brother David's work includes close pastoral care: "People tend to treat you with kid gloves when you're a novice. I'm very protective of anyone who is under me. We're not saints. As in any human institution there are human situations you have to resolve. In a closed community on an island, with a few people living together twenty-four hours a day, problems can become magnified."

"If you look at it rationally and dispassionately you'd realise there was nothing there at all. But worries can be blown out of all proportion – for a novice especially."

Part of David's role requires him to observe monks under his care: "Quite often choir is a good indicator – you can see in their facial expression whether they're joining in. Everything comes out there. You're there for three-and-a-half hours and you're off guard, so you can kind of tell if there's something wrong with him there or if perhaps he's ill."

A good candidate will generally survive the first year without too many problems, but the second year proves to be particularly testing. Invariably if a novice is going to leave he will do so during the first two years.

Brother Robert, a former Abbot of Caldey, remembers his early days only too clearly: "The first year was wonderful; I enjoyed singing the office, I liked the physical work, I think I was just settling in. But in the second year suddenly everything went black – God disappeared.

"It was in the literature that this sort of thing happened, but when it does happen books don't mean anything."

Robert's anxieties became darker and darker: "At one stage I went out and was standing on the edge of the cliff looking down, wondering whether it wouldn't be better to jump – it was that bad. But why it was I couldn't tell you, and then all of a sudden – gone!"

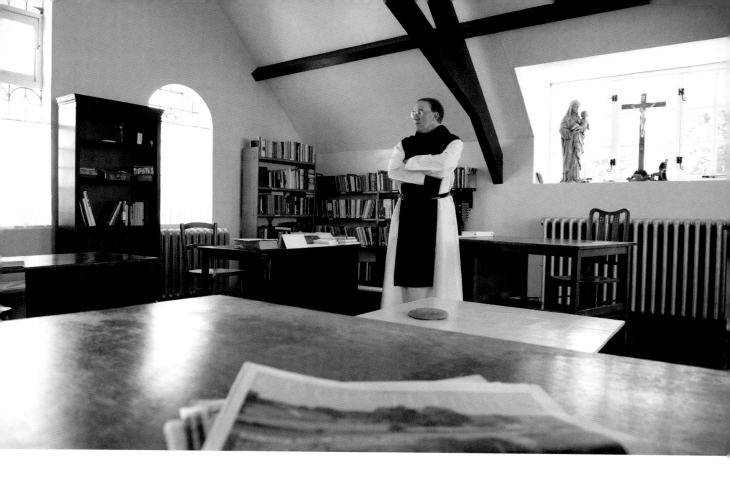

Above: Brother David in the novitiate teaching room.

As a novice develops he is tested in different ways. Each phase; being clothed as a novice, then as a junior professed, and finally as a solemnly professed is a milestone. There is no set length of time before a monk opts to take full vows. Some are ready to make a final commitment earlier than others. For many, though, that final step is the biggest psychological hurdle of all, and they may delay making it.

"Monastic life is a challenge," says Brother David, "and the pathway to God is a challenge and it has to be. You've got to expect to hit tough times."

About four out of five novice monks leave within their first two years. The rest persevere and become full members of a community. Almost all the brothers are pragmatic about this issue. They are not surprised by the low success rate. A past novice master, Father Senan, says: "We don't always retain the ones who come but at least we've given them an opportunity. If it was something that they had been seeking at least they've come here to try. That's all we've asked them to do is try – some stay, some don't."

Above left: Front door to the monastery guesthouse.

Above right: Novitiate teaching room door.

Vocation

It is easy to forget that taking the vows is one of the early steps in a monk's career. The life is challenging and each brother tells a different story about what prompted him to follow the life of a monk. Some are very open and honest and tell you all you want to know, some just tell you the broad details, and others are very guarded and tell you very little.

Father Daniel is very open when asked about his vocation: "I never had the ambition of becoming a monk at all, it never showed in my youth. I was brought up as a practising Catholic, but when I was about fourteen I turned away from the church until I was about nineteen."

Over a drink in a bar in Holland a friend told him that he was going to see his uncle who was a monk. Father Daniel recalls that evening: "I was quite amazed to hear that. I said, 'Do they still exist?' because I never bought into those parts of religion at all. My friend said, 'Oh yes, are you curious about that?' I said 'Yes – I would like to see what that part of life is all about.' And that's how it all started, that's how I became acquainted with the monastery and I entered when I was quite young, especially by today's norms, at the age of twenty-one."

His family were divided. "My mother thought it was a good idea but my Dad was more sceptical; my brothers and sisters were not happy with it at all. In a sense they understood but they thought, 'Oh well, he'll only last for a year or so' – and I'm still here!"

Father Senan's road to Caldey was not straightforward: "I tried my vocation at Mellifont Abbey in Ireland many years ago and it just didn't work out. I went back to the world but there was always that pull. So I came here." Giving up his career as a nurse in the military, he tried the life of a monk once again. "I found it difficult," he says. "But with family and community support you settle down and it's very fulfilling. I didn't envisage being part of this, but you grow into your vocation."

Brother David sees the abbey's location as fundamental to a vocation: "To be a monk you're called to the place as well as the life. I didn't grow up by the sea, but I don't think I could live anywhere else."

Once monks have taken their vows they commit to leading a life free of material wealth. They are required to part with all their possessions so that they can focus fully on their vocation. Any assets are given to the bursar of the Order or to the monk's family. The brothers become totally dependent on the community. Everything they need is provided for the rest of their lives.

Below: Brother Stephen opens mail in the refectory.

Apart from the stress of making such a life-changing decision, there is the continuing pressure of keeping to it and following life in a certain way. It is more than the loss of possessions or living a life of celibacy. Sometimes the straightforward, simple things you are required to do are overwhelming – such as going to seven services a day. The monk's life can be a daily test of mental strength.

Inevitably, monks experience severe doubts about their vocation. Father Daniel remembers his: "At the end of my twenties, early thirties, I felt that I had made a wrong decision and it took quite a while till I got over that. I had a very good spiritual director who helped me, who really understood me, who sympathised with me, but who also pulled me, eventually, to a positive self acceptance."

Appearing at ease and devoted to his life, Father Senan seems to take little for granted: "Anybody will go through different phases. But one mustn't ever become complacent and think everything is fine now. It's a constant struggle. It's a constant renewing of ourselves, renewing ourselves in our journey towards God – that's what it's all about, basically. And that doesn't come easy."

Father Daniel, too, sees doubt as something that is almost necessary for a monk to experience. "Almost everyone gets a crisis," he says. "In the monastery but also outside." Brother Benedict concurs: "There's always tension, but the monks I've spoken

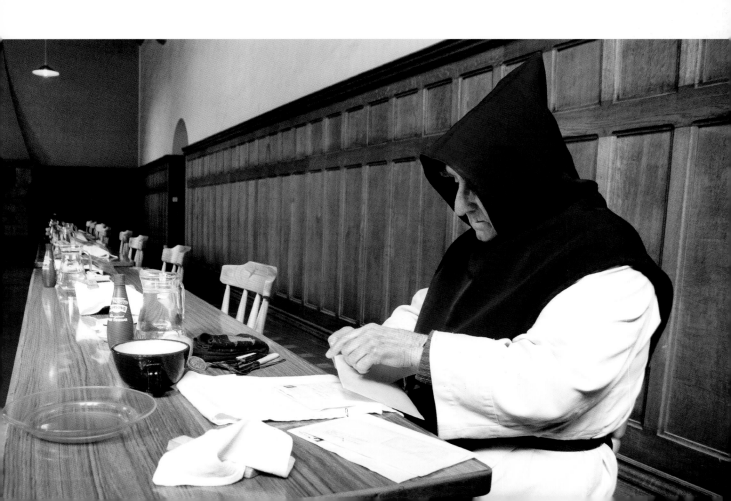

Right: Brother Gildas serves lunch in the refectory.

to have told me not to get too concerned about tension and struggle, because that'll probably go on for the rest of your life here on Earth."

Father Daniel believes the way to face times of struggle is to take on the role and challenges of a monastic life in a fully committed way. "If you try to live out religion in a very radical way you need to meet yourself. If you don't meet yourself then your whole vocation becomes a sham. It becomes something where you're keeping up appearances. Yes, you're wearing a habit, but it's much more than that. The whole person needs to be involved with it."

The community of Caldey has kept a record of the men who have been monks on the island. In the archives there is an obituary for every monk who has served there. In the eighty years of the Cistercian foundation, along with the present eleven fully-vowed monks, only another forty-eight men have followed the Benedictine life on Caldey Island.

For many Cistercian communities the number of new vocations has been steadily decreasing. Dom Armand has visited most Cistercian abbeys in the world and so has a broad view to offer.

"As a whole the order has good amount of vocations," he says. "There is a slight increase of the numbers every year, but it's not always from the same part of the world."

In South America, Asia and Africa many monasteries currently enjoy a healthy number of devotees, but in richer societies this it's not the same. "In the old Europe and America, for a number of years now the vocations have been reduced. But, we are not in the business of giving out vocations.

"Our monasteries are not like corporations, or even an active religious order that has a specific service to render, like a school or a hospital.

"We are a group of people who are called together by God to live a monastic life, so if many come it's okay. If few come it's okay. If by any chance, and I hope not, you are the last one, it's not a disaster."

Throughout the history of monasticism every abbey has experienced periods of growth and contraction. What matters is that the tradition of the Cistercians is continued, whatever the strength of the community. Dom Armand cites an example of why this is so important. It concerns a very famous monastery in Switzerland dating from the eleventh century. At its peak there were hundreds within its community. "Now it must be fifty to fifty-five," he says, "but there was a period when there was one monk. It came down to one. It never closed." Dom Armand holds up his index finger: "This one transmitted the tradition."

Caldey has experienced highs and lows, and will again. "If you don't put the situation into a larger context you can easily get discouraged," says Dom Armand. "If you put it into the larger geographical context, if you look at what happens in other parts of the world, if you look at the context of history...it's like the stock market!"

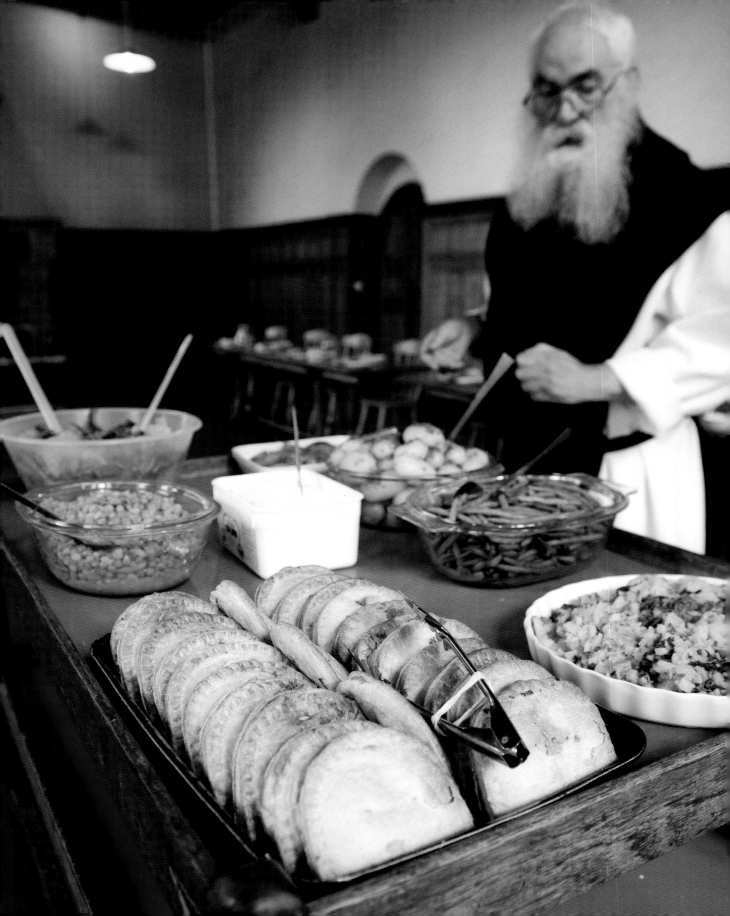

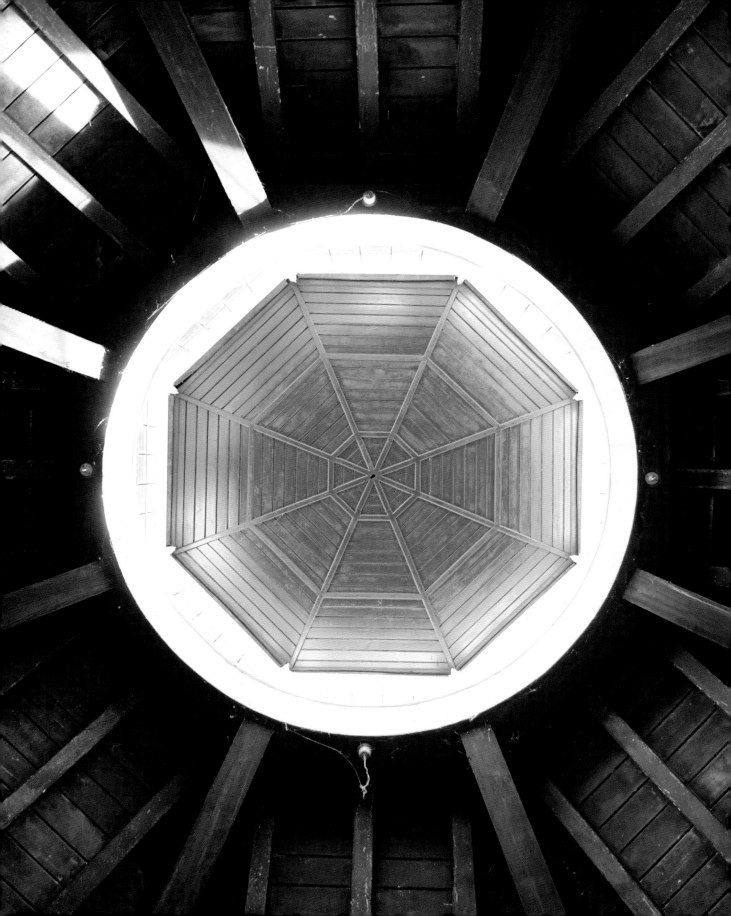

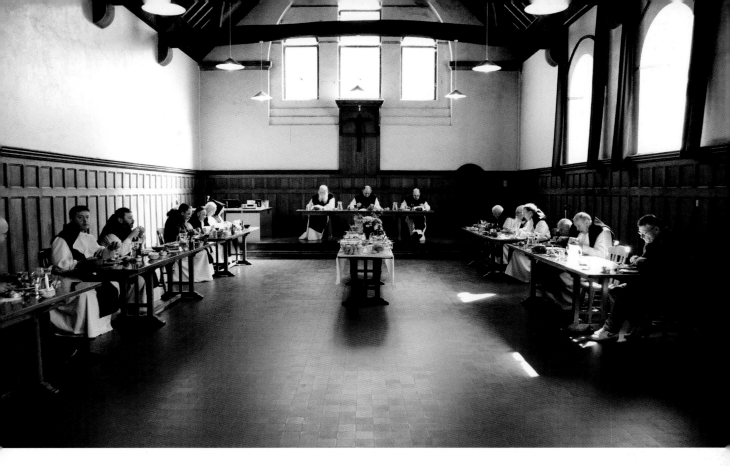

Mealtimes

Three chapters of the Rule of Saint Benedict are dedicated to the monks' diet and their mealtimes. The original rule stated that the monks were permitted two meals a day and were always given a choice of dishes; meat was prohibited except for the sick and the weak.

The monks' food on Caldey is managed and cooked by the community's Prior, Brother Gildas, helped by Irishman Brother Gabriel. "Gildas is really the master chef," says Gabriel. "He's marvellous, really and truly. I cook for five or six days a week, but he's still teaching me."

Brother Gildas is an imposing man, well over six feet tall, well built and with a biblical beard. He was born and brought up on the Isle of Wight where his father worked as a supervisor at Parkhurst Prison. He spent the 1960s in London. He is a mix of playfulness and deep seriousness and freely admits to being surprised at becoming a monk. "I lost my faith," he says. "I flirted in my teens and the swinging Sixties with the whole Eastern trip, Hinduism, Buddhism – the lot!"

An incident in London changed the course of his life. On a busy shopping street he noticed a man lying on the ground. "People were just walking past him. Nobody was looking at him. They obviously thought he was an alcoholic." Gildas crossed the road to find the man conscious, his nose bleeding. Clearly he was seriously ill. An ambulance

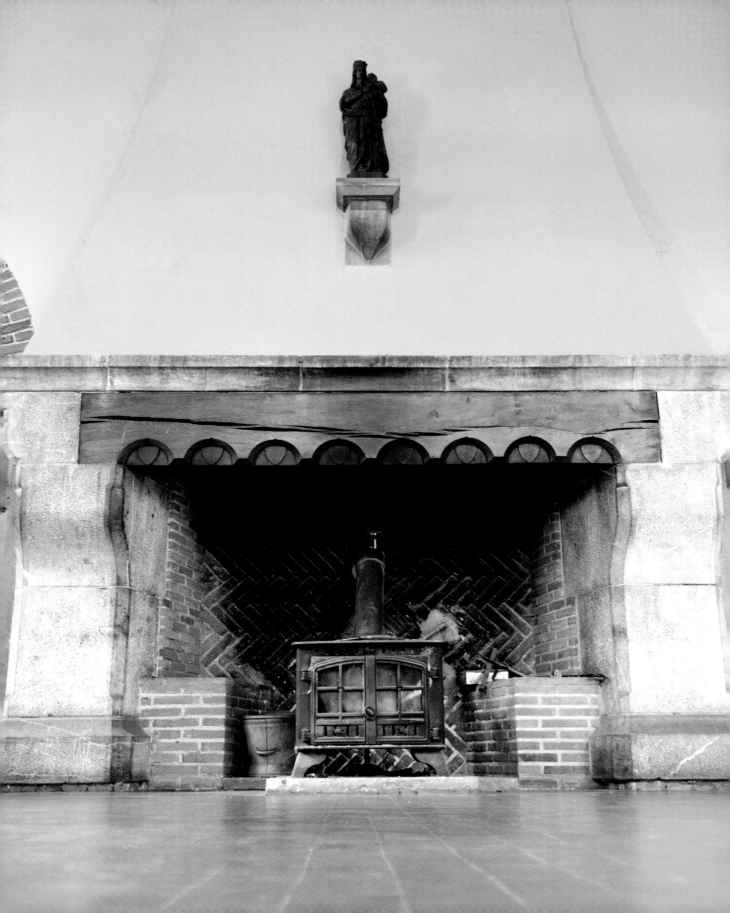

Left: The fireplace in
the refectory.

was called and later that night Gildas phoned the hospital to be told that the man had
died, having suffered a massive heart attack. He was left angered and frustrated by
what he had witnessed. "I thought to myself, 'What is this world all about if people are
just going to walk past and leave this bloke?' I realised I didn't want to have anything to
do with it, and so I left London." In his despair he discovered something about himself:
"I thought I was a Sixties drop-out, but I realised that I wasn't." He visited Caldey in
1982 and a year later became a novice. "I knew I wanted to go into religious life and
I totally fell in love with the place. I felt that coming here, I rediscovered my ancient
Celtic roots."

Brother Gabriel and Brother Gildas order the food together but Gildas is in charge of
the menus. He shows his serious side when talking about his role in the refectory:
"Napoleon said that an army marches on its stomach. It's the same for monks. You
feed them well and they'll do their job well. Within a monastic regime of simplicity and
austerity it is possible to eat well, even with the simplest of ingredients."

In the history of monasticism, diet has been treated with varying importance and
sometimes the desire to lead an austere life was taken a little too far. Gildas has
come across many examples of this: "It says in one of the other monastic rules that
when you're eating food you should be trying to think of things that disgust and revolt
you – I mean that's perverted! One of the French houses during Lent sometimes used to
sprinkle ashes on their food. You're not going to tell me that comes from Him up there!"

He is also sceptical of some ancient written accounts by monks who claimed to have
had profound religious experiences. "It was because they weren't being fed," he says.
"They were on this massive starvation diet! During Lent they'd only eat one piece of
bread or something. No wonder they were having visions and going into hysterics and
ecstasies – it was because they weren't eating properly.

"Also we know that when barley gets damp it produces a spore that is very similar
to LSD – several so-called visionaries were probably actually eating barley bread."
Invariably the monks were encouraged to think of food as something to keep them
alive; not something that Gildas subscribes to. "Let's face it, God gave you a stomach.
He's giving you a job to do, so you might as well do it properly. Food is a gift of God and
it should be used properly and lovingly and with care and enjoyed."

Gildas clearly remembers what the food was like when he first joined the community
in the early 1980s. "The meals consisted of boiled cabbage – and it was boiled to death
– boiled potatoes and some kind of gravy sauce. You had soup and you had stewed fruit,
and you could get that day-in day-out with no variation. You've only got to ask Senan
about it – he used to go hysterical!"

Gildas makes regular telephone calls to a Pembrokeshire community NHS dietician,
who advises him about catering for the community as a whole, and also for a few who
require special attention for conditions such as diabetes. Brother Gildas has looked
at the diets of other monastic cultures such as the Greek Orthodox monks who live on
Mount Athos. Previously food such as rice, pasta, or olives would never have been seen
in Caldey Abbey. In many ways he is lucky in that he can design practically any menu he
wishes. "I like to be experimental," he says. "Being brought up in the early 1950s, there

was still food rationing and when you came home from school you know exactly what you were getting. I've got a phobia about that so I like it to be different."

He feels firmly that the life the brothers lead requires a varied diet. "I try to work on a three-week menu, which means I try not to repeat a meal during that period. They're a good community; they'll eat practically anything you put in front of them."

Brother Gildas

What does Caldey mean to you? To live on Caldey is to be aware of its past, a deep sense of the past. A full knowledge of our past, not in something gone by but as a living part of the now. You've only got to go up to the Old Priory and touch the Ogham stone and you are physically touching the ancient past.

What is your favourite part of the island? To say do I have a favourite spot on Caldey is to ask whether I have a favourite part of my body!

What are your jobs on the island? Prior of the Community and Refectory cook.

What do you miss from the outside world? There is no outside world. We are the world, life itself, or how else could we be monks?

Most Cistercian communities are practically vegetarian, largely because the Rule of Saint Benedict states that they should avoid meat, but in recent years the Caldey monks have been eating meat far more frequently.

"The Rule stipulates it in quite an amusing way," says Gildas. "'Meat from four legged animals'. Saint Benedict didn't seem to mind if the monks were eating chicken or fowl. It was red meat that was the taboo – it was considered to cause all sorts of sexual temptations. But he was writing around the time of the eclipse of the Roman Empire where food had gained a certain taboo. Food had become quite a debased thing; it had a lot of other connotations attached to it other than just sustenance."

The monks and the islanders have to be constantly mindful about food stocks. The island produces very little food these days so everything has to be brought from the mainland. With one eye on the weather and the other on the 'best before' date and storage space, getting it wrong means being extremely wasteful or, in the worst case, risk having to ration what is eaten. The monks have become masters of reusing food – whatever is leftover at lunchtime will be recycled at the evening's dinner sitting.

Gildas' management of the winter food stocks starts early: "I take a leaf from all the ladies on the island. They all build up quite a good stock during the summer, canned food, powdered soups, tinned fruits, powdered milk, biscuits, cooking oils. I reckon I could keep going for about three weeks with what I've got. There are times though when I think, 'Oh God I wish I could just give them beans on toast!'"

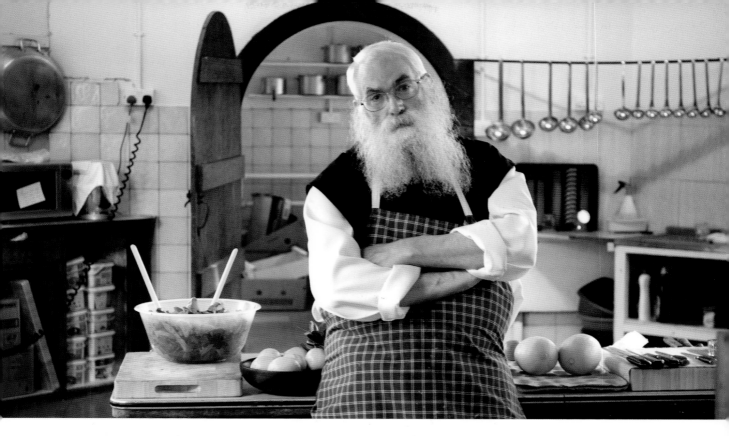

The refectory

The refectory is a long wood-panelled room, with a huge hearth at one end. Just a few years ago it housed an open fire that gave off a vast amount of heat and released a gentle, reassuring tang of woodsmoke. It was an inefficient way of producing heat, however, so now there sits a black cast iron wood burner.

At certain times of the year, the warm light of sunset pours in, creating dust-filled shafts of light across the tiled terracotta floor.

Eating a meal with a community of monks for the first time can be a strange experience. Each community member and the guests stand at their table place and wait for the food to be brought in. A prayer of grace is said and then a calm, monastic-style stampede breaks out as everyone serves themselves from the trolleys left in the centre of the room. If you've been up since 3am, by midday you have become rather hungry. Soup is popular. In the middle of winter the sight of a monk eating a hot broth along with a large chunk of homemade wholemeal bread generates an ancient image.

There is no conversation. Chapter 38 of the Rule of Saint Benedict says that one of the community should read aloud from religious books during meals. Despite the constant sound of a human voice from the reader, eating with the monks feels like a silent experience. All that is heard is the gentle noise of cutlery on plates and dishes. As each person finishes their plate they then serve themselves the next dish.

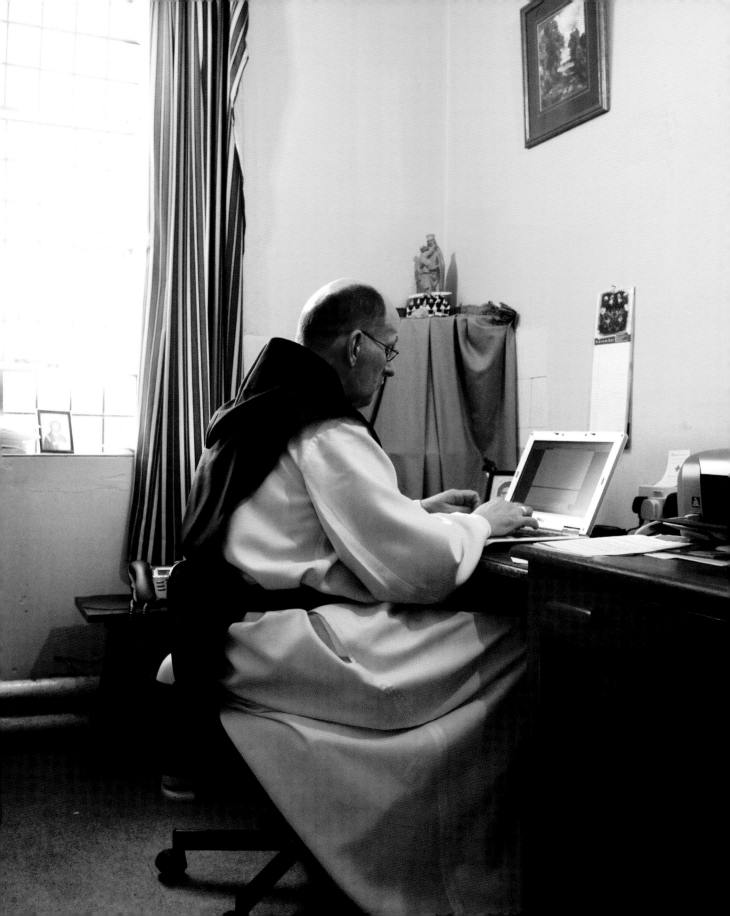

Left: Father Daniel
works in his office.

Those who have finished take their plates to the kitchen. In contrast to the way in which the meal starts, the way it ends is unexpectedly free from ritual. Each person simply finishes in his own time, clears up, makes himself a mug of tea and leaves. The time after an evening meal seems to be a short part of the day during which the monks are often able to do something to please themselves: read, listen to some music, catch up with correspondence. The atmosphere after the evening meal is especially calm: the day's work is almost done.

Father Daniel goes to his office. One of his recent tasks has been to update the monks' services. After a previous visitation by the Abbot of the Belgian mother house Notre-Dame de Scourmont, it was recommended that Caldey should renew its prayer books and with it write new chants.

The community was very aware just how tired the services had become. Father Daniel says: "The liturgy we have sung so far has been running for over twenty to twenty-five years, some say thirty. But if you sing things day-in day-out every time, it's a bit hard to have the same conviction."

To rewrite many hours of religious services, that contain within them thousands of years of history, is a massive task of intellect, devotion and stamina. It also requires significant musical ability. "I have managed to buy a nice music program for the computer where you can write music and put lyrics under it," says Father Daniel. "It looks very professional, easy to read and hopefully we'll bring it all into practice. Quite a lot of stuff I got from other composers, but a few things I did write myself. I got the right inspiration at the right time. You have to catch it very quickly!"

Facing a duty that would deter most people, Father Daniel has embraced the job, undaunted: "I love music, it's a hobby. When the brothers come in and they see me working they say, 'Terrible, it's such a job,' but it doesn't bother me because time flies when I do it."

As the sun dips down below the village green the evening turns to dusk and the last service of the day will shortly begin. As he talks, Father Daniel signs off his last e-mail, clicks the send button and shuts down his computer. Clearly the task of rewriting the services has sparked his thinking about liturgy, the celebration of faith in public, and its importance in a contemplative life: "I could talk for a whole week about this, but even after a whole week what have I actually said? If you could express it just like that, it wouldn't make much sense to devote your whole life to the monastic life."

For 1,500 years since Benedict's Rule was written, its principles have guided communities of monks to live and work together throughout the Christian world. And yet its qualities have long been relevant to people of all kinds. As rewarding as it can be to live in the Caldey community it still presents a challenge. Father Daniel feels that the brothers have a collective strength: "There is a toughness in our community. It went through quite a lot. It's grown, it's dwindled, but there's always that determination in the house. And when that spirit is there I have great faith for the future."

Some papers are tidied, the latch clicks and the big oak office door sweeps open. And Father Daniel goes down the corridor to the peaceful service which gently brings the day to a close – Compline.

Brother Stephen

In 1943 Brother Stephen was a journalist on the Yorkshire Evening News. Not yet 21, he was called-up and joined the Royal Air Force as an air-gunner. Stephen had become good friends with a Roman Catholic sub-editor at the newspaper who introduced him to the faith. Before he left for the war Stephen became a Catholic: "It was a rush job. The parish priest said 'If you're going in as an air gunner, you're not likely to survive the war so we'll get you entered into the church before you go!'"

Stephen saw most of his service in India and Burma. He recalls various missions, flying in American Liberator heavy bombers to attack key locations: "We were the first daylight bombing squadron, we would fly five planes in formation to pattern-bomb places such as a Japanese base in Mandalay that had been built as a prelude to an invasion of India. It was completely demolished."

In 1947 Stephen was demobbed and returned to his reporting job, which he now found uninspiring: "Some of the old journalists were still there. All my contemporaries had come back and gone, mostly to Fleet St. I thought this doesn't carry any purpose for me. So I started looking for something with more basis and meaningfulness in life."

He joined a Dominican order in the Midlands. When two Caldey novices came to visit, Stephen became interested in their lives and went on holiday to the island: "I decided that this was where I ought to be, so I came back three months later and I've been here ever since."

A prominent member of the community, he has been at Caldey for more than 60 years, and is the longest serving brother. One of his responsibilities was looking after the abbey's business projects. The tourist boom of the 1980s in south-west Wales brought hordes of visitors to the island.

"We used to see 70,000 people a year, so it needed a lot of supervision. When I was procurator I was living almost on the fringe of the community because there were so many business projects underway that I had to go out to see manufacturers and suppliers. In the winter I was out quite frequently."

Brother Stephen has seen many peaks and troughs but he is confident about Caldey's future: "I think there's room for a few more to maintain the life of the monastery. I think we've got it indefinitely because we're in the fortunate position of being a Papal monastery, in a way. It was bought at the request of Pope Pius XI when the Anglicans had to leave, he asked the Cistercians to take on the island. So if any problems become acute we've always got the Vatican to intervene."

When Brother Stephen came to Caldey in 1948 community life was very different: "The regime, the outlook, and the philosophy were extremely austere. We used to have straw mattresses and slept in dormitories with just curtains as partitions, and we got up at half past two in the morning for the various religious services. When you look back, you think 'How on earth did I survive and get through?' It was rough!"

Place and date of birth:
Brownhill, West Yorkshire on
17th November 1924.

**When did you become a
novice?** 1949.

When did you take full vows?
Took vows on Caldey in 1955.

**What other monasteries have
you been part of?** Notre-Dame
de Scourmont.

Why Caldey? In response to an
invitation from God to devote my
life to him in prayer and worship.

**What is your favourite part of the
island?** My room.

**What is your favourite canonical
hour?** Lauds.

What are your interests?
Psychology.

**What are your jobs on the
island?** Sub Postmaster –
otherwise retired.

**What do you miss from the
outside world?** Raising a family.

5 How Caldey makes a living

Tourism is the main source of income for the monks and the islanders of Caldey. Every year between Easter and Autumn around 55,000 day-trippers come to the island.

The island's business operations include the Caldey Boat Pool, which provides passage for visitors, the retail of gifts and perfume, rental income earned from the tea shop and chocolate maker, and the letting of six houses on the island. The Abbey runs itself as a separate entity. Everything Caldey does as a business relies on a continued boat connection with the mainland.

Next to a door within the abbey cloisters hangs a blackboard. It looks inconsequential but it symbolises the monks' contact with the outside world: every evening the time at which the post boat will leave Tenby harbour the next day is chalked up on it.

The door is typical of a monastery. The thick oak is scratched and worn. The click of the latch echoes around the cloisters and opening it requires physical effort.

Within lies the Abbot's office, a small, squarish room. The shelves are stacked with academic texts, music manuscripts and clerical yearbooks, as well as a Harry Potter book and a baseball cap bought in Rome. Space is limited but it is neat and tidy and clearly plenty of work goes on here. The office is a focal point of the monastery – almost everything that has anything to do with Caldey Island has been contemplated, talked about, read and signed in this room.

Father Daniel's computer is one of few in the monastery; as the Abbot of Caldey he is the prime link to the outside world. The Rule of Saint Benedict forbade monks from unnecessary contact beyond the monastery walls, but today the Order has embraced the communications revolution. "I greatly admire our predecessors, who in ancient time took months and months to communicate, but today it's instant access," says Father Daniel.

All Cistercian houses are required to be self-supporting, but when your business relies primarily on tourism your economy can be vulnerable. If the weather is good then business is good. But anything can happen with the variable weather fronts that come in from the west. Father Daniel listens to the shipping forecast to stay in tune with what may happen. "Caldey is like a big ship on the sea," he says. "You depend on the elements. Spiritually speaking, it's beautiful, but if you are earning a living it can be a pain."

Past years have seen the summer season lose more than 40 out of 170 boat days. Estate Manager Ben Childs puts it into perspective: "That sort of loss is always going to badly affect you, but when seven of those days happen in August, and August gives you 40 per cent of your overall income, it can get tricky. It has become increasingly important that we generate money from other sources."

Left: Bottles storing compound formulas in the old perfumery.

Next page: Brother David chats to tourists on the village green.

Right: Islander Simon Curnin casts off the Post Boat as it departs to return to Tenby harbour.

Below left: The sign in the cloisters with the Post Boat arrival time.

Below right: Father Daniel works in his office.

The fact that visitors can experience the island's unspoilt nature is considered a positive psychological experience. Caldey attracts people who are looking for something else in their lives, something that Father Daniel has often experienced: "When you walk in a habit, you're bound to be asked questions by tourists, but you also hear their story, what they hope to find, what difficulties they have in their life. Sometimes people very quickly open their hearts to you. They want to share their burdens and they ask us to pray for them and we do, we remember them every day."

Boats to Caldey

The Caldey Post Boat – that vital daily link upon which all the islanders rely so heavily – has been managed by Alan Thomas since 1970. One of the most experienced mariners on the South Wales coast, he has been a member of the Tenby lifeboat for more than forty years and the coxswain since 1982. His awards from the Royal National Lifeboat Institution include a Silver Medal. In 2004 he was awarded an MBE.

The Caldey Boat Pool is a collective of eight boat owners who operate tourist trips out of Tenby Harbour. The ticket price that visitors pay covers the boat fare and entry fee on to the island. The revenue raised is divided equally between the self-employed boatmen and the Abbey Estate Company.

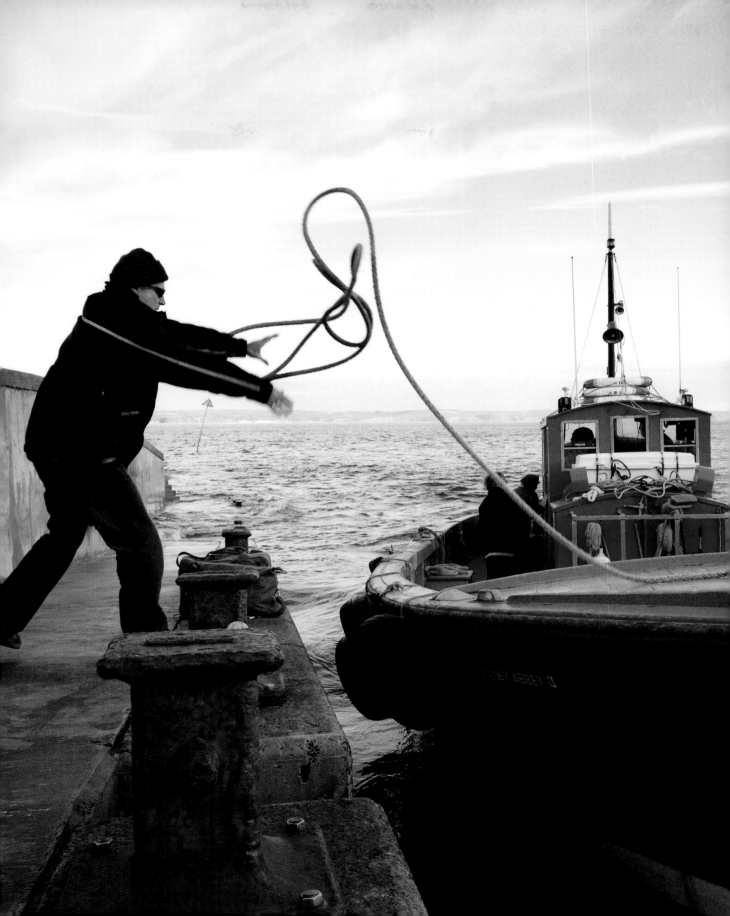

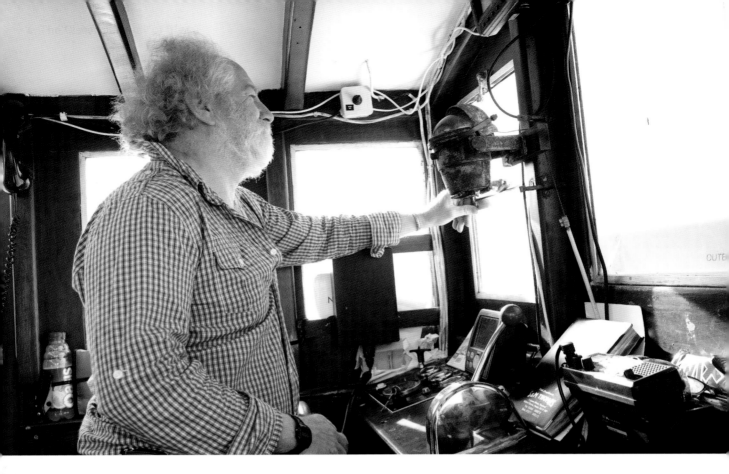

Above: Alan Thomas, owner of the Caldey post boat. He is also the coxswain of the Tenby RNLI.

For decades now Caldey has relied on the sale of gifts and products in its shops on the island and in Tenby. This is overseen by commercial manager John Cattini. In his time in the job it has, he says, become increasingly challenging: "When I first started we had a captive audience. Caldey was one of the few attractions in the area. But that has waned and now we have to work harder to maintain a market share."

John and Veronica Cattini went to Caldey for the summer with their three-month-old daughter Nancy. Almost forty years later they are still there.

"I didn't understand a small community at all," says John, a Londoner. "When I was first here I would quite happily walk past somebody outside the post office not knowing that everyone knows who you are and if you don't say anything they'd probably think you were stuck-up." As time passed he became attuned to the realities of living in a village atmosphere where everyone knows your business: "I think then you find out the benefits. There's always someone to help you if you need it."

Bringing up their children on Caldey was a privileged experience, they say. In 1975 the Cattinis had their second daughter, Johanna, and fully expected that they would have to return to the mainland when their children started school. Luckily other island families such as farmer Gwyn 'Blackie' Bolton and his wife Suzanne, and the present chocolate maker Frank Miller, had young children, so the islanders established an infants and primary school, which remained open until the late 1990s.

Below: Post bag for Caldey Island.

Next page: Brother David in the old perfumery.

By the time the Caldey children were of secondary school age they had to go to school on the mainland, mostly in Tenby. Some boarded during the week or stayed with relatives in the area. "They were quite prepared to go to a school where there was enough to make up a netball team and they enjoyed broadening their horizons," says Veronica.

Clearly many recollections of this time have been etched into their memories. She says "The children still say: 'Do you remember those Monday mornings when we used to listen to the wind and think 'Oh there'll never be a boat' and you'd poke your head around the door and say 'The boat's coming!' and we'd say 'Oh no!'"

The islanders talk with great affection about the time their children were schooled on Caldey. They say it contributed to an extraordinary atmosphere. The children are all adults now. "They all say what a fantastic childhood it was, such a unique way of growing up, an idyllic childhood in many ways", says Veronica.

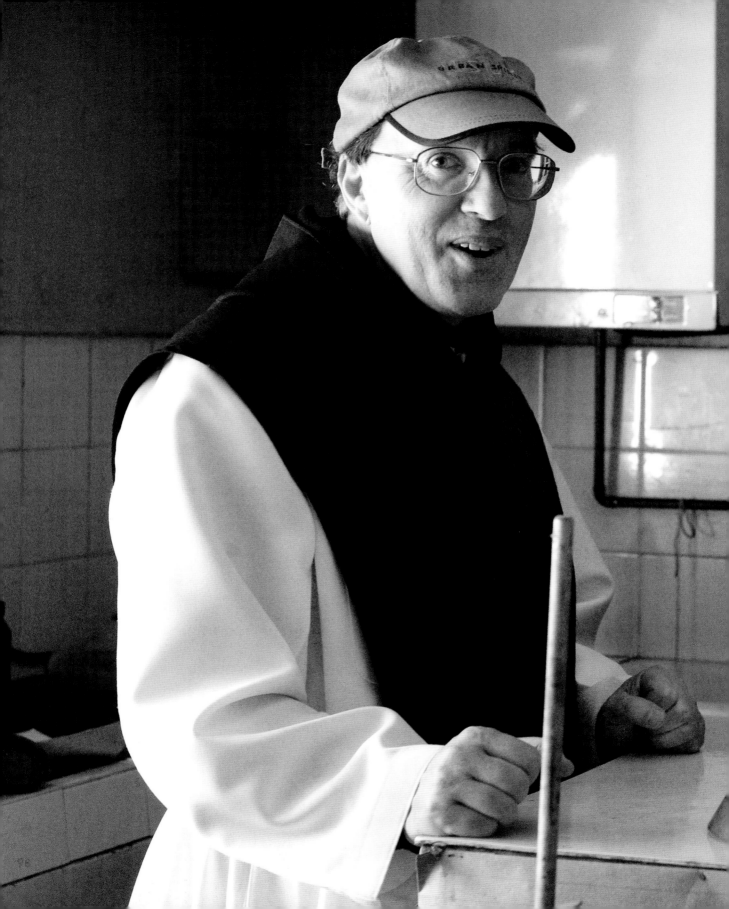

Above left: The old
perfumery.

Above right: Islander
Rita Cunningham.

Right: Bottles storing
ingredients in the old
perfumery.

Perfumery

The island's perfume industry began in the 1950s. When the sale of dried flowers and
herbs had been successful, Brother Thomas suggested they sell lavender water. Its
success led to the abbey asking a Polish pharmacist, Henry Kobus, to leave London and
develop a perfumery for them. He cultivated a foreign species of lavender and lemon
verbena on Caldey and worked out how to extract oil from gorse flowers for use in a
perfume. After Kobus had left the island in 1959 to marry the sister of one of the monks,
the community was advised by the renowned perfumier, Walter Poucher. The Island
Lavender and Island Gorse are fragrances that are still sold today.

The perfumes are no longer wholly made on the island. Formulas are compounded by
an outside perfumery and sent back for mixing with the scent and other ingredients by
the monks.

Rita Cunningham

Rita Cunningham came to the island in 1981 to help run the guesthouse in the summer.
A month later she started working in the perfumery.

Rita, from Liverpool, became a nun when she was sixteen. In 1973, after 28 years in
the Carmelite convent in Cilgerran, Cardiganshire, she left with no qualifications. She
took a computer course, graduated, and eventually worked as a computer operator in
Pontypridd. When the offer of temporary work on Caldey came, she simply couldn't
turn it down.

Left: On the way to one of the island's most popular areas.

Below: The mixing of Caldey milk chocolate. Abbot's Kitchen dark chocolate bars.

Her favourite chapel on Caldey is Saint Illtud's in the Priory, at the centre of the island. Throughout the summer season visitors write prayers, wishes and aspirations on small pieces of paper and leave them in the chapel. They are stuffed in holes in the wall, wedged in door frames, or left on the altar.

At the end of the season Rita clears these up. "I think the Lord must have a quiet laugh each evening reading all those little notes that children have written," she says. "One message said, 'Please God look after my grandfather who is in Heaven. P.S. I hope they've stopped you smoking.' They're absolutely charming the things that they write, absolutely beautiful." Once Rita has collected them all she arranges for a novena of masses to be said "for anybody who has prayed or visited that church this season, it doesn't matter who they are".

Chocolate on Caldey

Caldey, and the Cistercian Order in general, is renowned for its chocolate.

The first mention of chocolate in Europe came in 1520 in a letter sent from Mexico by the Spanish explorer Hernán Cortés in which he described the cocoa bean as "a fruit like an almond, which they treat as money throughout the land".

Above: Abbot's Kitchen milk chocolate bars.

It is claimed that a monk who travelled with Cortés, Brother Jerónimo de Aguilar, sent cocoa beans and a recipe for making chocolate to Antonio de Alvaro, the abbot of the Cistercian Monasterio de Piedra in Spain. The monks at Piedra were the first people in Europe to taste chocolate and they established the 500-year-old custom for chocolate making by Cistercian houses.

The chocolate business on Caldey started in the 1980s. The business is now franchised to Frank Miller, who uses the facility near the Old Priory for production.

Kathy and Michael Scullion

Some of the islanders have general roles. Throughout the year a great deal of grass and hedge cutting, painting and simple carpentry needs to be done.

Kathy and Michael Scullion came to Caldey in 1992. Michael, a farmer's son from Northern Ireland, studied English at University College Dublin and gained a scholarship to study journalism in Denver, Colorado. He got a job working for a Catholic newspaper and during a reporting assignment in British Columbia, Canada, he met Kathleen Lennon, a Dubliner teaching at a high school in Prince George. After a long distance relationship in 1969 they married and settled in Oxford.

Below: Estate manager Ben Childs arrives on the Post Boat met by island farmer Gwyn 'Blackie' Bolton.

Their local parish priest was Father Anthony Ffrench-Mullen, a former brother on Caldey, who was visited by Caldey's longest serving brother, Father Stephen, in 1974. Michael and Father Stephen became firm friends and the attachment to Caldey began. After many years visiting the island Kathy and Michael were offered the opportunity to live in a cottage in return for their labour – thus hastening their retirement.

Michael's childhood prepared him well for Caldey life: "If you're a farmer's son you know one end of a spade from another." After nearly two decades they have seen the island go through a cycle of change. "The thing you do miss is the children," says Michael. "When you don't have the children the balance is wrong." That said they are both captivated by the island: "I love the ethos of the place," Michael adds, "the camaraderie of the monks, the spiritual side and the tranquillity. If I had to go somewhere else, it'd break my heart, but I'd have accept it. When you have to go, you have to go."

Among the items on sale in the island shops is a range of poetry books written by Brother David. He started writing poetry at university after being introduced to the work of TS Eliot. Brother David recalled the experience as 'mind-blowing'. His law career reduced his passion for the art, but his creative streak returned when he became a monk. In 1999 he published his first book of poetry Songs from Solitude.

On the Night Tide

As we cut across
rays of dancing light
drumming machine
above the water sound,
soon the harbour lights
become a distant ring
beyond the black
and seaspray.
Thoughts drift
between
regret and expectation,
seeking a glimpse
of the far shore,
but soon
the sea fills
all my thoughts.

David Hodges

From *On the Night Tide* published 2001.
Reproduced with kind permission from
Brother David Hodges

Father Daniel's predecessor as abbot on
Caldey was Brother Robert, the island's
bursar. Only Brother Stephen has been living
in the community longer. Brother Robert was
brought up in New Cross, South London. He
first visited Caldey in 1948 when he was staying
with relatives in Pembroke Dock. He joined a
seminary in London at 16 to become a priest
but, just before he had completed his studies,
he wavered in his vocation. He explains: "I got
a strong impression that God wanted me to be
a monk on Caldey and I was told, 'Oh it's the
temptation of the devil, be ordained, do three
years' work and by the time you've done that,
you'll have forgotten all this nonsense of being a
monk!'" So he carried on with his ordination as
a priest. His desire for the monastic life never
left him and aged 27 he took his vows on Caldey.

Top left: Islanders John and Veronica Cattini.

Bottom left: Perfume products on display in the Caldey Island shop.

Brother Robert affectionately remembers some of the monks from Notre-Dame de Scourmont who could barely speak English. "The first group was very strict," he recalls. "They didn't seem to have too many hang ups about anything – they got on with whatever had to be done. They definitely had this attitude, 'We are monks of Caldey – we want Caldey to carry on. If that means I've got to go up a ladder and nail some tiles back, I'll go up a ladder and nail some tiles back.'"

In his 50 years on Caldey, Brother Robert has done most jobs, so has an in-depth understanding of what it takes for the island and the community to run well. In the 1960s he set up the island's dairy, making yogurt, butter and milk from a herd of Jersey cows which invariably produced more than the island could consume. "I think I had four tons of butter in the freezers at one point and I remember on one occasion saying to the cowman, 'I don't think we need much milk now'. He replied, 'Well you tell the cows!'"

Changes in farming regulations have made it uneconomical to run what was a once profitable farm. Gradually the herd changed from dairy cows to beef-producing Welsh Blacks and Aberdeen Anguses. The herd is now around one hundred strong. The key factor in sustaining a profitable farm on the island now is a Tir Gofal grant from the Welsh Assembly Government, which rewards them for reserving some land for wildlife, and contributes towards the cost of employing the farmer, Gwyn 'Blackie' Bolton.

"I felt that some people didn't have a governor," says Brother Robert, referring to the mechanism which regulates the speed of a machine to prevent it overworking itself. The constant need to generate money in a specific period was a major issue: "I felt that one of our problems as a community here was everything was put into earning our living in the six months we've got, then it all comes to a stop. That was the time that I knew that we were working too fast. So I used to deliberately screw down the governor – and decided we'll do something like have a fortnight where we got up half an hour late."

Any financial surplus Caldey has made has always been given to other charitable causes. During Brother Robert's time as abbot the island had become extremely profitable, which brought more pressures. "At one point we were worried it was getting too big and of course we are a registered charity," he explains. "The charity commissioner sent a letter which basically said: 'What's all this money? If you don't know what to do with it, we'll give it away.' It only took about three or four years and we were getting a bit short. But it's not easy to downsize a business and remain viable."

From the Cistercian Order's earliest days each house has enjoyed the guarantee of support from the abbey that founded it. This mother and daughter relationship is central to the Order's continuing strength. Caldey's Belgian mother house helps out with major expenses such as a new crane or essential repairs and also offers advice on other ways to generate income.

Top left: The Caldey herd grazing on the south western part of the island.

Top right: Arable farming on the island in the 1950s.

Left: Island farmer Gwyn 'Blackie' Bolton.

Like their medieval predecessors, modern Cistercians are very adept at spotting new opportunities to earn a living. Abbot Dom Armand has much experience of working with other communities all over the world: "I think there are now means of communication through the internet that can make earning a living less dependent on people coming to the island. I've been doing this with African monasteries where it is much more difficult to make a living because of the country's poverty. Nobody has the money to buy your products, and if you sell them in the local market you deprive other people."

For Caldey's brothers, diversifying with instant success is easier said than done. There is still the commitment to prayer and Father Daniel has to manage carefully the introduction of any new ideas: "When you have a small community, fifteen brothers, it's not easy to adapt quickly. We're very pleased with how the web shop goes, for example, but you need to balance your life. Otherwise you might as well be on the mainland and run a company there rather than being here."

Father Daniel is aware of the challenges he faces as Caldey's abbot. It's a role that has many pressures. "You need to keep your eyes open all the time," he says. "You need to be realistic. You need a source of income so that the island can be run well, but also you need to look after the spiritual needs of the island and my own spiritual needs as well. If I can't look after my own needs how can I look after my brothers?"

Dom Robert O'Brien
abbot emeritus

When Brother Robert first lived in Caldey Abbey the brothers were required to keep the silence expected of a Trappist Order. When you ask him what the Belgian monks told him about themselves or the community, he looks back at you with puzzlement: "They didn't talk! In those days we did not talk. We had a lecture every day as novices – so you got very used to listening. As you didn't do any talking the only words in your life were what other people said. I have memories of some of the fathers doing something but not actually speaking. And there is the famous story of a book flying out of the kitchen window and the cook shouting 'Madame Beeton!'"

When Abbot James Wicksteed left the Cistercians in 1980 Brother Robert was appointed superior. He inherited a difficult task, "a holding process," as he describes it. But the community held together and eventually he was elected abbot, which allowed him to make changes. He decided to employ more people to help the community so that the monks could concentrate on monastic life. He was faced with many challenges: the community lost eight of their elder members in six years. During its lowest point the community numbered nine brothers, which led them to seek members from other Cistercian abbeys.

After five decades Brother Robert is still focused on the community and on its spiritual and financial health. He has seen the island at its highest and lowest points, but what of these days? "I think we're still on track. I think we've got something as valuable as we had then, in fact possibly more valuable."

Just a few months after this interview Brother Robert passed away following a short illness. Two boats took friends and family to the island to attend his requiem mass. He is buried in Saint David's Churchyard. One of the sisters at Whitland recounted a conversation she had with Brother Gildas not long after the funeral. She asked how they were all keeping. He said they were getting back to normal but he missed Robert more than he could have ever guessed. "He used to drop into the kitchen in the morning and ask us what was for dinner, or tell some joke he had heard, and his death has left a real gap in the community."

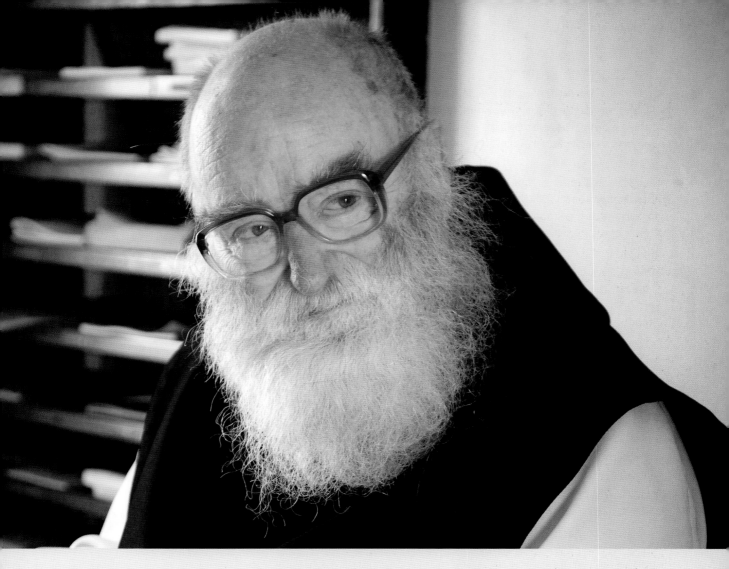

Date of birth: 27th April 1933 –
8th July 2009.

When did you become a novice?
11th August 1960.

When did you take full vows?
Took vows on Caldey in 1963.

Why did you become a monk?
To seal my commitment.

Why Caldey? I felt called to God to
seek him as fully as possible.

What does Caldey mean to you?
It's my home, my community, my
meeting place with God.

**What is your favourite part of the
island?** The woods.

**What is your favourite canonical
hour?** Vigils.

What are your interests?
Computers, reading, crosswords.

What are your jobs on the island?
Bursar, some maintenance,
jam making.

**What do you miss from the
outside world?** Travel.

Brother Teilo

The son of a dentist, Brother Teilo Rees won a scholarship to Harrow school and then studied modern languages at Cambridge, where at twenty he converted to Catholicism.

He then taught French at a school run by Carmelite fathers near Llandeilo in Carmarthenshire. During this time he took a group of pupils to Caldey for a weekend, and met a Belgian monk, Brother Francis (Jean Mahieu), who made a lasting impression on him. On All Souls' Day 1957, before dawn, they shared a private mass in the Old Priory church. The experience was hugely memorable and atmospheric: "Just the Latin, and the silence, and the memories of all the saints from the past. It was very, very impressive. It wasn't he who changed my life but he sowed the seed. It was one of the most moving things I've ever experienced in my life I think."

Teilo's early mentor, Brother Francis, left Caldey to found a monastery in India, Kurisumala Ashram – Mountain of the Cross Monastery – high in the Kerala hills of southern India. Forty years later the abbey was so successful that it was accepted into the Cistercian Order with Brother Francis as abbot. When he died in 2002, aged 90 several thousand people attended his funeral.

In London Teilo worked for an export company. Although still spiritual, a monastic life was always a step too far: "It was always at the back of my mind, but there were big obstacles. I didn't want to give up the world, you enjoy London life. You don't fancy knuckling down to the discipline in a monastery. You admire the ideal, but to be actually tied down to a rule is something you rebel against unless you're very good or pious. But in the end I realised I had the call."

When he retired Teilo returned to Wales. After his mother's passing his ambition to become a monk became far more realistic, although he was now 68. "I asked Abbot Father Daniel, who was 25 years younger than me, if there was any chance of trying my vocation here. He said he wouldn't give a categorical no. So I did try."

Being a brother on Caldey, more than fifty years after his first visit, affects Brother Teilo in a profound way: "Caldey is my vocation, the place that I was made for, I suppose, the place I always wanted to come to, but I didn't realise it at first. Always the ideal on the horizon, but it's like a dream that I'm actually here."

Place and date of birth: London, 1931 but raised in Carmarthen.

When did you become a novice? Saint David's Day, 2000.

When did you take full vows? Took vows on Caldey in 2002, final vows were taken in public in the church.

When did you first come to Caldey? Since 1954 I have often stayed in the monastery.

Why did you become a monk? To offer the rest of my life to God and to pray.

Why Caldey? Caldey has the only Cistercian house in my native land and in my better moments I have felt drawn to this contemplative order ever since my last year at school.

What is your favourite part of the island? The woodland part of the monastic enclosure, especially the path along its southern edge from which, weather permitting, the blue water of Carmarthen Bay can be seen through the trees.

What is your favourite canonical hour? Vigils, the night office. It has the best psalms, a substantial Bible reading and usually a rich reading from the Wisdom of the Fathers of the Church and of the Order.

What are your interests? Welsh history and literature, the life and poetry of Lord Byron, translation.

What are your jobs on the island? Archivist, arranger of talks from outside speakers, packer of the shortbread we bake and sell, cloister bell-ringer, daily rainfall observer for the Met Office.

What do you miss from the outside world? Foreign travel.

6 An island of supernature

Caldey Island enjoys an exceptionally diverse landscape.

Just 550 acres (2 sq km) in size, with its highest point at 200ft (60m) above sea level, the island's diverse landscape provides a habitat for a broad range of wildlife. Caldey has a rugged, rocky seascape, dune systems, woodlands and fields that support a huge variety of species – almost a hundred different types of bird, numerous flowering plants, fish and molluscs.

The geology is uncomplicated. One half of the island is Carboniferous Limestone, the other Old Red Sandstone. Positioned in the Bristol Channel, the weather systems can pass quickly; on a hot summer's day Caldey can seem like a Mediterranean island, whereas the winter can bring sustained, wild storms.

If you visit Caldey, you may meet a middle-aged man of wiry physique, with a shock of hair and the weather-beaten complexion of someone who has spent his life outdoors. This is Simon Curnin. During the tourist season he will clear rubbish, cut back hedgerows, deliver goods. One of the island's grafters, the majority of his working life was spent in the oil and gas exploration industry, which often meant living and working in inhospitable and wild locations.

Most mornings Simon will be on the jetty waiting to help out with any goods coming in or going out on the cargo boat. More often than not it will be Caldey Island products sold online, and groceries from suppliers in Tenby. Some days it will be materials from a builders' merchant, or the occasional cow craned onto the boat in a trailer.

If you sit on the slipway and watch the approaching boat early in the morning it is easy to take in the atmosphere of Caldey. The variations in weather can be extreme from one day to the next. One morning the sea is a flat, glistening, shining plain, the next day there is a howling storm with seaspray and rain swirling all around you. Whatever the weather Simon's demeanour barely changes; he is wholly absorbed by this landscape. "It's all here," he says. "There are gannets, falcons, peregrines, all the finches are here and songbirds, robins, goldcrests, long tails, tits; you get your bird book out and you can identify an awful lot. You've got supernature, the peace, the sea obviously and, as Brother Dominic used to say, you've got Jesus Christ too!"

Those who love Caldey are effusive about its nature and its environment. Simon has a special devotion for the beaches and the solitude. His favourite is the west-facing Sandtop: "It's just a beautiful beach, desert island atmosphere, lovely cliffs, driftwood washes up. I have a barbecue in the summer. I've got my grill over there, so I have meat obviously, maybe some wine. I go swimming, fishing, snorkelling. I'll be there all day sometimes. On a warm night I'll camp there. Sleeping bag, pillow, fire – it's ideal. You can't do that in a city!"

Left: The woodland within the monastic enclosure.

Next page: Priory Bay.

Left: Duckling near the village green pond.

Below: Oystercatchers and gulls on Priory Bay.

Shellfish and oystercatchers

Caldey's seashore has extensive and varied habitats for molluscs, including sea snails, slugs, mussels, cockles, clams, and razorshells, barnacles and periwinkles.

The scarce lagoon snail (Paludinella Littorina) is primarily a Mediterranean species, but is found on western European coasts from the island of Madeira to the south of England. It survives in rock fissures and areas of shingle, and it is very difficult to survey. A small, pale grey, globe-shaped snail, it grows up to two millimetres high. Its shell is shiny and semi-transparent, its tentacles are short and stubby and its eyes appear as two black dots. The lagoon snail presently thrives in the limestone area of Caldey, where the island was once quarried. Caldey is one of the few known sites in Britain where it exists, with other findings recorded on the Isle of Wight, Dorset, Devon, Cornwall and the Isles of Scilly.

Oystercatchers

Watching, waiting...
grouping, black and white,
and rising
into the clear, clear air,
to form a line,
an arcing, whirring line,
to skim the surface of the sea,
the sea like glass again.
They hold my gaze,
smaller, smaller,
pulsing, throbbing there.
Willing them further, further...
Deeper, deeper into prayer...

David Hodges

From *Delayed by Rough Seas* published 2003.
Reproduced with kind permission from Brother David Hodges

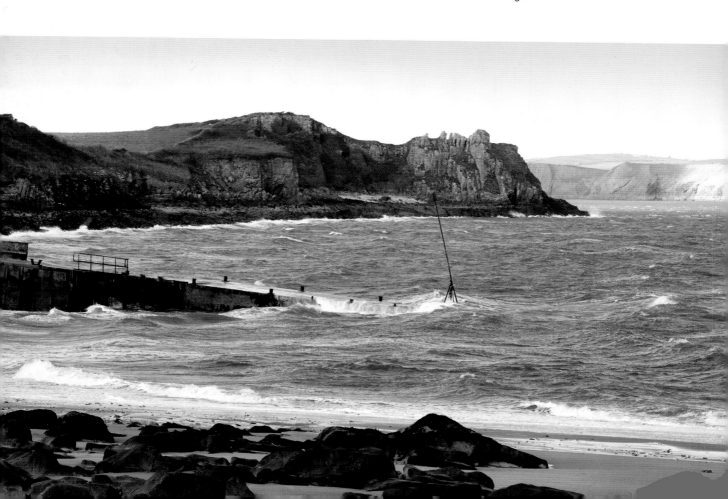

Below: Reef between Saint Margaret's Island and Caldey Island.

As the tide sweeps in across Priory Bay, the island's oystercatchers probe the flat sands for molluscs, limpets, mussels and cockles with their powerful, slightly rounded bills. Individual birds have differing feeding techniques which are indicated by the condition of their beak: short and blunt on those that hammer open molluscs; long and pointed on those that prise them open.

The oystercatcher is very a sociable bird, living among large, noisy flocks. Black-and-white-feathered, in flight its wings show a wide white stripe; its bill is a bright orange or blood red; its eyes are yellow with an orange orbital ring and its legs a shade of pink. According to Gaelic tradition an oystercatcher "covered Jesus with seaweed when his enemies appeared in hot pursuit. The bird was therefore blessed, and still shows, as it flies, the form of a cross on its plumage".

Mostly monogamous, the oystercatcher makes its nest in a small divot in the shingle or short vegetation close to the sea. Both parents will brood the nest. Confronted with numerous predators, they are vociferous in defending their young and will "buzz" intruders.

The oystercatcher lays its eggs in late March and they hatch around 25 days later. The first chick is fed quickly and, as the chicks grow, a hierarchy of size develops with the largest fledgling given first refusal on food foraged by the parents. The downy young are able to leave the nest in a day or two and will fledge in five weeks. Young birds, though, will rely on their parents to provide food for months before successfully

mimicking their techniques and choices of prey. They will mostly live on worms and invertebrates until they feed solely on hard-shelled molluscs.

The name 'oystercatcher' is something of a misnomer as they rarely eat oysters. In Britain and Ireland the bird has had many different names such as sea-pie, mussel cracker, sea-pilot and the sixteenth-century English name of olive.

It has been estimated that in winter one bird will eat its own weight in shellfish every day. This has brought the oystercatcher into conflict with commercial shellfish farmers in the past. If the beds are over-fished the cockle population can be vulnerable. In the early 1970s public debate surrounded the effect the birds were having on the livelihood of fishermen who farmed cockles and mussels in western areas, particularly in Wales. In 1974 the Ministry of Agriculture and Fisheries allowed more than 7,000 oystercatchers to be culled on the west coast. That said, over the past half century there has been a general increase in the bird's population. Present numbers are estimated to be between 98,000 to 127,000 breeding pairs.

The oystercatcher is linked to an inspirational Irish abbess, Saint Brigid, whose career was at its height in the early sixth century, around the time that Caldey was first used as a monastic island. In Connaught in Ireland the oystercatcher was known as the Giolla Bride meaning Brigid's Servant. When the great winter flocks were seen to be

thinning it was regarded as an indication that her feast day was nigh. To this day Saint Brigid is often depicted with the oystercatcher as a symbolic servant.

Caldey has a varied population of seabirds, woodland birds, songbirds and finches. A 1916 report listed 79 different species; a survey in 1956 mentioned 90. The feeding grounds along Caldey's coast, the micro habitats in the rock pools, the disused quarry and sand dunes are all scenes of constant bird activity throughout the day.

In the late 1990s the breeding seabirds on Caldey, including a colony of herring gulls, groups of lesser black-backed gulls, and some great black-backed gulls, were extensively surveyed. Other prominent species on the island were fulmars, razorbills, cormorants, guillemots and shags. The island's cliff-top grazing provides perfect feeding conditions for chough and, away from the rats on Caldey, puffins are able to breed in small numbers on nearby Saint Margaret's Island. In the nineteenth century passing seamen talked of the puffins on Caldey as 'Welsh parrots'.

At Bullum's Bay and West Beacon Fields, shelducks breed and live near the islanders and tourists. Caldey's farmer Gwyn "Blackie" Bolton once saw a mother duck lead its ducklings a mile and a half from the lighthouse down to Priory Bay.

Peregrines, ravens and stonechats also breed on the Caldey coastline, and linnets and whitethroats are also often seen. Its fields are home to skylarks and meadow pipits, while migrant buntings are attracted to the windswept cliff-top fields on the western side of the island. Other reports of rare birds include the Alpine swift, red-backed shrike, rosefinch, the yellow-browed warbler, wryneck, hoopoe and Sabine's Gull.

Marram grass and dunes

The sand dunes above the tide line at Priory Bay built up through the late nineteenth century. Until the eighteenth century the sea around Caldey splashed on the rocks below the abbey, some 400 yards (365m) from where the highest tides now reach. The tide reached the present village green near the cottages, but in the late 1800s the tidal inlet was filled by blown sand.

The dunes were formed with the help of plants such as marram grass, lime grass, sea holly, sea spurge and sand couch.

Marram grass is an extremely efficient, cleverly adapted seashore plant. Its root system helps to fix the sand down, stabilising shifting dunes which can expand as much as 30 feet (9m) a year. Its leaves are flexible enough to stand up to the most violent gales and its blades are covered by shiny cuticles that protect against abrasion from blown sand.

The presence of marram grass here is a clue to the geology on this side of the island. Marram grass will not grow in sand with high levels of sea-salt. Unlike dunes on the east coast of Britain, Welsh dunes generally contain a great deal of broken shell material. Marram grass proliferates in a calcareous, lime-rich environment and the dunes on Caldey have built up between the carboniferous limestone promontories on the north side. Mysteriously, once marram has completely covered a dune it begins to die out.

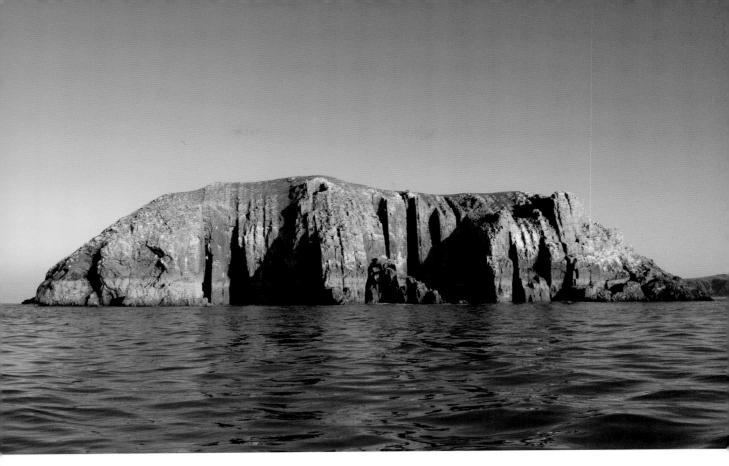

A carpet of flowers

Some of the flower displays on Caldey are considered outstanding. Bluebells carpet the monastic woods, and the sea holly on the dunes at Sandtop and Priory Bay is thought to be the best in Pembrokeshire. A survey in the late 1980s listed 304 flowering species.

Caldey has a number of scarce plants, such as tree mallow, rock sea lavender, curled pondweed and greater spearwort. Nationally scarce plants include Portland spurge, golden samphire, the parasitic ivy leaved broomrape and dotted sedge.

The lesser meadow-rue, a rare native perennial of cliffs, rocky outcrops and grassland can also be found.

Caldey's fields are also special. The combination of low intensity grazing throughout the year, and fields given up to wildlife under the Welsh Assembly's agricultural grant scheme, Tir Gofal, allows sward to grow naturally. This has created flower-rich meadows producing a wonderful range of springtime flowers, including the bee orchid and the green-winged orchid.

The island is blessed with that very British feature of the landscape – hedgerows. Documentary sources indicate that many hedges in Britain are more than a thousand years old, and archaeological evidence exists that dates some hedgerows to the Bronze Age.

Right: Caldey Island's north coast. Priory Bay, the village and the woodland enclosure are situated on the uppermost promontory.

Below: Daylight Rock, Small Ord Point

Gorse

An important part of hedge banks across western Britain, gorse is a signature plant of wild open space and common ground, and buds into flower all over the island at springtime. Characteristic of Atlantic coastal heath, gorse hedges can thrive on poor growing ground and will survive drought. The dense thorny cover of Caldey's gorse is perfect for protecting nesting birds.

Its power to evoke is celebrated in an old British saying, "When gorse is in blossom, kissing's in season." A sensual plant whose flowering marks the warming weather, its flowers give off an aroma of coconut and vanilla. In the island shop you can buy Caldey's Island Gorse, the fragrance developed in the 1950s by the pharmacist Henry Kobus.

Abundant and fast-growing, gorse has a multitude of uses. In the past it has been used as fuel for ovens and feed for livestock. In Wales there were gorse mills and fields were devoted to growing gorse as a crop. It has been used to make chimney brushes and as a cover to protect growing peas from mice and birds. Its flowers can be used in salads, to make a gorse tea and wine, and its vibrant warm, yellow hue has been attributed as the source of colour for Easter eggs.

> Yonder came smells of the gorse, so nutty,
> Gold-like and warm: it's the prime of May.
> Better than mortar, brick and putty,
> Is God's house on a blowing day.
>
> From *Juggling Jerry* by George Meredith

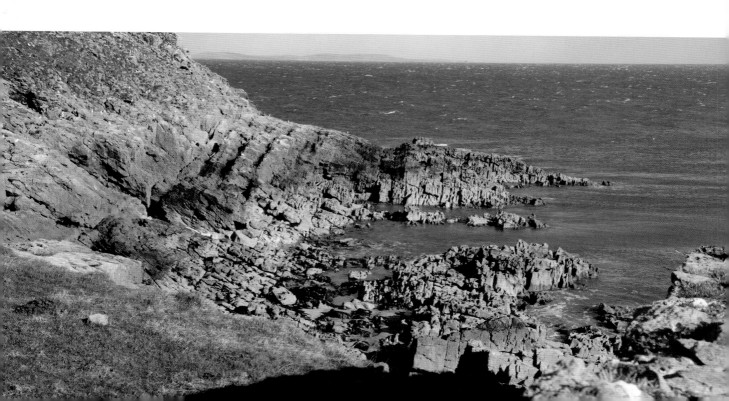

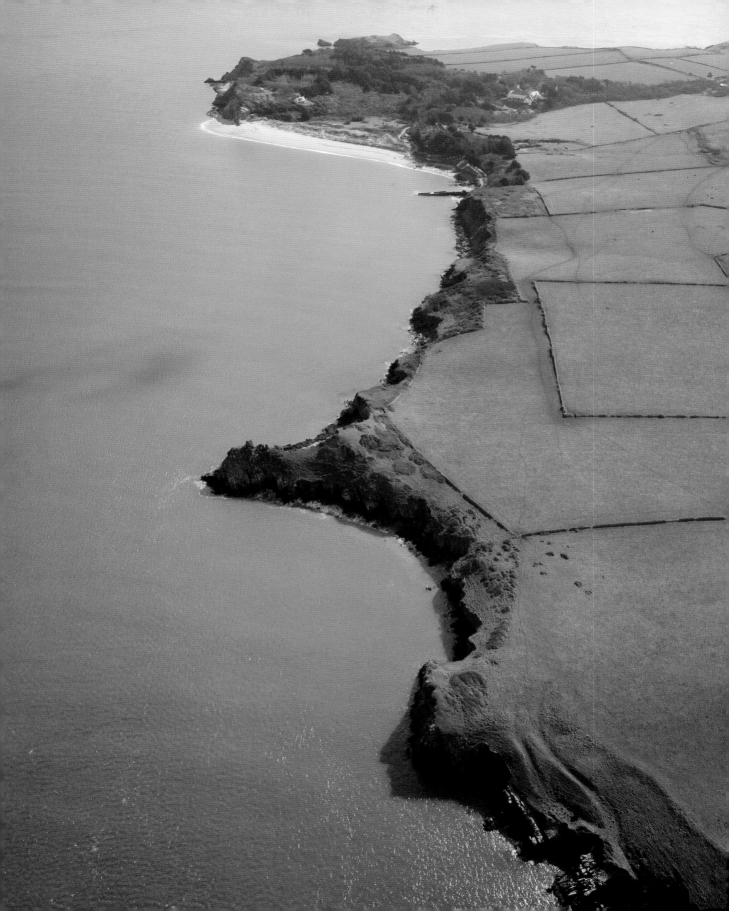

Previous page:
Sandstone coast of
the southern section
of the island.

Right: Bullum's Bay.

Rabbits and bats

Like other coastal islands, Caldey has few mammals. Those there are were mostly introduced by man, intentionally or not. The accidental introduction to the island of the brown rat, which feeds on its nesting birds, is attributed to centuries of human activity and farming.

Surprisingly there are no other rodents on the island. Surveys indicate that there were and still are no foxes, mice, voles or shrews present.

In the early nineteenth century the Anglo-Irish natural history author and illustrator Edward Donovan wrote that Caldey Island was in a "meagre state of cultivation" and "thinly inhabited", but its rabbit population was so great that the sale of skins paid for half the rental of the island.

Mostly confined to the coastal edges, the rabbits were easily caught by opening gaps in the walls that surrounded the crop fields. Rabbits would attempt to pass through these holes and be caught in the waiting sack. Up to the mid-1950s rabbits were still present in large numbers, but declined greatly due to myxomatosis; the remaining population was later eradicated using poisons. The lack of grazing on shrubland has allowed more aggressive plants and grasses to overpower less invasive types.

Caldey's only other resident land mammal is the hedgehog, which was introduced in the late 1980s and has since thrived. Most evenings they are seen on Caldey's village green, and as hearty consumers of slugs their presence is welcomed by the island's gardeners.

Bats were first discovered on Caldey in March 1975, hibernating in the cold and stable environment of the island's caves. Apart from their normal hibernating period of October to March, they have been seen as late as May and July. In the late 1970s there were thought to be 40 greater horseshoe bats. An increasingly threatened British species, greater horseshoe bats usually feed in the air by catching insects in flight. Another Caldey inhabitant, the lesser horseshoe bat, will pick its prey off shrubs and trees. The only other bat recorded on the island is the brown long-eared bat, the second most common in Britain, which feeds on moths and large insects.

Seals

British islands have some of the most extensive and varied coastal cave systems on the European Atlantic coast. The caves cut into the sandstone stretch of Caldey's shoreline are used by grey seals every year for pupping. The grey seal is one of two seal types throughout the world that uses the intertidal zone inside sea caves.

Seals are predators at the top of the marine food chain; they mainly live on fish, supplemented by shellfish, squid and octopus and on very rare occasions will eat seabirds.

About 40 per cent of the world's seal population is found around the British Isles. Wales has about 6,000 seals that are thought to produce 1,300 pups every year. On Caldey, numbers and populations have varied; in the late 1990s as many as 80 seals were present at one time. Though it has been difficult to ascertain just how many seals are born on Caldey, it is generally agreed to average around two seal pups every year.

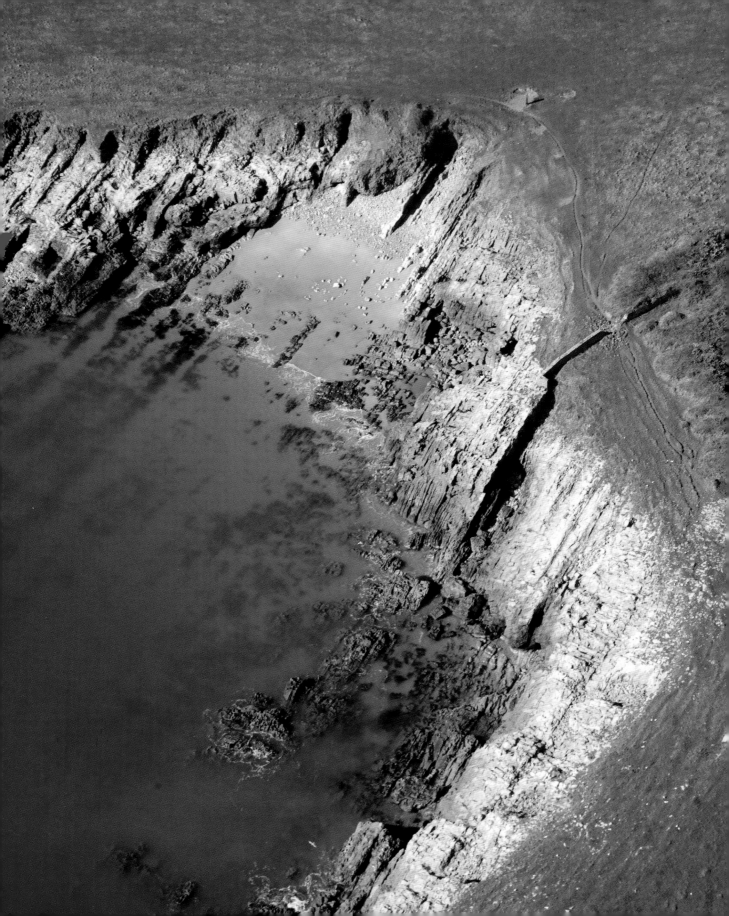

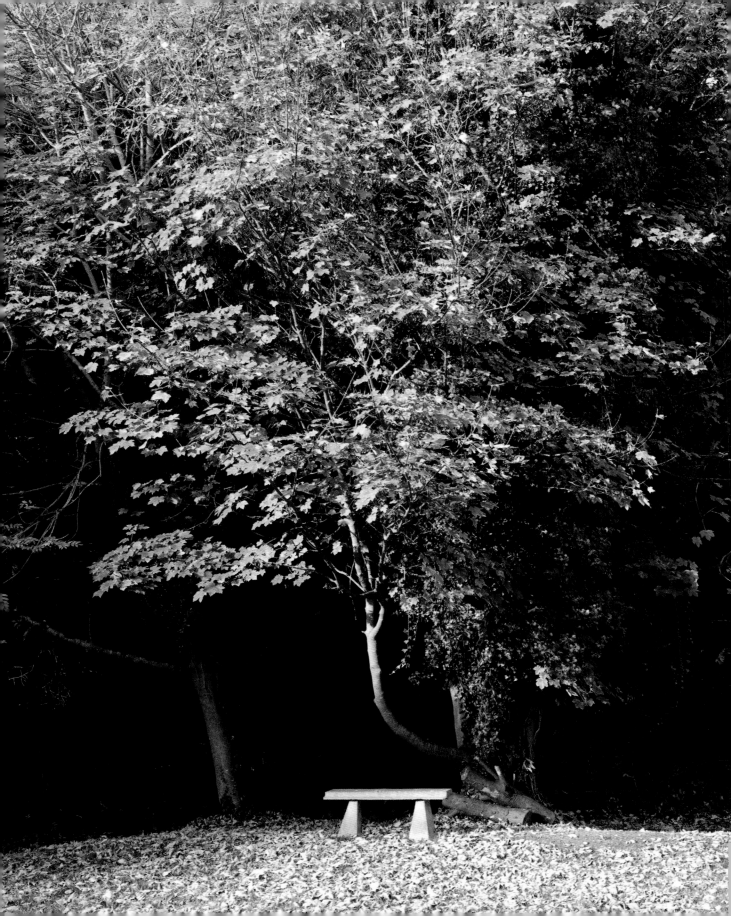

An island forest

Just five per cent of Britain is covered in trees, making it the least wooded country in Europe. On Caldey the woodland contributes hugely to the wildlife and the atmosphere, providing shelter for the village and abbey; a once-windswept area is now well protected from the harshest of conditions. The forest of the monastic enclosure is unusual on an island in western Britain. None of the other islands off the Welsh coastline, such as Skomer, Skokholm, Ramsey or Bardsey, has forestation on the same scale as Caldey.

The forest consists of a varied range of trees – oak, holly, hazel, rowan, hawthorn, cedar, cypress and birch. Generations of monks have coppiced sycamore, ash and willow to provide fuel for the abbey before the installation of the electrical heating system in 2004. Sycamore, introduced into Britain from central Europe in the fifteenth century, is an especially good tree for coppicing with a sustainable cycle of eight years. In Wales, sycamore became the preferred material for the famous Welsh token of betrothal, the love spoon.

In the monastic woods each April there is a wonderful show of bluebells; the flower that is thought to capture the very spirit of springtime generates an intensely coloured carpet in the darkest of forests. It is a famously popular flower and possesses a colour that in nature is very rare.

The island provides a safe habitat for threatened species such as the song thrush and the bullfinch. The bullfinch can be seen all year round in Britain, but due to the removal of farmland trees and hedgerows has been in serious decline; the population has reduced by more than 60 per cent in the past three decades. It is a quiet and secretive bird and spends most of its time among branches and dense undergrowth.

From the Celtic monks of the Dark Ages to the present-day Cistercians, Caldey has attracted people who have a deep desire to live away from the mainland. Blessed with one of the most exceptional landscapes in Britain, Caldey also possesses an ever-changing and varied natural history. The seascape, woodlands and fields and fast-moving sky provides the perfect atmosphere for contemplative monks to reflect peacefully on their faith, and think about their fellow man in a way that would not be possible living amid wider society.

Caldey Island, a small monastic island of great antiquity that sits off the Pembrokeshire coast is an island of peace, supernature – and Jesus Christ too.

Brother Titus

In the 1960s Brother Titus worked as a press photographer in the world of motor sport and also drove in Formula Ford. "In those days it was more friendly, it was not very commercial, the sport was about the danger, the speed," he says.

Among the drivers there was a strong bond of friendship and camaraderie, but the life was extremely dangerous. Titus was a good friend of the great British driver, Jim Clark: "I stayed several times at his house in Berwickshire but he crashed fatally in April 1968. Every year we lost two or three of our comrades."

The continual accidents slowly became too much for Titus and for another of his racing friends, Jochen Rindt. The German-Austrian Rindt was an audacious driver who was adored by fans and the photographers.

In 1970 Rindt joined the reigning World Champion team, Lotus. Approaching the season's penultimate race Rindt was in the running for the world title. On a practice lap his Lotus veered off a corner at high speed and he was killed. In the event Rindt became the only driver to have won the Formula One World Championship posthumously – his widow Nina received the winner's trophy. He had promised her he would retire as soon as he had won the F1 title.

For Brother Titus this was one death too many and his despair was profound: "It culminated, it happened so often around you. I had some accidents myself on the Nürburgring in Germany and one in Zandvoort. You think about things. I was very lucky, I could have been crippled or dead, perhaps, and so you think about your life."

After Rindt's fatal accident he went to a monastery in Belgium for some solitude and "to think about my life and my future. When I was there I thought this could be a new life for me. I liked it – the silence, the poverty, the choir song and to live in a community, so I stayed and I still stay!"

It is difficult to understand how Titus was ever able to make the change from Formula One to a monastery. He sees many similarities, though: "In motor racing, in sport, you have to be disciplined and you have to be committed to your own goal, and in monastic life you have to be disciplined to commit your life to God."

He no longer watches television or listens to the radio and does not use the internet. He reads a great deal, and when he is not digesting spiritual texts he reads history books and biographies.

"I read in the newspaper what's going on with television in Britain, I'm glad I don't have television – it's all rubbish! So let me sit in silence and I go outside and have the view of the sea – nothing is better!"

He was born very close to the Hague so he has a life long attachment to the coast. Caldey is perfect for him: "It is so pure, you meet God here very simply, in the nature, in the light. I like it very much here – the simplicity of life."

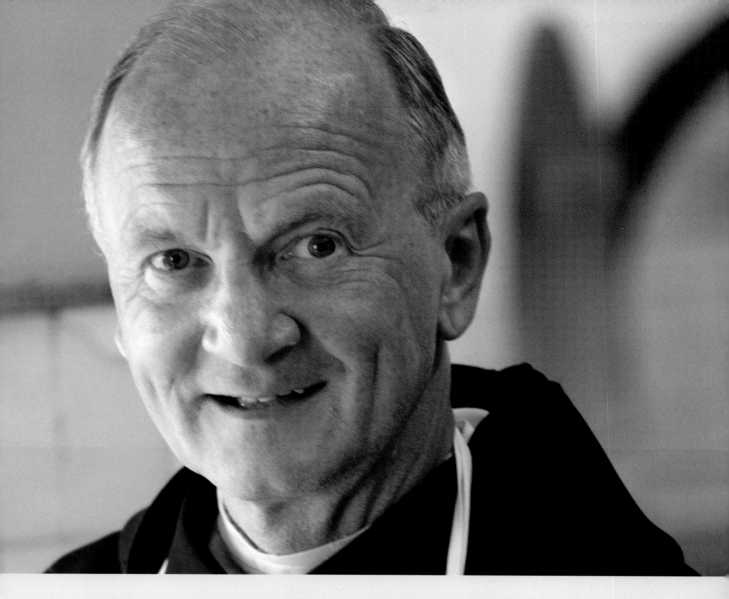

Place and date of birth: The Hague, Holland on 11th May 1948.

When did you become a novice? 9th April, 1972.

When did you take full vows? Took vows in Abbey of Achel on 12th April 1974, solemn vows taken on 11th April 1977.

When did you first come to Caldey? September 2004.

Why did you become a monk? Vocation.

What other monasteries have you been part of? Abbey of Pey-Echt, Netherlands 1970 – 1971.

Abbey of Achel, Belgium 1971 – 2003

Abbey of Orval, Belgium 1991 – 1992, Temporary 2004

Abbey of Mont de Cats, France – Temporary 2004

Why Caldey? To continue and deepen my monastic life.

What is your favourite part of the island? Sandtop Bay.

What is your favourite canonical hour? Vigils and Compline.

What are your interests? Reading, writing, photography and art.

What are your jobs on the island? Refectory/Sacristan.

What do you miss from the outside world? Nothing!

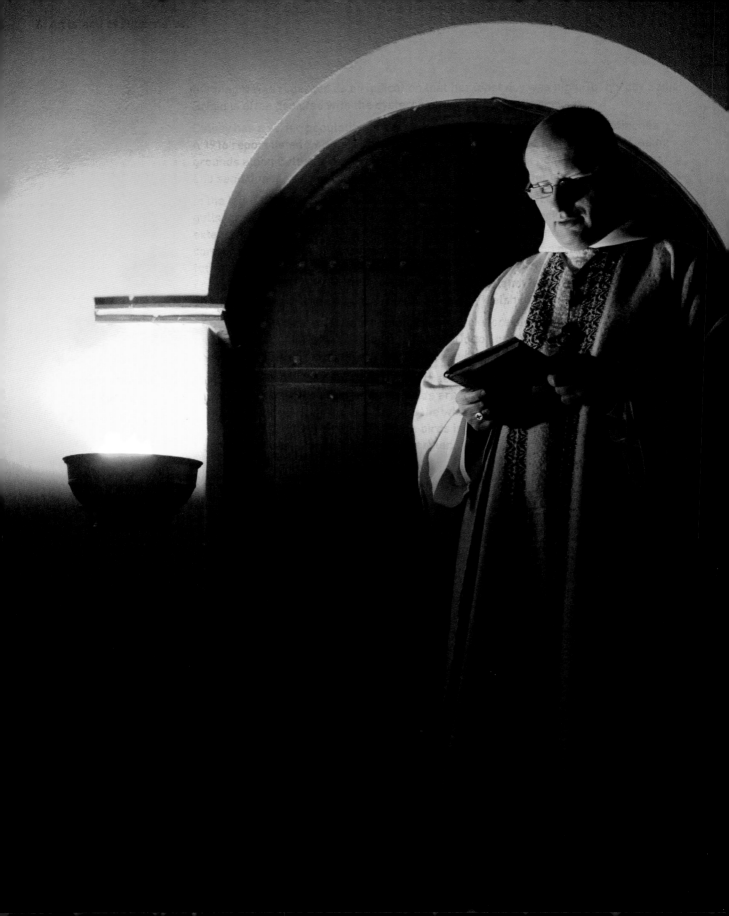

7 Holy Week and Easter on Caldey Island

For all Christians Holy Week is the most important time of the year. It is the last week of Lent – a 40-day period of soul-searching and repentance that takes its inspiration from Jesus's withdrawal into the desert.

Holy Week is the re-enactment of the culmination of the life of Jesus Christ – the week follows his last days and goes to the root of Christian belief.

Palm Sunday – Jesus returns to Jerusalem.

Maundy Thursday – The Last Supper is celebrated and the institution of Communion within the Christian faith is born. We also witness the betrayal of Jesus by Judas.

Good Friday – The arrest of Jesus Christ, his trial, crucifixion, death, and burial.

Holy Saturday – The Sabbath on which Jesus rested in the grave.

Easter Sunday – The Resurrection of Jesus Christ.

It is dusk in springtime and the church lights are still on; by now the monks would normally have gone to bed but tonight, Maundy Thursday, they sit in the church as the Abbot moves silently from one to the other washing their feet, as Christ did for his Disciples at the Last Supper.

The next few days are the most important of the year for Caldey's monks. Spiritually and emotionally, Holy Week is central to their vocation; it is the time when the foundation of their religious belief is contemplated. It is also a time when Caldey Island acquires a mystical atmosphere. To witness masses and services practised by people so quietly devoted to their faith is a privileged experience.

Preparations began far in advance for this weekend of services; now everything is about fine-tuning. On the morning of Good Friday the monks are in the church rehearsing the afternoon's service that will mark the crucifixion and death of Christ. They are guided through the motions by Brother Gabriel. Whenever the rehearsals become intense the atmosphere is lightened with a smile or knowing look. Everyone there is keen to ensure the mass runs without a hitch.

Left: Father Daniel leads the Easter vigil.

Next page: The community pray in the Abbot's Chapel following evening mass on Maundy Thursday. The collective prayer is a re-creation of Christ's contemplation in the Garden of Gethsemane after the Last Supper.

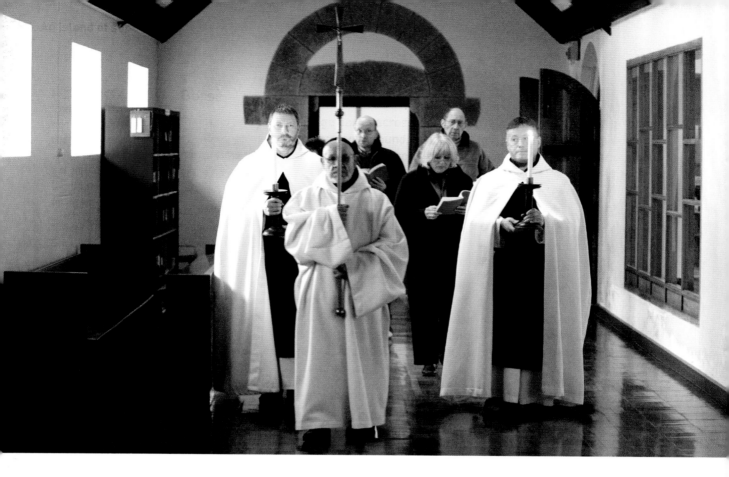

Above:
The congregation process with the brothers to the Abbot's Chapel on Maundy Thursday.

Right: Father Daniel washes the feet of his brothers in the community.

Brother Gabriel is the self-proclaimed "Master of Ceremonies". He appears to be a man who takes life with a pinch of salt. "It's my job to know what everyone else is supposed to be doing," he smiles. "If it all goes wrong it falls on me!"

From the oldest, and frailest monk to the youngest novice, all the brothers are perfecting and correcting each other for the Good Friday service in four hours' time. "A rehearsal is a time for making mistakes, for falling over yourself, so that on the day you're doing everything practically perfect," Brother Gabriel says. "But it's not Hollywood here you know – it's real life! But that's why with any ceremonies I've been responsible for I've always believed in rehearsals, rehearsals, rehearsals." Brother Gabriel has a gentle manner, and is a man you can rely on.

Before he became a monk he served in the Irish Guards. He now sees his army career as good preparation for overseeing a run-through. "When I was in the Army I wasn't in charge of the rehearsals, but I did participate in them. Rehearsals for things like Winston Churchill's funeral, Trooping the Colour, the state opening of Parliament or a state visit or something like that. That's what I did. Things stick with you."

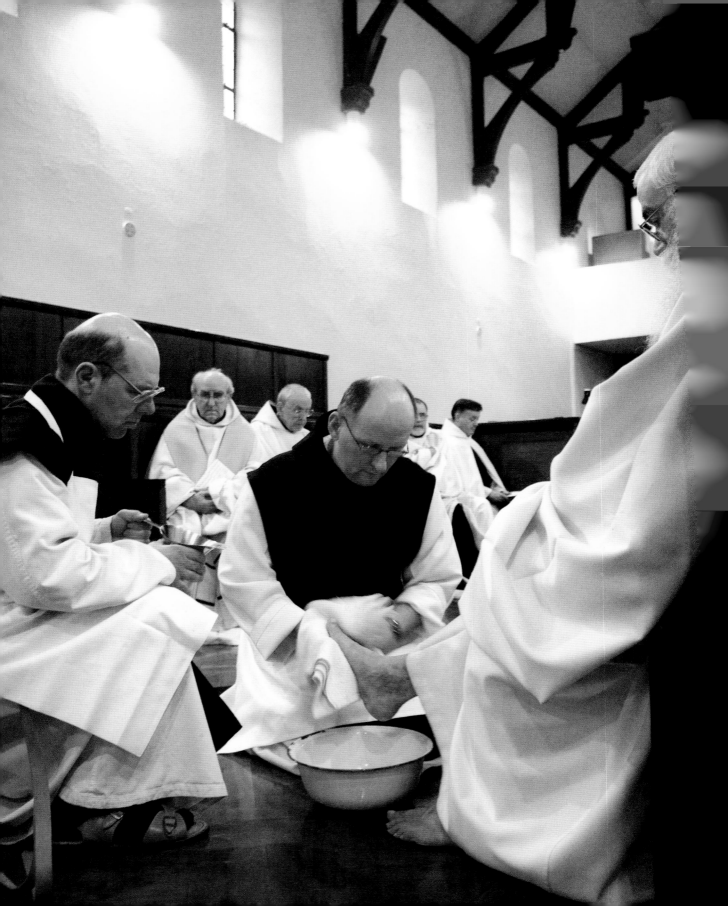

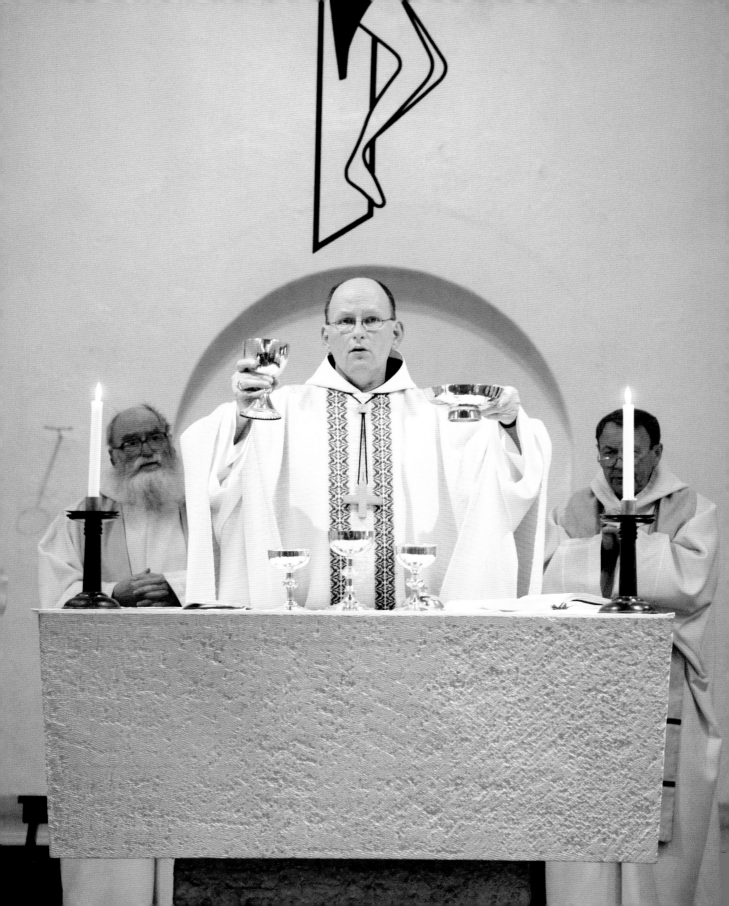

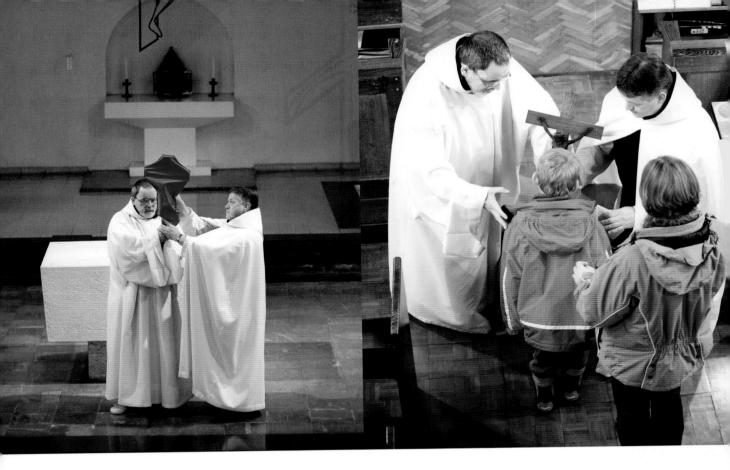

Above: The Veneration of the Cross on Good Friday. Brother Gabriel and Brother Benedict hold the cross covered with blood red cloth and members of the congregation kiss the feet of the crucified Christ.

Left: The Eucharist being celebrated at Maundy Thursday Mass.

To be a soldier or a monk one might perhaps draw on similar qualities. For each, life has rigidity and structure. Each is part of a group in which no individual is more important than the greater ideal, be it serving God or serving their country. Each must be able to follow unquestioningly the wishes of a senior whether they completely agree with them or not.

So, if you have been a good soldier, you might think you could be a good monk. But for Brother Gabriel it was still a huge jump for a young squaddie to consider seriously following a monastic vocation. "It was eating me," he says. "It really was eating at me and I'd think, 'Me be a monk? You're mad!' Eventually I went to speak to the chaplain about it and the chaplain thought, 'Hmmm'." Gabriel re-enacts the chaplain's quizzical look.

"I was stationed in Windsor and I cycled over to Slough to the Cistercian convent and I made a retreat there for a few days. I spoke to the novice master and he decided I should come back, so I saw him and the abbot all over again and they decided I was alright to maybe come and enter... and I became a novice monk in September 1971. It's been a pleasure really. There are days I might want to scream, but most of the time it's been a great pleasure."

Above: Father Daniel contemplates at the start of the Good Friday service.

It has not always been straightforward for Brother Gabriel. His four-and-a-half years in a monastery in Leicestershire did not work out but, still determined to lead a religious life, he joined an order in America where he worked in hospitals in Chicago and Albuquerque, New Mexico, with mentally disabled youngsters. Although it was a very fulfilling time, Brother Gabriel did not feel that he was leading the life he should. "I still wanted the monastic life and it never stopped eating at me until I did something about it," he explains. "I remember one of my superiors saying to me, 'Patrick, Why don't you go and do something about it?' and I decided Caldey was the place – I came in 1990 and I'm still here".

Behind Brother Gabriel the final preparations continue. One monk distributes the hymn books for the congregation, another lays cloth on the altar, and another is buffing the deep dark brown parquet floor with a broom covered in a yellow duster. Each one does his job to perfection; today is a day when things must go right.

Brother Gabriel is aware of the buzz behind him: "The community pulls together at Easter above all other times." His service will be observed by all the islanders, as well as people visiting Caldey.

This is also an important time because Easter Monday usually means the start of the tourist season. Outside the monastery, preparations are underway. For the first time since last autumn the tourist boats will bring day-trippers across from Tenby.

Below: The brothers pray during the Good Friday service.

Last year's blue and white signs, which have spent the winter piled up in a porch, are dusted down, given a new lick of paint and placed back in their positions ready to guide the visitors to the toilet or the tea gardens. After a winter of relative solitude, the brothers and the islanders must prepare for tens of thousands of visitors trooping over their immaculate island.

At ten to three in the afternoon the village green is empty, there is no one on Priory Bay, the footpaths are completely clear and there is no sound of a hedge trimmer, a chainsaw or a small tractor – the island appears to be deserted. Inside the monastery church the pews and the balcony are full; some people are standing at the back. Here sit the islanders and Eastertide visitors, some of whom are relatives of the monks. It is absolutely silent.

The church ceremony on Good Friday contains no consecration of bread and wine so it is a service and not a full mass. There is an important distinction to be made. Father Daniel explains: "As Christians, we want Good Friday to be focused on the extraordinary love of God. That he gave himself completely for us, that he was willing to lose everything to become an outcast for us."

The church is silent. The bell tolls and there's a whispered conversation between Father Senan and Brother Dominic next to the sacristy. The monks enter the church. Father Daniel is the last to come in. He wears a white alb, a deep red stole and a simple

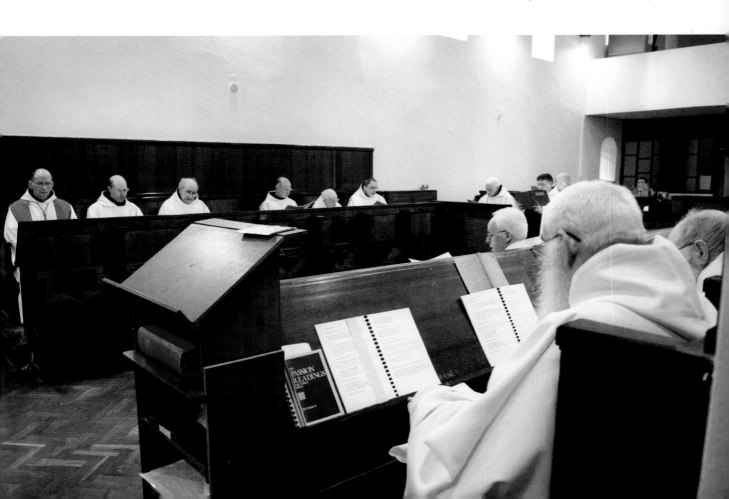

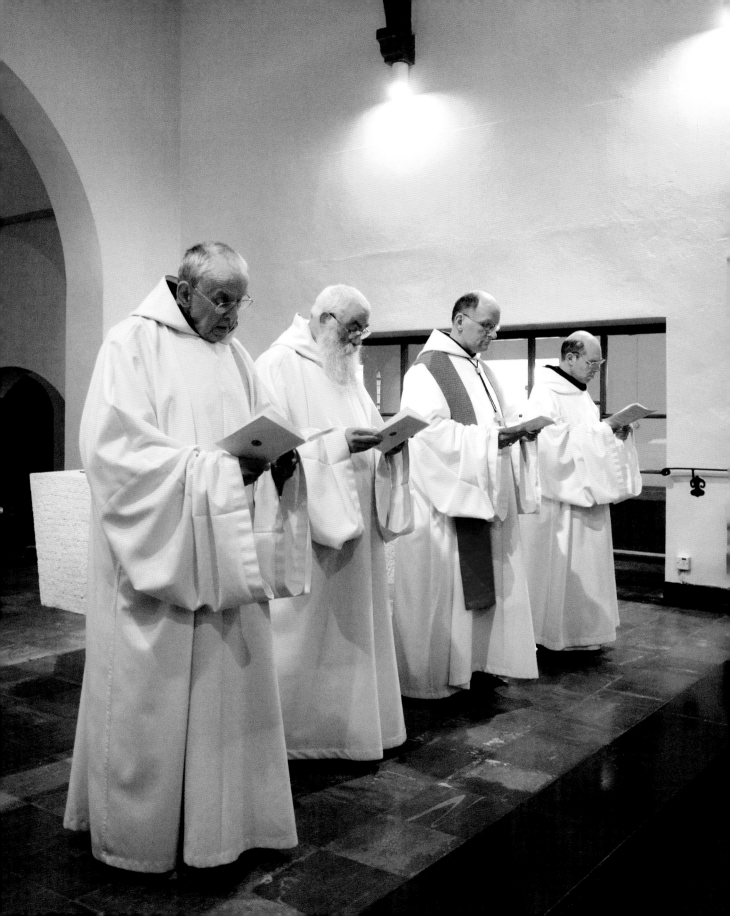

Left: The Passion of Christ from the Gospel according to Saint John read by Brother Teilo, Brother Gildas, Father Daniel and Brother Luca.

Below left: Father Daniel's vestments worn on Good Friday.

Below right: Father Daniel's abbatial ring.

Next page: The abbey bell tolls on Good Friday.

wooden crucifix with a rope chain. He stands at the end of the pew close to the altar, sits down and together the monks contemplate. At 3pm precisely the Good Friday service begins.

Father Daniel stands up, and the community and the congregation follow. He says, "Let us Pray." He says this many times a day but since this is Good Friday his tone has a greater resonance.

"Lord by the suffering of Christ your son, you have saved us from the death we inherited from sinful Adam. By the law of nature we have worn the likeness of his manhood. May the sacrificing power of grace help us to put on the likeness of our Lord in heaven who lives and reigns for ever and ever."

"Amen."

There is silence. They ponder.

The reading of the Passion of Christ from the Gospel according to Saint John begins. Father Daniel is the voice of Jesus, Brother Teilo the narrator, Brother Gildas voices the crowd, and Brother Luca reads the responses of Pontius Pilate. We hear the widely accepted account of the final twenty-four hours of Jesus's life leading up to the moments before his last words and death.

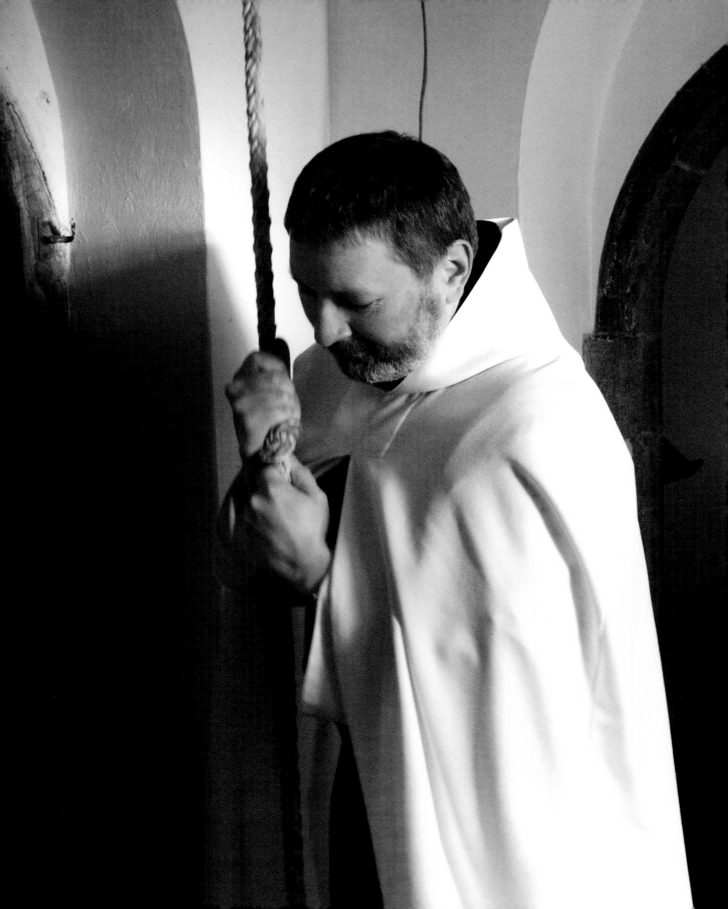

Above: Easter Vigil preparations completed the Paschal candle, four studs to indicate Christ's wounds and candles for the congregation to hold.

The Passion starts with Jesus in the Garden of Gethsemane and relates the trial before Pilate, the crucifixion and finishes with the burial of Jesus in the tomb.

At the point where Jesus is dying on the cross, Father Daniel reads: "It is accomplished." Brother Teilo, the narrator: "Bowing his head he gave up his spirit."

A pause... then in a final act of devotion, the brothers lie face down on the floor of the church in silence as a sign of their total dedication to God. Seeing grown men, regardless of age or physicality, give themselves up in such a way is a sign of commitment never to be forgotten. The moment of silence is like no other.

As Father Daniel explains: "The lying down on the floor is the complete surrender to God. And it is always done after Jesus gave up his spirit. When Jesus gave up his spirit he bowed his head and it is accomplished, and we express that by prostrating ourselves as we call it."

Almost a minute passes; then they stand up as a representation of the Resurrection of Christ. In the Catholic faith it is one of the most physically demonstrative expressions of faith you will witness, a compelling moment.

Father Daniel says: "It is the complete surrender to God so that His Will will be done and it is from the prostrated position that you can rise up again. So it is giving witness to His death, but also to His Resurrection when you rise.

"The ancient monastic fathers taught the monks that the real prayer is to prostrate yourself and stand up again. If you keep on lying down it is to be like a spoilt child who wants to be comforted at all times. No! You believe that Christ is risen so you rise from your prostration. I think it is very positive."

The Veneration of the Cross

Later in the service Brother Gabriel and Brother Benedict leave the church and return with Gabriel carrying the cross; it is veiled in blood-red cloth. They stand before the altar and Brother Benedict unveils the cross to reveal the crucified Christ.

Gabriel holds the cross towards the congregation. This is the Veneration of the Cross, one of the pivotal points of worship for the Catholic faith. He carries the cross from the altar down the aisle. In turn each brother and every member of the congregation kisses the feet on the cross.

Many Catholic services can be hugely grand and ceremonial, but with Cistercians there is a subtlety. The vestments are simple, with clean lines; the church ephemera are of minimalist design. The plainness has a refinement to it, a style of grace. The Veneration is presented in an understated way.

Father Daniel: "When you remove the veil he is revealed to the believing community as the crucified Christ. We venerate the crucified Christ because it is in the acceptance of the crucifixion that we also welcome the Resurrection. It is an expression of love and veneration. A kiss is an expression of being united with the other and that is what we want to express."

Holy Saturday – Easter Vigil

It is a quarter of an hour before midnight on Saturday; the wind swirls around the abbey turrets. It feels like a south-easterly, the one that will see the Post Boat cancelled. Looking towards the village green it is pitch black; the lights of the cottages are few. Around the upper floors of the monastery all the lights are off.

The cloud cover is black and the only brightness is the distant shimmer of the lights of Tenby. Almost imperceptible, hushed conversation can be heard, together with firm, deliberate footsteps on the paths around the green. The cottages and the steps up to the monastery are peppered with moving torchlight. The islanders and visitors are coming to attend the Easter Vigil.

Many practising Catholics will have attended an Easter Saturday Vigil at least a few times in their life. In some urban areas it tends to be avoided as going to a late night service can present a problem for reasons of safety. If you go to Caldey Abbey it feels as if it's one of the most important services you will ever attend. Being there is a lifetime experience.

The vigil commences at midnight, in darkness, suggestive of the tomb where Christ's body lay.

Next page:
(clockwise from left) The congregation in the pews of Caldey Abbey's church. Brother Luca takes light from the Paschal Candle. The brothers start the procession from the cloisters into the church for the Easter vigil.

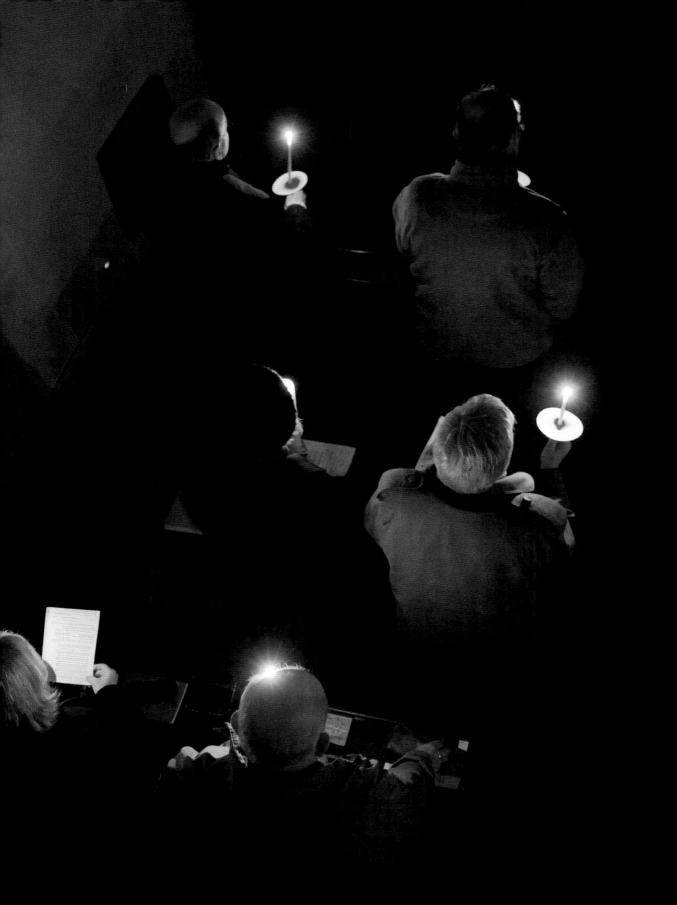

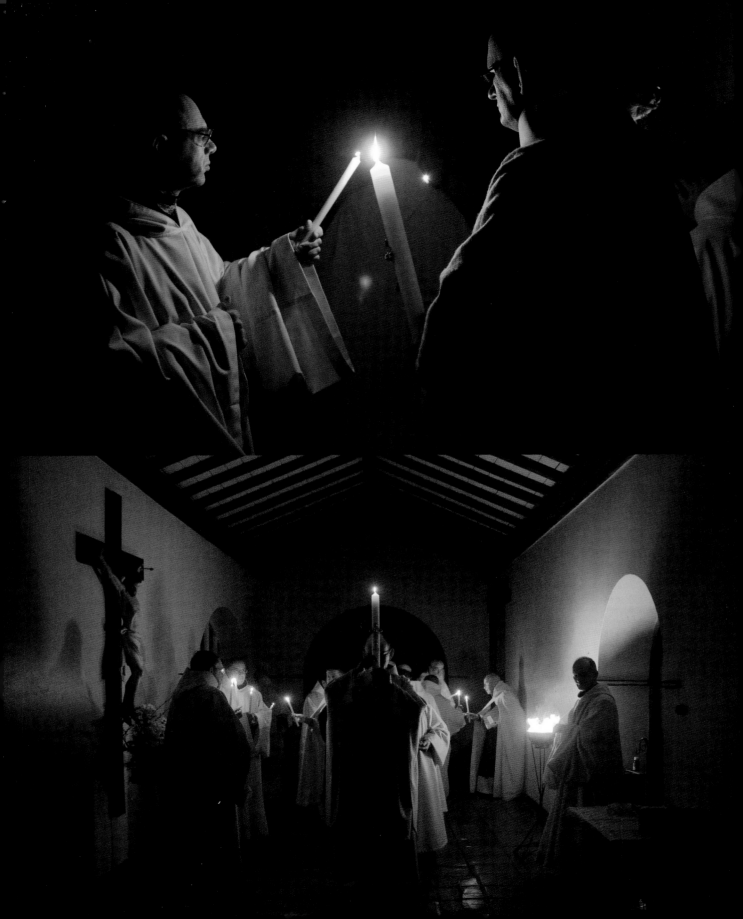

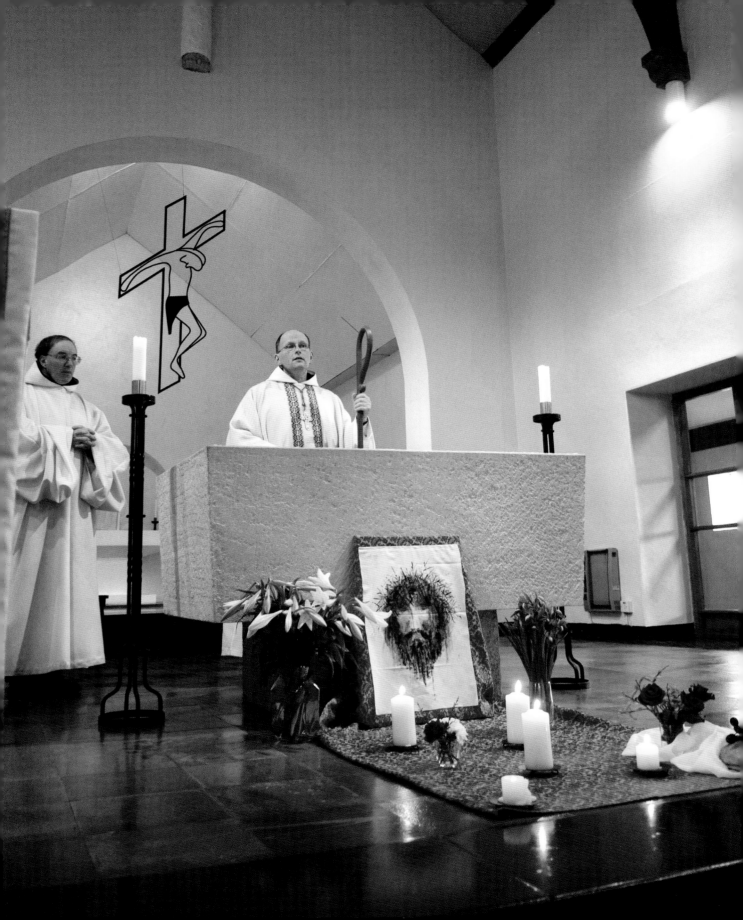

Left: Mass on Easter Sunday.

Below left: A decorated egg in the refectory.

Below right: Father Daniel's vestments worn on Easter Sunday.

Next page: Brother Paul and Brother Gildas take wine at Holy Communion on Easter Sunday.

Father Daniel: "It's a silent Saturday because we are focusing on Jesus who is now in the tomb. Everything falls silent; we are sharing that silence of Christ's death, a silent expectation. You can say the silence before the storm. We believe that Jesus is the Word of God but a word without silence cannot express itself properly, fully. You need silence in order to communicate. So the silence of the tomb is an essential prelude for the Resurrection – for the new life."

There is one light on by the bell in the cloisters. The shadowy shapes of the monks drift around the corridor and collect out of the light. A torch illuminates Father Senan's face. The monks are grouped on one part of the cloister square, the congregation on the other. Father Daniel, Brother Gabriel and Brother Paul stand between the two groups. The brothers and the congregation are now gathered in the darkness and the entire population of the island stands within an area of about 20 square metres.

At a time like this it is easy to imagine how cold parts of the Abbey must be especially in winter, and wonder what it must have been like before the roof was replaced.

Brother Titus lights the fire and steps away. Brother Paul carries the incense burner. No-one utters a word. The half-lit outlines reflect in the windows, distorted and refracted by the metalwork. Father Daniel steps up to the fire, Brother Gabriel stands behind with the 3ft high Paschal Candle. From tonight it will stay in the church for

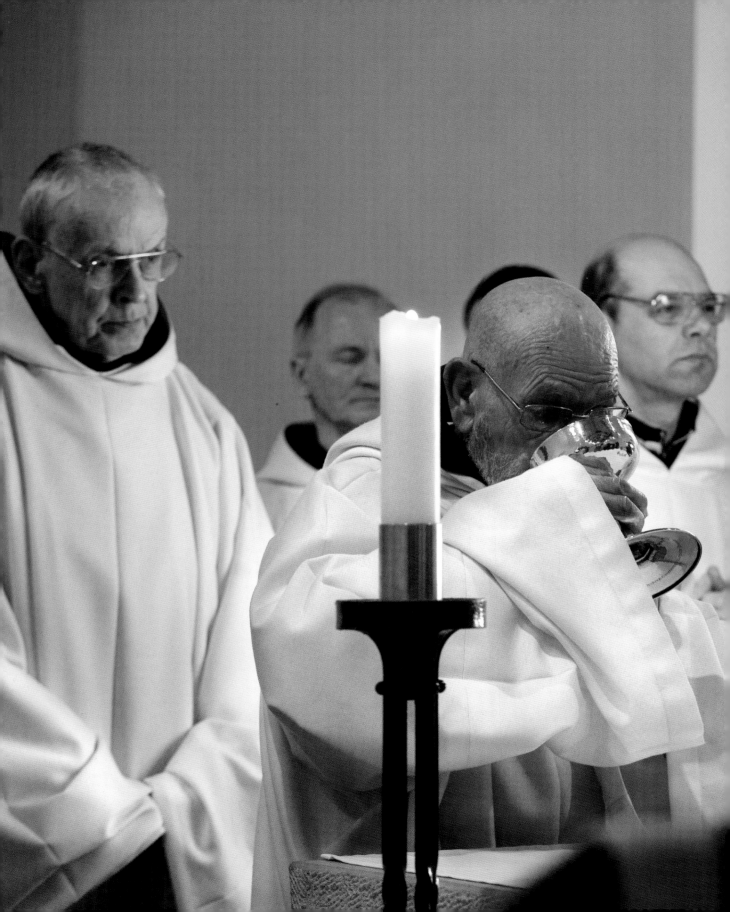

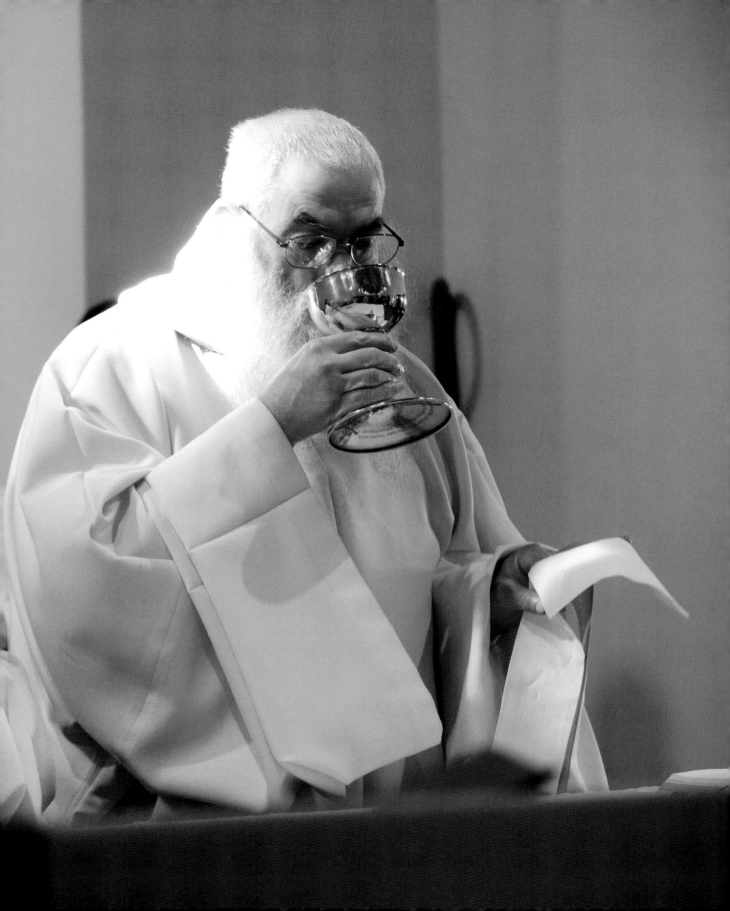

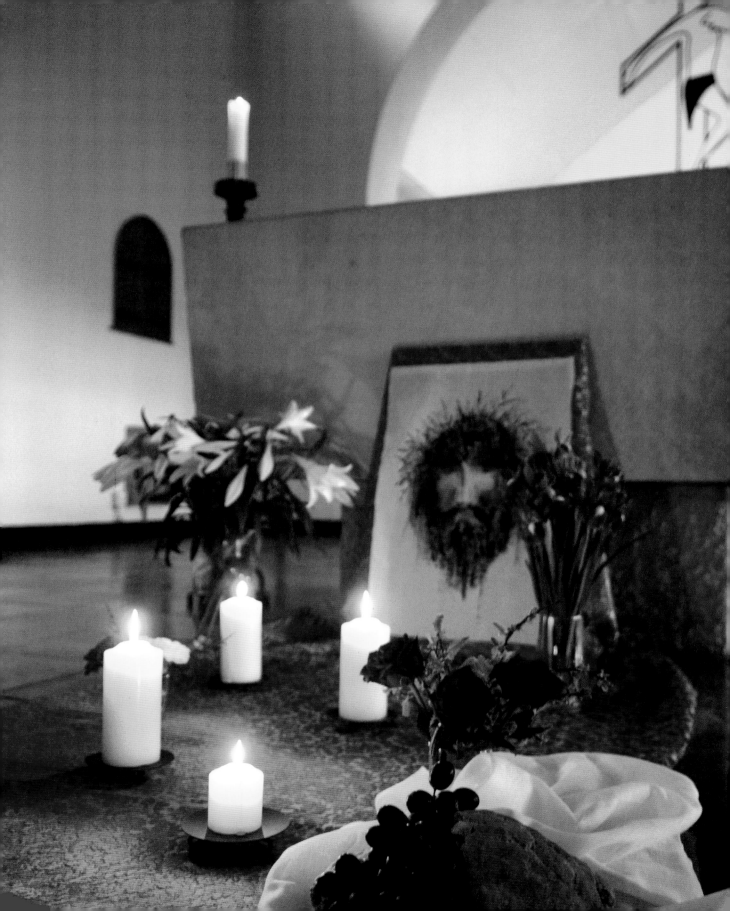

Left: Altar display on Easter Sunday.

a year. Father Daniel starts the service: "The Lord be with you." The congregation answers: "And also with you."

"On this most Holy night when our Lord Jesus Christ passed from death to life, the Church invites her children throughout the world to come together in Vigil and Prayer. This is the Passover of the Lord. If we honour His death and Resurrection by hearing His word and celebrating His mysteries then we may be confident that we shall share His victory over death and live with Him forever in God."

A pause.

"Let us Pray."

From the fire, he lights the Paschal Candle. "Make this new fire Holy and inflame us with new hope, purify our minds by this Easter celebration and bring us one day to the feast of eternal light. We ask this through Jesus Christ, Our Lord."

"Amen."

Gabriel holds the Paschal Candle and Father Daniel runs his thumb down it. "Christ, yesterday and today the beginning and the end, Alpha and Omega, all time belongs to him and all the ages to him the glory and power through every age forever and ever."

"Amen."

He then deliberately and carefully forces four silver stud nails into the points and centre of the image of the cross that is embossed on the candle.

"By His most glorious and Holy wounds, may Christ our Lord guard us and keep us."

"Amen."

In turn everyone lights their candle from the Paschal Candle, one by one their faces light up and mysterious shadowy figures become recognisable as Brother Dominic, Brother David and Brother Paul.

The monks all process into the Church alongside the congregation, taking with them a stream of light that illuminates the Church and the celebration of the resurrection of Christ begins. As they progress Daniel carries the Paschal Candle. He sings: "Christ our Light" at short regular intervals. The congregation and community respond in song: "Thanks be to God."

In the dark of the church the small lights shift slowly from the cloisters through the entrance to the church. As everyone finds their seat they sit quietly; Gabriel starts the service with a sung recitation.

The monks then read from the Book of Genesis, the Book of Exodus, the Book of Prophets and the Book of Romans through to the New Testament's Gospel. In this way, the entire history of the Bible's story up to this point is considered; and the past and the new life of Christ to come are contemplated.

Right: The late Brother Dominic at lunch on Easter Sunday.

Father Daniel explains: "That's why the Paschal Candle stands alongside the lectern where the word is read so that the new light, the risen light, is shining its rays on the word of your life. Our life with all its idiosyncrasies and its wounds are embraced and accepted completely in the presence of God and that life is crowned with the celebration of the Eucharist – it is so rich!"

Easter Sunday brings the Easter services to an end. Now the brothers are free to enjoy time with their families, some of whom have travelled from across the world to visit the island and share in the services.

But first the community must face the biggest lunch of the year. A table laden with wine and rich foods, marking the end of Lent with gifts from visitors and friends of the island. The atmosphere contrasts greatly with other lunchtimes. Just as they do on special feast days, the monks listen to sacred music rather than a reading.

Tomorrow the tourists will arrive.

Brother Dominic Maria Morgan

Date of birth: 10th May 1922 – 2nd December 2008.

When did you become a novice? 1947.

When did you take full vows? Took vows at Saint Pauls Church Massachusetts, USA in 1951.

When did you first come to Caldey? 1989.

Why did you become a monk? Vocation.

What other monasteries have you been part of? New Melleray, Iowa, USA 1947 – 1989.

Why Caldey? For the Lord and the cows.

What is your favourite canonical hour? Vespers and Vigils.

What are your interests? The woods.

What are your jobs on the island? Barber and working in the woods.

What do you miss from the outside world? Nothing!

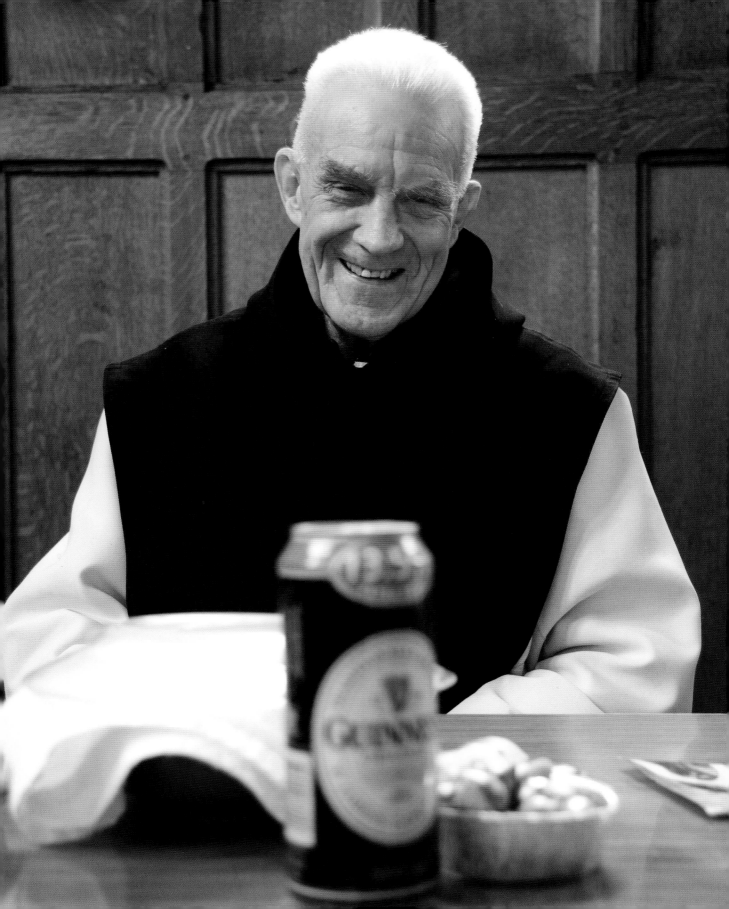

Brother Benedict

Brother Benedict came to Caldey as a novice in 2000 as part of the long journey to find his vocation, a journey that started in a family of Jehovah's Witnesses in Middlesbrough. As a teenager he started to read the Bible. "I was always a fairly God-conscious child, but then at about the age of fourteen I started looking elsewhere for my spiritual home. I became more and more fascinated with Jesus because Jehovah's Witnesses are Unitarian – they don't believe in the divinity of Christ and I started to see more and more that Jesus is divine and so I came into what I believe is revelation knowledge."

It was not until he met a Catholic priest that he felt he had found something. The priest talked with Benedict about faith and answered his questions about spiritual matters. "What impressed me about Catholicism was the definitive way in which they believe," he says. "I wanted something more definite, more dogmatic."

Amid much opposition from his family, Benedict became a Catholic at sixteen. "The Jehovah's Witnesses' belief system didn't answer that gap inside which I believe only Jesus can fill."

At eighteen he went to Canada to join an apostolic missionary community in the Laurentian Mountains of Quebec. Realising their life was not what he was looking for he became a lay member and worked for missionary projects in Guadeloupe, in the West Indies, Puerto Rico and Italy. Later on he was a pastoral worker in a drop-in centre for the homeless in Middlesbrough and spent a year in London with a Franciscan community working in local parishes.

His desire to find his place in the church, along with a wanderer's spirit, took him to Mexico where he visited a group originally set up by Mother Teresa of Calcutta – the Missionaries of Charity Fathers. Benedict was impressed by these priests who helped the poor, but again it was not the vocation he was seeking.

Back in Britain, a Catholic priest who had stayed on Caldey suggested he try the island out. Benedict was far from convinced: "I asked him 'What order are they?' and he said, 'Trappists – you know, Cistercians,' and I said, 'Definitely not!' And he said, 'Try it anyway. Just go.' So I did and I was smitten!"

Caldey contrasted greatly with Benedict's experience of busy mission-based groups: "A lot of people felt that coming to an enclosed community wasn't for me, but I knew it was. Very often you'll find that people who enter contemplative communities had been very active social workers, teachers..."

He was struck by the unspoilt beauty of Caldey and experienced a sense of peace and homecoming: "It's been a long road in finding my place, but that's fine, that's all part of the tapestry of God's plan."

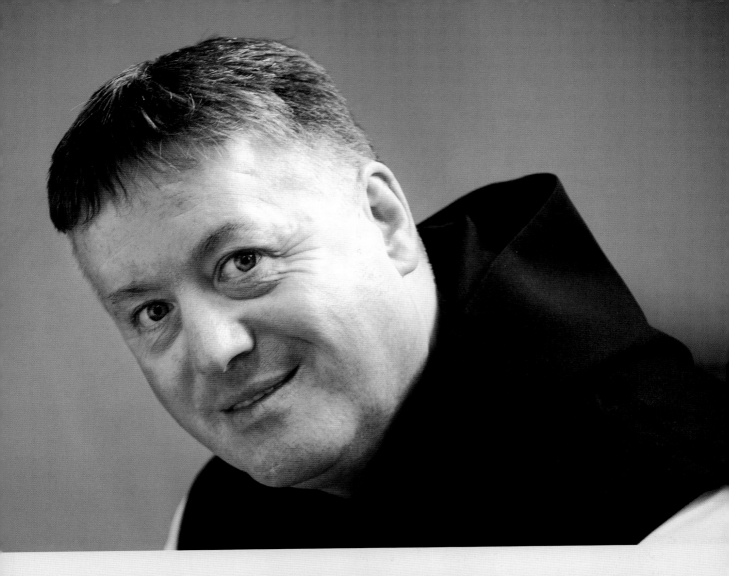

Place and date of birth:
Middlesbrough, 1960.

When did you first come to Caldey? 1997.

When did you become a novice?
Became a novice in 2000.

When did you take full vows? Took temporary vows in February 2005 and became solemnly professed on 1st May, 2009.

Why did you become a monk?
Vocation.

What other monasteries have you been part of? Mount Melleray, County Waterford, Ireland, for six months as part of my formation.

What is your favourite part of the island? Bullum's Bay because of its privacy (it is in the enclosure) and rugged beauty.

What is your favourite canonical hour? Vigils, because it's the beginning of the day and nothing has spoilt the pristine, pure character of that hour, and I like the idea of giving to God the first fruits of the day.

What are your interests? I enjoy reading, walking and listening to music.

What are your jobs on the island? I work in the bakery making shortbread. I clean, do housework, work outside cutting the lawns and help wherever I'm needed.

What does Caldey mean to you? Caldey means a lot to me because of its deeply spiritual atmosphere and long monastic history.

What do you miss from the outside world? Women (their company) and children.

Index

Bibliography

Books

Ansom, P.F. The Benedictines of Caldey

Armstrong, K. The Bible – the Biography

Barrett, J. & Yonge, C.M. Collins Pocket Guide to the Sea Shore

Buczacki, S. Fauna Britannica

Cambrensis, G. The Journey through Wales

Dalgairns J.B. The Life Of St. Stephen Harding

Donavon, E., Newman, J.H. & Thurston, H. Descriptive Excursions through South Wales & Monmouthshire

Felix, J. & Hísek, K. Sea & Coastal Birds

Friar, S. Cathedrals & Abbeys

Herbermann C.G. The Catholic Encyclopedia, Volume II

Pace, E.A., Pallen, C.B.,Thomas J.S., Wynne, J.J.,

Lambert, T. & Mitchell, A. Lamberts Birds of Shore & Estuary

Howells, R. Caldey

Howells, R. Total Community

Mabey, R. Flora Britannica

Middleton, Dr A.L.A. & Perrins, Dr C.M. The Encyclopaedia of Birds

Moffat, Alistair The Sea Kingdoms

Murphy, D. Chronologica Monasterii Sanctae Crucis In Hibernia

Preston Mafham, R. & K. Collins Gem – Seashore

Robinson, D. The Cistercians in Wales : Architecture & Archaeology 1130 – 1540

Southey, R. The Book of the Church

Shepherd W.R. (Editor) The Benedictines of Caldey Island

Talbot, R. & Whiteman, R. Cadfael's Country

Lewis, J.M. & Williams, D.H. The White Monks in Wales

Tobin, S. The Cistercians – Monks and Monasteries of Europe

Williams, D.H. White Monks in Gwent and the Border

Williams, D.H. Atlas of Cistercian Lands in Wales

Williams, D.H. The Welsh Cistercians Volume 1

Williams, D.H. The Welsh Cistercians Volume 2

Williams, D.H. The Welsh Cistercians

Williams, G. Wales and the Reformation

Guides & Leaflets

Beynon, J. Caldey Monastic Island – An Introduction

Bushell, W.D. Caldey: An Island of the Saints

Hilling, J.B. St Dogmaels Abbey – Welsh Historic Monuments

Shepherd, A. A Visitors Guide to Caldey Island

Wildgust, D. The Prehistory of Caldey Island

Caldey Island Press Short Guide to Caldey Island

Caldey Island Press Why Are They Monks?

Caldey Island Press Cistercian Monasticism

Acknowledgements

There are many we wish to thank for their help with the Caldey Island book.

From Ross: I would like to thank Father Daniel and the community for the warm welcome and assistance given when shooting the book. The Islanders for being so flexible. Alan Thomas and the Caldey boatmen for the various trips across to Caldey Island. Rob Lomas for the generous time given to allow me to get the shots of the island from the sea in his boat. And last but not least, my wife Rachel for her patience and getting me up for those early morning starts.

From Chris: My parents, Michael and Dorothy who were, as ever, unremittingly supportive and willingly read draft after draft, never saying what they really thought but always making encouraging noises when it was most needed. My uncle, Philip Hutchinson for passing his editor's eye over the book. Brother Teilo who contributed so much guidance through his immense intellect. Brother Gildas for his historical knowledge and of course, his many meals. The late Brother Robert for allowing me to trawl through the photographic archive that he had meticulously collated. Father Senan and Robert Judd who always patiently dealt with my requests to stay in the monastic guesthouse. Father Daniel for many, many things that include always agreeing to my going over even when it didn't suit the community. Cathy and Michael Scullion for their hospitality. Alan Thomas and the Caldey Pool for their boatmanship, weather permitting. And of course the other brothers who have always welcomed me to the community when I have stayed with them – Gabriel, Stephen, the late Dominic, Paul, Benedict, Luca, David, Titus and Michael.

Thanks also to Dom Armand de Veilleux – the abbot of Notre-Dame de Scourmont Abbey, photographer Pierre Peeters, Faber & Faber, Tenby Museum and Gallery, Pembrokeshire National Park, the Countryside Council of Wales and Cardiff Libraries.

A very big thank you to everyone at Graffeg who worked on the book; Peter Gill publisher and art director, Ian Jones designer, Vanessa Bufton and Sarah Evans production, editing and marketing, Rhodri Wyn Owen and Penny Fishlock copy editors, and the Welsh Books Council.

And lastly thanks to my partner Sara for her total lack of patience and pestering me to finish the book before our children, Lydia and William leave home. his book forms another part of our attachment with Caldey and the community.